PORTSMOUTH
& GOSPORT
AT WAR

PORTSMOUTH & GOSPORT AT WAR

JOHN SADDEN

AMBERLEY

First published 2012

Amberley Publishing
The Hill, Stroud
Gloucestershire, GL5 4EP

www.amberley-books.com

British Library Cataloguing in Publication Data.
A catalogue record for this book is available from the British Library.

ISBN 978 1 84868 148 4

Typesetting and Origination by Amberley Publishing.
Printed in the UK.

Contents

	Introduction	7
1.	The Kaiser's Spies	9
2.	Preparing for the Storm	26
3.	Invasion!	38
4.	Tickled to Death to Go	50
5.	Faith, Hope and Charity	66
6.	Port in a Storm	74
7.	Voices of War	85
8.	Coming to Take You Away	99
9.	Zeppelin Attack!	110
10.	The War Effort	124
11.	A Little of What You Fancy	147
12.	The Fire Behind the Smoke	160
13.	Women and Children Last	166
	References	184

Introduction

This new edition of the history of Portsmouth in the First World War, originally published in 1990 under the title *Keep the Home Fires Burning*, offers a welcome opportunity to incorporate amendments and corrections as well as references which were absent from the original edition.

It was a privilege to have had the opportunity to interview and correspond with a number of people, all of whom have since died, who shared their memories of the war years: Doris Ball (née Loving), Ernest Ball, Bill Buckley, D. S. Ford, Anne Eason, Arthur Ferrett, James Gray, Cecil Harbut, Elsie Harbut (née Mullins), R. Gladys Whiteman, R. A. Lowe and members of the Anchorage Red Cross Club. Thanks to the local press for publishing my appeals for help.

I was fortunate to have received a level of help from staff at Portsmouth Central Library, Gosport Museum and Portsmouth Record Office that is, alas, no longer available to current users due to cuts.

Extensive use was made of published material and I record my obligation to the many historians whose work I have drawn on. William Gates's work, both as editor of the *Evening News* and as author of *Portsmouth and the Great War*, provided useful background material and Arthur Marwick's *The Deluge* was especially helpful in placing local events in a national context.

Thanks also to local historians Ron Brown and Peter Rogers, and to Hilary and Gerry Warren for their concise translations of difficult German text.

I would also like to thank the British Library, Portsmouth Grammar School, J. Stallworthy and the trustees of the estate of Rupert Brooke, J. Stretton, K. Lane, J. G. Adams, C. Titheridge, Lord Callaghan of Cardiff, D. White, C. Salter, the Reverend Brother Cyril, V. Billings (née Blanch), K. Shaughnessy, D. Dine, N. Rogers, G. Dunbar, S. Quail, B. Spier, M. Little, Royal Marine Museum, Public Record Office, (National Archives) Kew, R. Bente, D. Lee, Wessex Film and Sound Archive, A. E. Fleming, D. Parry, A. Wooton, Imperial War Museum, C. Clark, K. Gibbins, The Home Office, J. Berkett, Blackpool Libraries, Birmingham Central Library, C. D. Darroch, Royal Hampshire Regiment, T. Roper, Fort Brockhurst, English Heritage, B. L. Davies, Priory School, W. Sodeau, Q. A. Hospital, J. Plummer, D. Stevens, Hampshire Magazine,

Morris and Mrs Heynes, R. J. Bowles, A. Panton, Portsmouth Register Office, Portsmouth and Gosport Cemeteries. Acknowledgement is made to the commercial photographers of the period, especially Stephen Cribb whose work is well represented here.

John Sadden, 2012

CHAPTER ONE

The Kaiser's Spies

There was little to distinguish Heinrich Grosse from any other excursionist alighting from the Southampton train at Portsmouth Harbour Station one day in the autumn of 1911. It had been an exceptionally busy summer season, with the Coronation Review and record temperatures drawing thousands of visitors into the hundreds of hotels and boarding houses that dominated the fashionable and not so fashionable parades, avenues and terraces of Southsea. Only the late excursionist remained, determined to make the most of an 'Indian summer.'

But it was not the autumnal sun or the famous tourist attractions that brought Heinrich Grosse to Portsmouth. A glance at the luggage carried by the neat, broadly built forty-three year old suggested that he was a keen fisherman, with several rods hampering his progress as he tramped the Southsea streets in search of vacant rooms to rent. Having no success, Grosse booked into a hotel for a few days, using excellent English. Settled in, he wrote to a Mr Petersen in London informing him of his temporary address. In due course a reply and a sum of money was received:

Dear Sir,

Mr Stern has written to me about your meeting with him and sends you his respects. I think few words will suffice and hope to speak to you personally soon. Just look round quietly and take your time. Portsmouth and the immediate neighbourhood is the spot that I am keenest about. Kindly let me have your new address as soon as possible and let me know if eventually I can send registered letters there. You will then receive the remaining five pounds. I did not want to send the whole amount to the hotel. Mr Stern informed me of your idea of sending me a short diary: I shall be glad to get it. I agree with your plans up to date and hope for further news in the near future.

Yours sincerely,

R. H. Petersen.

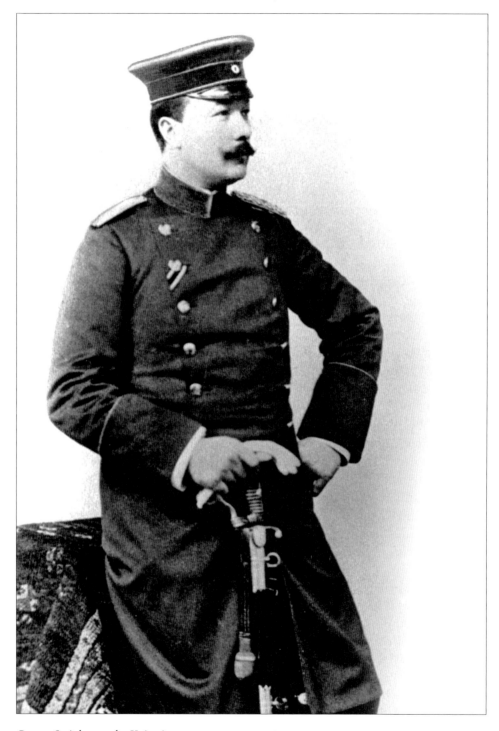

Gustav Steinhauer, the Kaiser's master spy.

Before travelling to England, Grosse had been briefed in Hamburg by Gustav Steinhauer, alias Mr Stern, described as a Prussian officer, ex-personal bodyguard to and close personal friend of the Kaiser. He had also been the controller of the German Secret Service for the previous nine years.

While 1911 was a good year for tourists, it was an especially bad one for international relations. It was a time of acute diplomatic tension between Britain and Germany and Steinhauer's immediate concern was to determine whether the Royal Navy was preparing itself for war against Germany. It was, then, inevitable that Portsmouth, with its dockyard, naval base and garrison, should receive such attention from the German Secret Service.

Steinhauer had established in Britain a small network of agents comprised of 'active' spies, like Grosse, whose duty was to find answers to lists of questions dealing mainly with changes that had taken place in naval matters. But because frequent foreign correspondence from British naval towns might arouse suspicion, a second network of agents was established in London to forward mail to and from Steinhauer's headquarters in Potsdam. This was the role of Grosse's correspondent 'R. H. Petersen' whose real name was Kronauer.

Using the alias 'Captain Hugh Grant', Grosse moved into more permanent lodgings at 'Meredith', Green Road, Southsea, where he mixed with fellow residents and the landlady with relative ease, though his conversation and interest centred on the more solitary pursuits of fishing and solving puzzles in the magazine *Tit-bits*. He clearly intended to stay in the Portsmouth area for some time as he placed an advertisement in the 'Miscellaneous' column of the *Portsmouth Evening News* offering to act as a language teacher as a cover. It was, perhaps, while perusing this column to ensure that his ad had been inserted, that Grosse came across the following: 'Gentleman wishes to undertake private inquiries. Meeting arranged to suit conveniences. William Salter, Percy Road. Southsea.'

Grosse's indolence transcended the advice that he should 'just look round quietly and take his time'. He met Salter and asked him to find out the amount of non-domestic coal (used to fuel ships) stored in Portsmouth and Gosport, including the dockyard, and the number of men in the local naval barracks.

William Salter, a former sailor who was attempting to supplement his meagre naval pension as an inquiry agent, was told the details were needed for a book Grosse was writing and that such information might be useful should a coal strike occur. In the event of an industrial dispute, he explained, German merchants would be able to export coal and make a quick profit. The number of men stationed in the barracks was of interest because it would indicate something of the manpower available to strike-break. Salter agreed to undertake the commission but was not convinced. The idea that bluejackets (sailors) would be sent down the mines was especially hard to swallow and from his own experience in the Navy he knew that the information he was asked to get was potentially valuable to foreign powers. He cursed his luck that this, his first potentially lucrative job, was of such a suspicious nature and immediately reported the matter to the admiralty and the police. Salter was then used to feed Grosse disinformation,

after which he abandoned his inquiry agency for the tranquil occupation of telephonist.

Once alerted, the authorities put Grosse under round-the-clock surveillance. With Salter paid off, Grosse sought corroboration from another source. Engaging his local newsagent in what he evidently believed passed as casual conversation in a naval port, he asked if he could find out the same details of coal supplies and manpower, explaining that he had a £5 bet on the subject and it was a condition that he was not to ask a soldier or sailor. The newsagent dutifully reported the matter to the police.

Grosse bought his newspapers and puzzle magazines from Messrs. Prescott and Co. of Kings Road, regularly taking *Tit-bits* and *Answers*. The mental agility developed in solving the teasers posed by these magazines would have served him well when he received the next letter from 'Mr Petersen':

Dear Sir,

One of my friends tells me that your 11, 22, 14, 8, 29, 5, 2, 12, 11, 8, 22, 10, 2, 33, 2, 3, 3, 28, 29, 2, 12, 21 and without any personal embellishments. I was very pleased to hear this. I hope that you will take the trouble to make our joint business a good one in the future. You will see from the newspapers that there is a special interest at present about things relating to 21, 22, 32, 23, 2, 22, 18, 2, 22, 18, 32, 17, 29, 30, 2, 22, 6. This happens most opportunely for you, and you can see that your 14, 11, 17, 23, 18, 8, 14, 19, 1, 21, 29, 2, 12, 11, 8, 22, 33 will be a valuable one. I don't wish you to hurry too much, but I am now giving you still further questions, the answers to which I consider will be very useful to me: (*Six numbered questions follow, all in code*). There is, therefore, work and stuff enough. I wish you every success in my branch of the work.

Yours sincerely

The letter could be decoded by remembering a short sentence: 'Pack my box with five dozen liqueur mugs.' The individual letters corresponded to the numbers one to thirty-three in order. Thus the letter was signed with the number one, which represented 'P' for Petersen.

When the six questions which make up the substance of the letter were deciphered, the extent of Steinhauer's interest in Britain's naval affairs was revealed:

1) Is it really true, as was stated in the newspaper, that the new submarines are being fitted out with guns? How and where are these mounted?
2) Where are the guns stored for arming merchant steamers in time of war?
3) What sort of guns have the mine-laying cruisers *Naiad*, *Thetis* and *Latona*?
4) Have these got wireless telegraph?
5) How much coal is there on shore? Is there no more coal in the dockyard than what is stated?
6) More details are required about the system of range-finding.
The information about a floating conning tower is surely imaginary.

Deciding that such information could not be gleaned from his local newsagent, Grosse set off to do some fishing of his own in a hired boat off Gosport, home of Fort Blockhouse, Britain's premier submarine base. He had little success, catching only crabs. Undeterred, he turned his attention to the fortifications of Southsea Castle, where regular target practice drew large crowds. Resourceful as ever, Grosse approached a sentry and interrogated him on details of the guns, their type, range, number and whether the targets at sea were fixed.

Grosse's every move was being carefully monitored. Early in December it was feared that he intended to return to Hamburg and the authorities acted swiftly. Grosse was arrested at his rooms in Southsea and charged under the Official Secrets Act of 1911. Shocked and apparently unaware that his less than subtle methods could possibly have attracted any suspicion, Grosse's immediate reaction to the police raid was to ask who had betrayed him. His consequent court appearance at Portsmouth attracted keen interest, with every seat in the house taken. The proceedings proved a disappointment to those spectators who were used to tales of evil and conniving Hunnish spies, for Grosse had stubbornly and persistently refused to conform to the popular stereotype of an efficient and calculating German. His defence in this, and the subsequent trials at the Assize Court in Winchester, was that the nature of his business in Portsmouth was commercial and that he was acting for a German coal merchant in gathering information:

> I have done nothing. I came to Portsmouth for fishing. I am fond of the sea, and fond of fishing. I have not been near the Dockyard or any ship. I spend all my time with my friends or walking in the streets and fishing. I do a little business, but nothing political.

The judge, Mr Justice Darling, pointed out in his summing-up that this would have been a plausible defence if it were not for the incriminating coded letters from 'Mr Petersen'. In an attempt to gain leniency Grosse revealed Petersen's true identity in open court, a disclosure that was to have serious repercussions for Steinhauer's operations in Britain. Herr Kronauer, alias Mr Petersen, who worked as a barber in Hampstead, was immediately isolated from the network. His dead body was later fished out of the Thames. Grosse was sentenced to three years of penal servitude, a sentence that the editor of the *Portsmouth Evening News* found 'surprisingly lenient'. Had his activities been discovered in wartime, Grosse would have met his death on the garrison rifle range in the Tower of London.

The commissioning of espionage activity was not, of course, solely the preserve of Germany in this age of 'fatal competition' when the latest modifications to dreadnoughts and submarines might give one side an advantage in a war that, it was firmly believed, would be won or lost at sea. For every dastardly, devious and despicable agent of the Kaiser there was a brave, British Baden-Powell type, gathering information with tactics worthy of *Boys' Own Paper*. Few, however, were as clumsy or inept as Heinrich Grosse.

Later, during the war, it was confidently asserted that Steinhauer had 'actively at work a swarm of agents in every dockyard town, garrison and naval base', supplying secret information in preparation for war. Such statements were inaccurate, fed popular hysteria and led to some very tragic events in the Portsmouth area.

Nevertheless it would be rash to dismiss Grosse as an isolated case. Certainly, no evidence emerged at his trial which pointed to there being any other spies in the Portsmouth area at that time. But equally, the following question, posed by a correspondent of the *Globe,* remained unanswered:

> If not from spies, from whom did Germany obtain the very valuable information that oil was to be the sole source of motive power for the *Queen Elizabeth* (a Portsmouth-built Dreadnought, launched in 1913) that appeared in *Taschenbuch der Kriegsflotten* (the German equivalent of *Jane's Fighting Ships*) published in January, 1913? Certainly not from any English official source, for we were kept entirely in the dark as to this momentous change until the *Morning Post* announced in July, 1913, that the battleship in question would consume liquid fuel only.

By replacing coal with oil, *Queen Elizabeth* and others of her class were allowed a greater weight of armour and a higher speed. This fuel 'leak' was no minor matter. To Detective Inspector Percy Savage, the arresting officer in the Grosse case, it was proof of further espionage activity. As a witness in the Grosse trial, Savage had appeared in court as an ordinary dockyard policeman. He was in fact 'connected' with the British Secret Service as a spy catcher who had responsibility for plugging breaches in security surrounding improvements to dreadnoughts, submarines and weaponry in the Portsmouth area.

Shortly after arresting and interrogating Grosse, Savage began spending his working day undercover in some of Portsea's less reputable public houses. The object of his attention was a man who embodied many contemporary hates and fears. Not only was this man obviously German, but, as the press was to later suggest, he was a hunchback who worked both as a pimp and a dentist. But, perhaps worst of all, Wilhelm Klauer, alias William Clare, was a spy.

Unlike Grosse, who was specifically sent to Portsmouth for the purposes of espionage, William Clare had lived and worked locally since 1905. As with most immigrant workers hoping to establish themselves, Clare's rented business premises were humble and not ideally situated. In his shabby dental surgery down a Portsea back street, Clare discovered that pulling teeth at a shilling a time was not very profitable. There was keen competition in private dentistry, with many qualified and unqualified practitioners vying for a potentially lucrative naval trade. The Navy's own dentists were quite justifiably feared by the average bluejacket who had to look elsewhere for promises of 'painless extraction'. But there was little money to be made simply pulling or filling teeth. Real profit could only be made by selling the client a set of false teeth after having first convinced him of the immediate urgency of extracting all of his natural ones. But Clare lacked both

the training and resources to provide this service. His only qualification for being a dentist was his description of himself as such, and he could only offer 'painless extraction' if the customer was insensible through drink. Nevertheless, he ran a surgery of sorts and was reasonably adept with his pliers.

Clare's meagre income was supplemented by his wife who provided another, quite different, service to Portsmouth's sailors and soldiers. Together they solicited for their respective custom in those public houses most popular with servicemen. But, like all entrepreneurs, Clare had ambitions of great wealth and realised that he was in a unique position to acquire it. He had read somewhere that vast sums of money could be obtained from the German Admiralty for supplying confidential information from British naval ports, and towards the end of 1912 he wrote to Germany cautiously asking that somebody be sent to see him.

Incredibly, Steinhauer himself decided to interview Clare. The head of the German Secret Service liked England, having visited it on a number of occasions as the Kaiser's personal bodyguard. It was the merits of English food and Scotch whisky that brought a heavily disguised Steinhauer to England, and the promise of a reliable source of naval secrets that brought him to the door of Clare's Portsea surgery.

'You see, Exzellenz,' explained Clare to his prospective employer (detailed with no sense of parody in Steinhauer's memoirs). 'While I am extracting people's teeth,

William Clare – Portsea dentist, pimp and spy.

I might just as well be extracting a little useful information out of their mouths. That will not only be of great value to the Fatherland, but will also do me a great deal of good.'

Despite considerable reservations about Clare's character and motivation, the lure of an endless supply of secret information dredged from the heart of Britain's premier naval port was to prove too much. Having established that Clare was no *agent provocateur,* he was put on the payroll. Generous money orders began arriving from Berlin via Steinhauer's network in London. In return, Clare forwarded his and his wife's latest extractions, suitably embellished to justify the largest salary he had ever known.

In Berlin, Admiral von Tirpitz was busy single-mindedly building up the Imperial German Navy by whatever means were at his disposal. War was seen as inevitable by many high-ranking political, military and naval officials in both Britain and Germany. By 1913 the performance of the British torpedo had become of vital interest to von Tirpitz, the Royal Navy having pioneered the development of this weapon at HMS Vernon in Portsmouth. A top secret annual report was compiled there which charted the progress and performance of the British torpedo as tested in local waters. Anxious to acquire a copy of the latest report, and perhaps misled by Clare's exaggerated claims as to what he could manage to find out, the German Secret Service gave him the important mission. If successfully completed, the repercussions in time of war would have been incalculable.

Such considerations were of no consequence to the Portsmouth dentist, who had been offered the massive sum of £300 for successfully enabling the German Admiralty to have sight of the report. Three hundred pounds! That represented 5,000 pulled and twisted efforts with his merciless pliers. And, unlike an extracted tooth, the report could be returned without anybody knowing that it had been removed.

But, unknown to Clare, his activities as a pimp had led to the British Secret Service being alerted. Normally, the offence of living off immoral earnings would have been dealt with by the local police and magistrates' court, but because Clare was an 'alien' and his wife's clientele were servicemen, the matter had been referred to counter-espionage officials.

Dressed in a cloth cap and oily garb of a dockyard worker, Detective Inspector Percy Savage carefully observed Clare's dubious activities. At the same time his correspondence was being intercepted and copied. When deciphered, it provided conclusive evidence that Clare was, indeed, actively engaged in espionage. The matter was referred to a higher level and the decision made that a trap should be set that, it was hoped, would net not only Clare but perhaps even Steinhauer himself.

A plausible *agent provocateur* was needed to provide the bait and Percy Savage found the ideal candidate in a man called Levi Rosenthal, a Queen's Street hairdresser who was of German origin but had spent all of his adult life in England. He had been recommended to Savage by a local town councillor who knew him as a dependable patriot, fiercely loyal to his adopted country. The bait

was to be the annual report of the Torpedo School (HMS *Vernon*), which the Secret Service knew from Clare's intercepted mail to be of immediate interest to the German Admiralty.

Rosenthal's shop was only a matter of a few minutes' walk from Clare's surgery and they knew each other by sight. It took the barber very little time to gain Clare's friendship and confidence, with talk of the Fatherland and business problems uniting them in relaxed expatriate camaraderie. Believing that they were kindred spirits, Clare was not in the least suspicious when Rosenthal casually boasted of knowing many people in the dockyard and of being able to get anything out. He could not believe his luck, especially when Rosenthal added, for good measure, that he had done it many times before. Clare gripped the opportunity as he would a bad tooth – there was considerably more than a silver shilling at stake. He promptly offered Rosenthal £25 to procure the torpedo report. Rosenthal replied as if such transactions were an everyday occurrence to him, saying that he would make some inquiries. They fixed another meeting.

The town hall clock chimed as three solitary figures made their separate ways to the Theatre Royal. As midnight's twelfth chime lost its resonance in the frosty night air, the figures met to become a shadowy group beneath a hissing gas lamppost. Clare and Rosenthal exchanged silent nods. The third man, it emerged, was a dockyard clerk called Bishop. In hushed tones Bishop explained that he had access to the secret document. Clare whispered gratefully that he needed it only for two or three days and that he would pay him the sum of £25. They silently shook hands and dispersed, the dark side streets swallowing them up.

From the shadows of an adjoining shop alcove Detective Inspector Percy Savage watched their rendezvous and departure with silent satisfaction. Everything was going exactly to plan.

Savage believed that it was only a matter of time before a high-ranking German agent would arrive in Portsmouth to collect the top secret torpedo report, the importance of which might even merit the personal attention of Steinhauer himself. In preparation for such an event both Clare's surgery in Portsea and his lodgings in Hudson Road, Southsea, were put under twenty-four-hour surveillance.

But it was becoming clear from Clare's coded mail that he intended to deliver the report to the German Admiralty in person, perhaps in the hope of obtaining a better price for it. There was, then, no advantage in prolonging matters. Under Savage's directions the document was handed to Clare in Rosenthal's shop. Clare thanked his confederates, promising payment later, and concealed the secret report under some nightshirts in a travelling bag. He hastily left the shop and made his way along Queen Street towards the harbour railway station.

Before he could get very far, the hand of Detective Inspector Percy Savage descended in time-honoured fashion upon his shoulder and he was charged under the Official Secrets Act of 1911 with 'obtaining information which was calculated to be, or might be, directly or indirectly, useful to an enemy'. The man who was to be dubbed 'The Hunchback Dentist of Portsmouth' had been caught red-handed and was sentenced at the Hampshire Assizes to five years of penal servitude. The

sentence was met with applause from a crowded court, which had appreciated the entertainment value of the unfolding melodrama, but also understood something of the consequences had Clare succeeded.

A few days after the arrest, a well-dressed, bespectacled man with top hat and cane knocked briskly at the door of Clare's lodgings in Hudson Road, Southsea. The landlady, an elderly widow named Mrs Wood, had not yet come to terms with the fact that she had been sharing her home with a dangerous and evil Hunnish spy. The British Secret Service had ransacked her home in search of incriminating evidence and she was not in the best of tempers as she opened the door. With a distinctive German accent the caller politely asked whether it was possible to speak with Mr Clare. Confused and angry, Mrs Wood pushed him away from her door, muttering something about spies. But the sudden realisation that this stranger might be a fellow agent prompted her to follow him on to the street. Looking around anxiously, and with some presence of mind, she told the visitor to wait for a minute while she ran up the street to find out Clare's new address from a mutual acquaintance.

With equal presence of mind, Gustav Steinhauer, 'Der Meisterspion' and head of the German Secret Service, darted into a neighbour's porch. Dispensing with his overcoat, hat, collar, tie, spectacles and cane, he pulled a rough tweed cap over his eyes and waited. A few minutes later a breathless Mrs Wood reappeared with a burly policeman in tow.

Steinhauer waited patiently until the coast was clear, and then made his way to the nearby town railway station with nothing to distinguish him from any indigenous navvy or dockyard worker. Boarding a train packed with noisy shoppers bound for home, he watched from a window as the redoubtable Mrs Wood appeared with her policeman, pushing their way along the crowded platform in search of the sinister visitor. A whistle sounded and the train slowly shunted away taking Steinhauer to safety.

Gustav Steinhauer's colourful career is described with all the style and suspense of the spy genre in his autobiography, which details his pre-war profession as 'personal bodyguard' to Kaiser Wilhelm II, though it is not known whether he was present in the entourage that accompanied the German sovereign on the occasion of his historic visit to Portsmouth in 1907. What seems clear, however, is that as a self-confessed Anglophile, Steinhauer had visited Portsmouth on a number of previous occasions in the 1900s and was familiar with the town. It is also clear that he milked his experiences for maximum dramatic effect in his memoirs.

The Kaiser's visit to Britain, which began with his arrival at Portsmouth on 11 November 1907, had augured well for a peaceful future. Welcoming the royal guest, the *Portsmouth Evening News* commented that 'none but fools or madmen would wish to see Britain and Germany at each other's throats, while those who openly advocate war should be treated as the enemies of humanity'.

There was no evidence of any desire for war amongst the motley crowd, brimming with cheerful goodwill that had amassed along Southsea beach, Old Portsmouth and Gosport Hard, to cheer the historic arrival of the Royal yacht

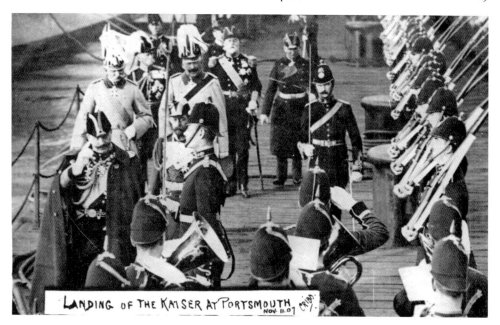

Kaiser Wilhelm II arrives at Portsmouth in 1907.

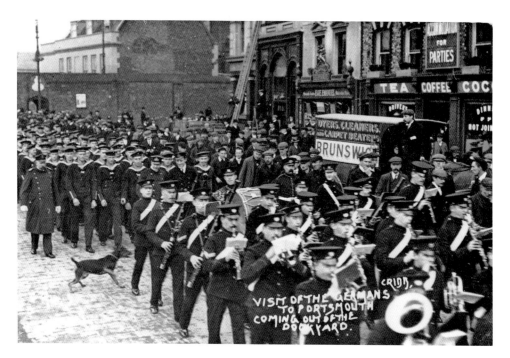

German sailors attract welcoming crowds at the Hard during the Kaiser's visit in 1907.

Hohenzollern accompanied by a squadron of German battleships. In the event an ominous impenetrable fog, described as the worst for many years, suddenly descended, depriving the sightseers of a view of the Kaiser's entry into Portsmouth Harbour. The portentous booming of guns was their only indication of his arrival; the salute from the garrison batteries of Southsea Castle being taken up by the Channel Fleet assembled at Spithead and Stokes Bay. The most powerful navy in the world provided an impressive royal welcome which also served as a show of deadly strength, for Anglo–German relations were at an all-time low.

The previous year, King Edward, nicknamed 'The Peacemaker', dressed in bicorne hat and full dress uniform of Admiral of the Fleet, had launched the battleship *Dreadnought* from the stocks in Portsmouth Dockyard. An impertinent bottle of Australian wine bounced back off its stern and caused some embarrassment, but otherwise 'the most important naval event leading up to the First World War' went without a hitch. *Dreadnought* heralded a revolution in naval design and construction and gave its name to a whole new type of battleship. The name was well chosen. The firepower of a dreadnought was such that it could shell a coastal town without being in sight of it, a potential that was awesome by Edwardian standards.

It was not without its critics. Lloyd George, later described as 'the man who won the war', regretted bitterly the laying down of the first dreadnought. He described it as a 'piece of wanton and profligate ostentation' that 'forced the pace by increasing the size of the ships, the weight of the guns and the speed of our vessels, beginning this fatal competition'. In the wake of her launch, Germany halted work on all existing battleships and, by the time of the Kaiser's visit to Portsmouth, a dreadnought programme was well under way in German shipyards, though diplomacy demanded that the subject of imperial rivalry should not be broached.

It must have been with more than a little trepidation that the Mayor of Portsmouth, Alderman Ferdinand Foster, stepped forward to greet the royal visitor as he disembarked on the Hard railway jetty. The *Evening News,* striving desperately to maintain a diplomatic balance, revealed that

> The Kaiser has the kissing habit, but is not promiscuous in indulging it. As a matter of fact although Kaiser William is the greatest kisser of men among sovereigns of the world he is also a hearty hand-shaker with a grip that is famous. His majesty has a big strong hand with muscles like iron. This grip, it is only fair to say, he reserves for strong men. For the opposite sex he has a hand that is as soft as velvet and a courtesy that is elegant.

Alderman Foster survived this ordeal with admirable mayoral composure and proceeded to deliver the welcoming address:

> We, the Mayor, Aldermen and Burgesses of the Borough of Portsmouth, beg respectfully to offer to your Majesty a very sincere and hearty welcome on your arrival in England. We feel sure that this visit will be highly appreciated by the people

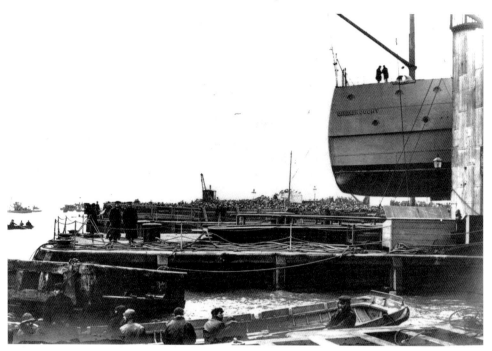

The launch of HMS *Dreadnought*.

of England as an indication of the friendly relationships existing between the Royal Houses of Germany and England, which we trust may be long continued to the advantage of the whole world.

The Kaiser, dressed in the uniform of a British Admiral of the Fleet, of which he held honorary rank, received the address and engaged the mayor in polite conversation. Bristling with civic pride, Alderman Foster advised him of the cost of building Portsmouth Town Hall and Technical Institute, information which was received with 'agreeable remarks'.

German sailors were entertained at the Royal Naval Barracks and at Whale Island and were allowed to travel free on Corporation trams. Portsmouth's goodwill was reciprocated by sailors from the cruiser *Scharnhorst*, who were treated as heroes after they helped extinguish a serious fire in the dockyard. All agreed that it was a cordial and very successful visit. In appreciation of the town's hospitality the Kaiser conferred upon Alderman Foster the Order of the Red Eagle, an honour which was later to prove some embarrassment.

During the war years stories emerged that the Kaiser had, after all, been very dismissive and rude during his visit. Others suggested that rudeness was the least of his problems. 'The Kaiser's sanity – Is he paranoid?' speculated a local newspaper in 1915, whilst an influential local Christian compared him with the devil, adding that 'his physical infirmity (a reference to the Kaiser's crippled arm) and his mental deficiency are equalled by his moral obliquity'.

The complex world events that transformed the perception of a man who was the grandson of Queen Victoria into a 'son of Satan' are described elsewhere – by all accounts he was not an attractive personality. Of importance locally was the dreadnought building programme which was to exert an ever-increasing strain on Anglo–German relations throughout the period 1906–1914. For Portsmouth, dubbed 'the cradle of the dreadnoughts', the escalation in production meant a healthy local economy, and for many of its inhabitants a security of sorts in dockyard jobs which afforded few luxuries, but at least provided bread and shoes for the children.

'Dockies' were justifiably proud of their work rate, with dreadnought launches becoming an annual event up to the outbreak of war. Of the twenty-two built nationally during this period, Portsmouth dockyard had built nine and their progress in the war was to be followed with more than a casual interest by the men whose blood, sweat and tears had been shed in their careful construction, rivet by rivet. The massive crowds that turned out to view the launches did so not only out of patriotic celebration and natural curiosity, but also to salute the builders – the ordinary dockyard men – who were rarely commended or acknowledged by the Admiralty or government.

The dockyard workforce numbered 13,000 by 1910, and the advantages for local manufacturers and traders were manifest. But it was not only the economic advantages that permeated the community, for local businesses were not slow in associating their wares with the prestigious and the patriotic. Thus, if one had the inclination and the money, one could ride a locally produced dreadnought bicycle whilst wearing a fashionable but practical dreadnought raincoat.

Not surprisingly, there were few local voices raised in opposition to the campaign for the continuation of the Dreadnought programme when it was under review after seven had been built. The MP for Fareham & Gosport, Colonel Arthur Lee, spoke for many with the catchphrase: 'We want eight and will not wait,' which gained national currency. Popular clamour for the programme was not, however, simply fuelled by its economic advantages. Sensationalist literature from the bookstall and newspaper vendor, and propaganda films in the local picture houses, were filling the public mind with the fear of invasion by a stereotyped enemy, 'the Hun', which was to increase popular agitation for a stronger navy, despite the fact that it was already the most powerful in the world. The government and the Admiralty dismissed concern about invasion, considering it 'impossible', but continued building dreadnoughts.

One example of this alarmist literature was William Le Queux's novel *The Invasion of 1910* that was adapted for serialisation in the *Daily Mail*. With an eye on the circulation figures, the editor shrewdly directed Le Queux to describe the German invaders capturing an improbable number of large southern towns. The scenario was so convincing that local readers could have been forgiven for believing that beneath every stone on Southsea beach lurked an evil 'Hunnish' spy. Such fiction as prediction paved the way for the xenophobia of the war years and the unfortunate treatment of many foreigners of all nationalities, not least those resident in the Portsmouth area.

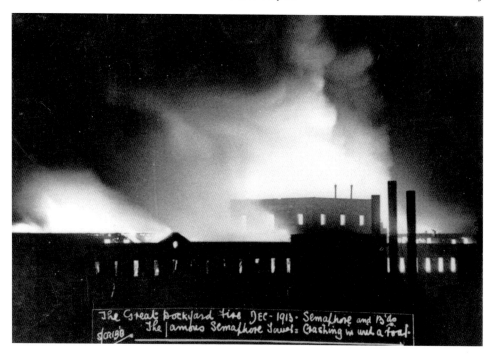

The Semaphore Tower on fire during December 1913. The fire was attributed either to German agents or suffragettes.

The true extent to which Portsmouth played host to the German Secret Service in the pre-war and war years was obscured by official propaganda and unofficial rumour. (Spies known to have been active during the war are detailed in chapter twelve.) The frequent fires which broke out in Portsmouth Dockyard were, for example, variously attributed to arsonist suffragettes and the ubiquitous 'Hun'. But whilst unexplained blazes inevitably led to wild speculation, there appears to be no evidence that saboteurs of any description were at work. It is of incidental interest that such rumours served the purpose not only of inflaming public opinion but of diverting attention from the Admiralty's apparent lack of concern with fire precautions and the safety of its employees, as the editor of the *Evening News* was not afraid to point out on a number of occasions.

By the very nature of espionage, instances only normally come to light when things go wrong, as they did for Grosse and Clare. The case of Siegfried Helm provides us with yet another example of how bad luck, but more especially bad judgement, compromised the activities of Steinhauer's *Nachrichtendienst* (Intelligence Service).

Lieutenant Helm was an intensely patriotic German army officer who arrived in Portsmouth in the autumn of 1910, eager to do his bit for Kaiser and Fatherland. Aged only twenty-three, he felt none of the reserve of the newly-arrived tourist. He booked a room at 'Glenwood' in Goldsmith Avenue, Milton, where his landlady, a Mrs Miller, suspected nothing of his intentions. He explained that the purpose

of his trip was to mend his broken English, which seemed eminently plausible. It was, perhaps, in pursuit of this ambition that the neatly-dressed, clean cut officer struck up an acquaintance with an attractive neighbour of Mrs Miller's, a Miss Hannah Wodehouse.

Helm appears to have been more eager to please the material Miss Wodehouse than his distant paymasters. In an attempt to impress her he boasted of his skills of draughtsmanship and revealed some sketches he had executed of the Portsmouth defences. The German lieutenant's woman was suitably impressed, so much so that she mentioned it to another acquaintance, a Royal Marine officer based at Eastney Barracks. The authorities were notified and Helm was put under surveillance.

Within a few days Lieutenant Helm had made sketches and plans of Point Battery, Fort Blockhouse, Fort Monckton, Lumps Fort and Southsea Castle. Then, on a day trip to Ryde, he added Horse Sand and Spitbank Forts to his pocket book itinerary, with estimates of their dimensions and armaments all neatly described in Gothic script. Next, he made his way to Portsdown Hill and captured Farlington Redoubt and Fort Purbrook in bold graphite. It was while the prolific lieutenant was putting the finishing touches to his *alla prima* impression of Fort Widley that the inevitable arrest was made, the honour being reserved for the Officer in Command of the Portsdown forts, Captain Martelli. The protesting, frustrated artist was blindfolded and directed into Fort Purbrook, where a search and interrogation revealed the true extent of Helm's aesthetic appreciation of the Portsmouth environs.

The prisoner was kept in "comfortable quarters" and treated very well, dining with the officers at the fort while the War Office in London pondered on how best to deal with the incident. Two days later a warrant was issued on a charge of espionage and the prisoner was taken before Fareham Police Court. The magistrate, Mr J. Sandy, remanded him in custody and the subsequent trial at Hampshire Assizes in Winchester attracted much press speculation and public interest. One newspaper reported that 'there was a great rush to gain admission to the court at an early hour, but only privileged persons (the leading county families being largely represented) were admitted and that by ticket'.

Alas the show did not match its colourful billing. The young lieutenant pleaded guilty and was released to return to Germany, having been bound over by a judge whose uncharacteristic display of leniency does not appear to have been unconnected with the fact that two British spies had recently been captured in almost identical circumstances on the coast of Wilhelmshaven. The matter appears to have been settled with a gentlemanly handshake and an exchange of one landscape artist for two students of Prussian architecture. Interestingly, the details of the Portsmouth fortifications collected by Helm had already been recorded by the Kaiser in person on a previous visit to the area when he was but a callow prince back in 1880. There was, however, nothing surreptitious about His Majesty's curiosity. His hosts were impressed by his interest and knowledge and a 'detailed report on the forts and docks of Portsmouth with sketches' was duly sent to Kaiser Wilhelm (the first) that 'would have been a credit to a spy'.

With the three incidents of German espionage that emerged locally in the immediate pre-war years, there were at least two further instances involving dockyard employees who appeared to be engaged in selling confidential information to foreign powers. A dockyard official called 'Bennett' reputedly sold or attempted to sell documents to France and Germany concerning naval stores, and an electrical engineer named Samuel Maddick was charged under the Official Secrets Act with 'attempting to communicate information prejudicial to the safety and interests of the State'. Maddick was arrested one night in the vicinity of the oil fuel tanks at Forton Oil Fuel Depot in Gosport. A search of his house in Byerling Road, Fratton, indicated that he had written to Steinhauer's headquarters in Potsdam offering to supply valuable information. A money order had been received in return which was intended to cover Maddick's travelling expenses to a rendezvous with German agents in Belgium.

At the subsequent trial and after hearing medical evidence, Portsmouth magistrates decided that Maddick was 'a person of unsound mind' and sent him to the Lunatic Asylum at Milton (now St James's). Curiously, exactly one year after his committal and in the midst of war Maddick escaped and there appears to have been no report of him having been recaptured.

The truth about the extent of espionage activity in the Portsmouth area before the war is equally elusive. Had the German Secret Service a 'swarm of spies' in Portsmouth, as has been implied, then it is hardly credible that, given a choice, the important torpedo report mission would have been entrusted to the conspicuous and unreliable Clare.

The rumours and concern generated by cases such as these contributed to a climate in which war was to become more than a distant prospect. But at the same time diplomatic overtures optimistically orchestrated by both sides suggested otherwise; a matter of six weeks before war broke out the British Fleet visited the German port of Kiel. Officers and men fraternised, entertained and dined with goodwill in mess and wardroom, reciprocating the welcome extended to the German Navy at Portsmouth several years earlier. There was little sign of mutual distrust and fear as the brass bands played under the hot sun and the sailors sang together, laughed together and drank together. They raised their tankards together and toasted 'to long life and happiness'.

CHAPTER TWO

Preparing for the Storm

The long, hot summer of 1914 has been used as a starting point by novelists and historians to symbolise calm before a storm, childhood before maturity, innocence before guilt and life before death. For Southsea it meant a busier season than 1913.

On the packed beaches a new and daring style of bathing costume offended the Victorian propriety of older inhabitants who had not yet recovered from the arrival of mixed bathing in 1911. The bathing skirt, which had offered some protection for a maiden's modesty, was discarded because it 'interfered with fast swimming', though sceptics suspected less innocent motives. In the genteel tea rooms of Southsea, 'dainty luncheons and drawing-room teas' were quietly consumed to the accompaniment of a string quartet by ladies who believed holidaymakers were vulgar invaders and that their curious habit of 'paddling' was particularly inelegant and 'tripperish'.

In local music halls, songs and monologues spiced with unsubtle double entendres were received with knowing smiles and raucous laughter from an audience educated by the permanent presence of the Navy. In Portsea pubs, thirsty bluejackets abandoned consciousness with their familiar friend Brickwoods Best at tuppence a pint; that German lager was strong but it would never catch on. Down dark alleyways and on insalubrious bedding, women who had turned desperately to prostitution made the most of the 1914 Fleet Review and Test Mobilisation, which was held a matter of three weeks before war was declared.

At Spithead, twenty-four dreadnoughts, thirty-five battleships, forty-nine cruisers, seventy-six submarines and seventy-eight destroyers manned by nearly 100,000 sailors succeeded in exhausting local journalists of their stock of superlatives. Winston Churchill, then First Lord of the Admiralty, described it as 'constituting incomparably the greatest assemblage of naval power ever witnessed in the history of the world'. Chief witness was the King himself, George V, who nearly missed the boats because of the deteriorating political crisis in Ireland, which required his personal attention.

Thousands of spectators travelled from all over the country, packing every accessible vantage point at Southsea, Old Portsmouth and along the front at

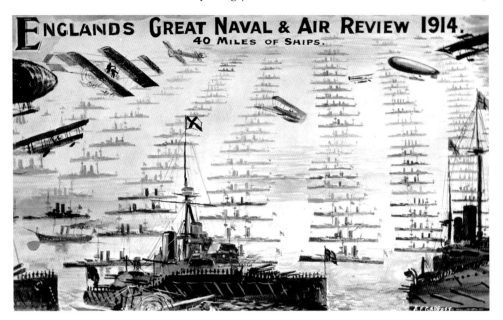

Local postcard featuring the Fleet Review, July 1914.

Stokes Bay to watch the 40 miles of ships drawn up in twelve long lines. A major attraction was a mimic battle spectacularly fought between two halves of the fleet under the capable direction of the German-born First Sea Lord, Prince Louis of Battenberg. There were no casualties. Tides of cheering reaffirmed the happily justified belief that Britannia ruled the waves.

Not to be outdone, the Commander of the Military Garrison positioned his men in lines stretching from South Parade Pier along the shoreline to the mouth of Portsmouth Harbour and from Haslar Hospital to Gilkicker Fort on the Gosport side. On hearing the fleet make its Royal Salute, the three-mile line of soldiers fired their rifles, consecutively, into the air. This impressive *feu de joie* served to demonstrate that the Royal Navy might be the Senior Service but was not, by any means, the only one.

For the first time, aircraft played a role in a Review, the novelty of their aerial antics providing an exciting and popular diversion from the flexing of more traditional muscle. An airship had been billed as another attraction but the clumsy and cumbersome *Gamma* dirigible demonstrated that Britannia's superiority did not extend as far as the clouds. She was stuck in the cabbage patch at Fort Grange, Gosport's newly established base of the Royal Flying Corps.

On the day after the Review, Tommy Oliver, a grammar school boy, was walking along Pembroke Road on his way to sit an examination when he heard the deafening roar of hundreds of anchor chains being hauled up simultaneously. The importance of the impending exam receded as he watched the awesome armada melt into the distant horizon. But one thing struck him as curious; the ships did not turn at the Nab lightship but continued on up Channel, as if they

were headed for the North Sea. Later, when he mentioned this to his father, he was told not to be so absurd, that the Fleet must be going to the Atlantic for exercises. On the Royal Yacht the King watched the armada pass in single file, each vessel dipping its colours in salute, a procession which took six hours. The Grand Fleet was, indeed, on course for the North Sea.

Few people amongst the thousands of bluejackets, holidaymakers, sightseers and souvenir hawkers could have realised the significance of this, and other events, that summer. Some days previously an obscure archduke in an unknown European country had been brutally shot to death by an excitable schoolboy. This tragedy was dutifully recorded in national newspapers but the rapidly escalating repercussions were felt to be of minor import set beside the more immediate domestic concerns of a prospective civil war in Ireland, the activities of militant suffragettes and the powers of trade unions. Indeed, relations with Germany appeared to be improving, with the *Evening News* announcing that Portsmouth 'would have the pleasure of welcoming and entertaining a German squadron of ships in the autumn'.

But to the families of holidaymakers on the beach, squinting and sweating under the merciless sun, the newspaper served only as a shade or fan. At the head of the family, and wearing the trousers with confident, consummate ease, was dad. While he rolled up his trouser legs mum safety-pinned her skirt with careful modesty. Then with bowler hat askew and briar pipe clenched between teeth, dad led her laughing and protesting over the shingle and into the cool, soothing breakers – a simple pleasure. Whether there was to be a war was a complex question that would be answered by others, preferably tomorrow. The sun was shining and there were songs to be sung:

Oh we do like to be beside the seaside,
Oh we do like to be beside the sea,
Oh we do like to stroll along the prom, prom, prom,
Where the brass bands play tiddely-om-pompom …

On 29 July 1914, a Mrs Stalkarrt of Victoria Road South made the most of the fine weather by having herself driven out of town in her latest concession to the twentieth century, a motor car. It was, after all, a useful means of putting some distance between oneself and those noisy crowds of vulgar excursionists. Crude suspension and the lamentable state of the roads conspired to shake her confidence in the wisdom of her investment, but failed. She enjoyed a trouble-free marathon ride of 22 miles, during which she 'took the air' and watched a procession of locals returning to Portsmouth after a day out at the Goodwood Races, for whom the weather, if not the horses, had been kind. Mrs Stalkartt arrived home with an appetite, but had to make do with a 'wretched dinner' having made the unfortunate mistake of giving her cook the day off.

Every night saw a packed house at the Portsmouth Hippodrome that week with Billy Williams topping a prestigious bill. A popular singer of chorus songs, Billy was one of the first music hall stars to recognise the potential offered by another

Pre-war view of
excursionists on
Clarence Pier.

mechanical novelty, the gramophone. His records had made him a household
name in those houses where such luxuries could be afforded. But his bread and
butter was earned the hard way. There was no substitute for the atmosphere, the
immediacy and the community feeling created by live appearances at metropolitan
and seaside venues, performing songs that were instantly recognisable as his own.
Everyone knew the words to the repetitive refrains of his most popular numbers.
'John, go and put your trousers on!' was a favourite, but his biggest hit was 'When
father papered the parlour'. The audience on those last, humid July nights would
have included off-duty servicemen and holidaymakers, singing along with the
choruses and laughing at the slapstick sketches.

For the more culturally sophisticated, a supporting feature with a suitably
exotic French name promised 'artistic reproductions of famous works of art', a
euphemistic description for that popular music-hall speciality act 'living statues'
or *tableaux vivants*. Diaphanous drapes protected the artistes' modesty while the
audience eagerly waited for a draught.

But in the midst of this aesthetic experience came the call. The master of ceremonies halted the proceedings and solemnly announced that all soldiers, sailors and marines were to report to their respective barracks immediately. And God save the King. The announcement was made in all music halls, picture houses, theatres and other places of amusement throughout Portsmouth that evening. In main streets, mustering marines blew bugles while precariously steering borrowed bicycles and sailors were stationed at strategic points on busy thoroughfares and junctions to spread the word.

Apart from rumour, newspapers were the only source of gaining any information about local and national affairs. For the many inhabitants who were unaware of the seriousness of the worsening European crisis through poverty, illiteracy and the day-to-day struggle to survive, the unprecedented scenes were the first indication that all was not well. This was confirmed the following day when armed guards appeared on the seafront and around all government property in the area, creating further curiosity, excitement and anticipation amongst residents and trippers. In the evening brilliant searchlights flooded the clear night sky across Spithead and the Solent, increasing speculation that war was imminent.

Few important national or international events had impinged on Mrs Stalkartt's comfortable world, which she managed very successfully to fill with domestic management and accounts, holding tea parties and musical soirees, crocheting and dipping into classic historical novels. But on the evening of 31 July she sat down at her writing desk, as she usually did before retiring, and opened her diary. She dipped her nib in the inkwell and recorded that there were 'disquieting rumours from abroad'.

Any hopes for better news were dashed the following day, the beginning of Bank Holiday weekend, when newspaper vendors' placards announced in bold type: 'Germany Declare War on Russia.' Overworked postmen began delivering buff envelopes to all men on the Services' reserve lists, ordering them to barracks but advising them to eat a hearty meal before departing. In local newspaper offices special editions were continuously updated and published to keep pace with the latest developments in the crisis, while out on the streets newspaper boys' shrill calls gave passers-by a tantalisingly incomplete description of the situation. They were on commission. Meanwhile, on the beach, some measure of the seriousness of the emergency could be gauged by the total dissolution of British reserve as groups of people sat around eagerly discussing what news there was. For holidaymakers determined to make the most of things there were always the popular boat excursions from Clarence Pier to the Isle of Wight, but even they began to be advertised with the unusual rider: 'Weather and circumstances permitted.'

Though the weather had taken a turn for the worse it was not a storm at sea which forced hundreds of excursionists to make alternative arrangements. The Admiralty began to requisition local ferries and pleasure craft to transport military supplies, vital equipment and reservists. Many more would-be travellers were disappointed when it became clear that nearly all departures from Portsmouth Town railway station had been suspended 'owing to the requirements of the military service'.

Local stationmasters had received alternative timetables detailing future troop movements in the area on London and South Coast Railway. Stamped 'SECRET', these instructions were activated by the code-word 'MOBRAIL' (mobilisation of railway), which immediately signalled the government takeover of the privately owned network.

During the bank holiday weekend the general concern and uncertainty over what was going to happen 'created a feeling of depression and nervous tension' which was 'almost unbearable,' wrote a journalist on the *Portsmouth Times*. Mrs Stalkartt concurred, recording 'great anxiety' and 'concern at general mobilising' in her diary. The weather deteriorated as rapidly and as inexorably as the effectiveness of international diplomacy. Throughout Europe unstoppable railway timetables, as A. J. P. Taylor famously put it, had taken over. The tripper's jolly theme 'Oh we do like to be beside the seaside' was replaced by the sentiment expressed in a sardonic poem published in expectation of war:

But oh what a tactless choice of time,
When the bathing season is at its prime.

Eager for spectacle the thwarted tourists headed for Old Portsmouth:

The trippers came in their hundreds down our normally quiet little street. Footsteps! Footsteps!! Footsteps!!! – all day long – that reminded me of Dickens's *Tale of Two Cities* and the footsteps that Lucie Manette was always hearing.

Mrs Wyllie, wife of the celebrated local marine artist who lived in Tower House, sent her son to find out what the commotion was all about. The object of their attention, it emerged, was the spiked boom defence which was being placed with considerable difficulty across the mouth of Portsmouth Harbour. Stretching from Fort Blockhouse to the Round Tower, this precautionary measure against invading enemy ships had a long tradition, dating back to the Tudor 'mightie chaine of yron', forged during the wars with France. Resembling a gigantic picket fence laid flat on the surface of the sea, the modern version had a gate mid-channel which enabled local traffic to go about its business. At night and during fog the gate was noisily secured by means of powerful steam engines, causing inconvenience to local fishermen. But this was only one of many restrictions put on mariners' movements in the Solent. Two tramp steamers suffered the indignity of having a shot fired across their bows when they failed to comply with regulations issued the day before by the Portsmouth Harbour Master. How the captains of these vessels were supposed to have known about the new regulations did not enter into it, but such actions served publicly to demonstrate the determination of the authorities to enforce emergency restrictions to the letter.

Dramatic happenings at home, combined with news of war in Europe, contributed to a siege mentality among some sections of the community. Those with the money and storage space headed for the shops in motor cars, carriages and taxis to stock up with provisions, creating a scarcity of many essentials.

When the Vicar of Portsea, the Reverend Cyril Garbett, learnt that his loyal cook had crammed the vicarage pantry with food, he immediately ordered that it all be returned forthwith and proceeded to deliver a basic Christian sermon to his confused and tearful servant. But such actions were rare and it was left to the responsible grocer to ration out provisions unofficially to his regulars. The well known grocery chain of Pinks, which regularly advertised its own popular brand name of tea and butter in the local press, took space to exhort its customers to refrain from hoarding and to be patient.

The scarcity of food led to a general increase in prices, exacerbated by some grocers who took advantage of the excitable crowds. In the course of one week, meat went up by 50 per cent and sugar more than doubled in price, with all other essentials similarly affected. Inevitably it was the poorest who suffered most. Volunteers at the Borough of Portsmouth Soup Kitchen in St Vincent Street, who normally only worked in the winter months, offered to open the doors in the middle of summer to help alleviate distress. This was particularly acute due to the priority in supplying military establishments in preparation for the influx of reservists, whose last hearty meal seemed a long time ago.

On bank holiday monday thousands of naval and marine reservists began arriving on special trains at Portsmouth town station. Their departure from Waterloo had been accompanied by 'unprecedented scenes of patriotism not unmingled with pathos at the parting of husbands and wives, fathers and children'. The scene at Portsmouth was equally emotional with rounds of enthusiastic cheering greeting every train as it discharged its human cargo. The importance of the event was given added weight by the conspicuous presence of a man working a hand-cranked film camera.

The high spirits of the men and their 'smart orderly and sober appearance' were commented on by the flag-waving crowds who lined the streets to cheer them to the Royal Naval Barracks in Queen Street. But behind the boarded-up perimeter of iron railings there was unmitigated chaos. The test mobilisation of the previous month now seemed to have been inadequate as far as manpower distribution was concerned. It did not compare in any respect with this, the real thing. One not inconsiderable problem was the Admiralty's allocation of hundreds of Hebridean fishermen to Portsmouth, many of whom had not been called up before, lacked any means of identification and were articulate only in Gaelic. Together with other fishermen from the East and South West coasts, these men comprised the mine-clearing Trawler Section of the Royal Naval Reserve. Described as 'fine specimens of sea-hardened manhood' they arrived in their working clothes of jersey and cloth cap. With not one bluejacket among them the demand for naval uniforms equalled that for provisions to feed the army of invaders. Staff at naval outfitters Gieves & Hawkes of the Hard worked night and day to clothe the men. Some tailors laboured for six or seven days and nights non-stop apart from a few hours when, overcome by fatigue, they slept prone on their boards.

Mrs Stalkartt woke up to a dull and cool bank holiday Monday and read in her morning paper: 'Armageddon has begun.' Having digested this news with a

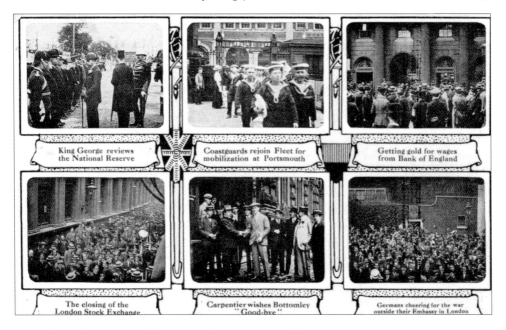

King George reviews
the National Reserve

Coastguards rejoin Fleet for
mobilization at Portsmouth

Getting gold for wages
from Bank of England

The closing of the
London Stock Exchange

Carpentier wishes Bottomley
"Good-bye"

Germans cheering for the war
outside their Embassy in London

Sailors head for Portsmouth as part of the general mobilisation.

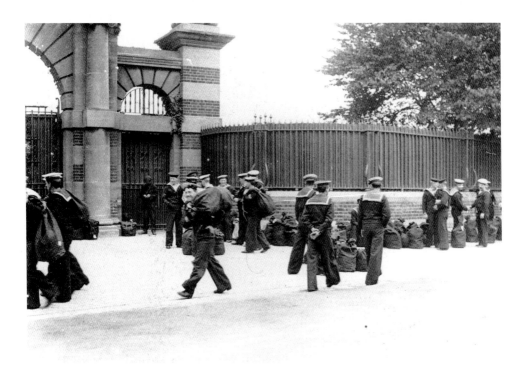

Sailors arrive at the Naval Barracks in Queen Street.

light breakfast she crossed the road to visit a neighbour for tea. The matter needed discussing. A local journalist who had reported on the practical preparations for war commented on a strange sense of unreality – the fractured routines, the excitement, the nervous tension contributing to a feeling 'as if it is all a dream'.

Drafting and mobilising staff at the RN Barracks were experiencing a very real nightmare. Accommodation in the barrack blocks had reached saturation point and many disappointed bluejackets had to be turned away from Unicorn Gate. The Army was experiencing similar problems at Victoria and Cambridge Barracks, and billets in hotels and boarding houses were urgently in demand, to the relief of proprietors and landladies whose busy summer season had come to an abrupt end. Many holidaymakers, fearful of being stranded in a strange town, had taken advantage of the few trains available for public use and made their way home.

Beneath hundreds of iron bedsteads the sandy sandal of the tourist was replaced by the polished boot of the soldier. Terms were generous if the authorities deemed that an establishment was comfortable and respectable enough to receive officers:

BILLETING TERMS
Lodging for Officer ... 3s a night *(15p.)*
Lodging for Soldier ... 9d a night (4p.)
Stable for horse ... 9d a night (4p.)

Such stark differentiation between ranks was not confined to the military services, but pervaded every aspect of everyday life. When, for example, Mrs Stalkartt had occasion to reprimand her maid Alice, both accepted their relationship as the natural order of things and something as inevitable as the weather.

In Europe the gathering storm clouds refused to reveal any silver lining. The newspaper boys' placards spelt out that war was imminent: 'Germany Invades Belgium.' Britain had a vital interest in maintaining the independence of Belgium as a buffer state and issued an ultimatum demanding the withdrawal of German troops by 11 p.m. on Tuesday 4 August. The dreadful gravity of the situation was communicated to a local population hungry for news of the latest developments. William Gates, editor of the *Evening News*, voiced the helplessness and desperation of many in a world that had apparently gone mad:

Today may prove to be the blackest in the history of civilisation... God grant that even now something may happen to stay the plague which threatens to devastate a continent and destroy the civilisation of centuries.

The will to 'stay the plague' was most visibly demonstrated by local Christians, radical liberals and socialists. Gosport churches sent a last-minute resolution pleading for Britain's neutrality to Sir Edward Grey, the Foreign Secretary, and Portsmouth Labour Party organised a 'Stop the War' demonstration in the town hall square.

PORTSMOUTH LABOUR PARTY.

War Against War!

LABOUR & SOCIALIST PROTEST.

DEMONSTRATION

IN

TOWN HALL SQUARE

To-Night at 7.45.

All Labour and Socialist Organisations will be represented.

WHOEVER WINS THE WORKERS LOSE.

Notice for the ill-fated anti-war demonstration.

But few people could conceive of what modern warfare would mean, and few people expressed any strong desire to stop it. When William Gates wrote with depressed resignation of the 'destruction of civilisation' and the famous local author and naval expert Fred Jane stated with equal fatalism that 'a million men will die', they were speaking thoughts drawn from experience and an education that the majority of people had not had. The concerned and anxious who petitioned and demonstrated had gained their education and experience in a different environment – the church and trade union – but had arrived at the same deeply pessimistic conclusion. All that was left to do was to shake a metaphorical fist at the black storm clouds overhead.

The town hall clock chimed a quarter to eight on the evening of Tuesday 4 August, while local labour and trade union representatives mounted a makeshift platform in the town hall square next to the railway embankment. At regular intervals troop trains shunted past, the empty carriages that were returning to London rattling in a way that the full ones arriving did not.

The Labour platform was adorned with handwritten placards proclaiming 'Woever Wins, the Worker Loses' which together with the presence of the police, roused the curiosity and emotions of passers-by. The demonstration had been publicised extensively and by the time the first speaker was scheduled to start a sizeable and volatile crowd had gathered. Mr J. MacTavish stood up and cleared his throat to begin his prepared speech, but was immediately subjected to a barrage of hostile heckling, shouting and booing. MacTavish, Labour's first ever town councillor in Portsmouth, was used to being given a rough ride and was not averse to heckling political adversaries himself in the council chamber. But here was something quite different.

For half an hour he slowly drowned in a stormy sea of waving Union Jacks and patriotic choruses. Then, without warning, the platform was dragged across the square by the more drunkenly aggressive members of the mob and MacTavish and his fellow representatives were thrown to the ground and manhandled. The first local casualties of the war, then, were idealistic socialists and trade unionists, bruised, grazed and thoroughly disillusioned. Two hours later, as the town hall clock struck eleven, the wishes of the rowdier elements in the crowd were granted.

War fever spread throughout the land and the night air was filled with tremendous, infectious cheering and the swelling cadence of heartfelt patriotic songs:

We don't want to fight,
But by jingo if we do,
We've got the men,
We've got the ships,
We've got the money too

Having built the ships and manned them, the people of Portsmouth had reason to claim substantial credit for the state of Britain's preparedness. The headline in the *Evening News* was one, simple word: 'Ready'.

Gunner William Titheridge, a local lad serving on HMS *Albemarle*, began preparing his ammunition and guns for action. He also made his first entry in a war-time diary: 'After having the Captain explain the reasons for war, the ship's company sang *God save the King* and a great enthusiasm prevailed in the ship leaving to join the battle squadron.' Another sailor on board HMS *Prince of Wales* wrote home to his parents at Portsmouth: 'We have just been told that war is declared and we leave for an unknown destination tonight. I hope and trust we shall make a name for ourselves and come forth with a great victory.'

There was a popular belief that the Royal Navy alone would win the war and that a decisive victory would be achieved quickly, most likely by Christmas. Indeed, the owner of the *Daily Mail* was busy writing an article entitled 'Not One British Soldier to Leave England's Shores', a prediction that was to set the tone for the reliability of the British press for the duration. But faith in the ability of the greatest navy in the world was absolute; people believed that it provided an impenetrable umbrella under which life at home could continue more or less as normal.

Contrary to expectation the first day of war brought rather pleasant weather. Dainty parasols were confidently twirled on the Ladies' Mile while their owners nodded in agreement that there was no alternative. For the first time in many years the nation was united in a common cause. The arms race, punctuated by its associated spy scandals, had culminated in a universally acclaimed conclusion. Protest from religious and labour groups dissolved overnight. The congregation of St Thomas' was told that the war was a manifestation of divine retribution for over-indulgence and sinfulness and Councillor MacTavish wrote to the local press to assert his patriotism. Commenting on this clamour to rally round the flag, a local journalist wrote approvingly of 'the magic of war' having transformed Britain into a proud, united force. But few people could imagine to what extent they would be called on in defence of what was soon to be described as the 'Home Front'. For while the people of Portsmouth and Gosport had always had close links with the naval and military services, the inhabitants had, for the most part, been passive spectators of earlier conflicts, following the progress of colonial skirmishes with a safe detachment.

But this would prove to be the first total war. It would transform the social and domestic life of the nation, with ordinary people subjected to regulation, privation and discomfort such as had not been experienced before. Nothing would ever be quite the same again. Nobody would survive it unaffected.

CHAPTER THREE

Invasion!

The lamps went out all over Southsea seafront by order of the King's Harbourmaster. No risks were being taken. Beneath the casual confidence and buoyant optimism lurked deep dread and fear of invasion. And yet, only a matter of weeks before, the children of Portsmouth High School Debating Society had discussed with measured and reasoned arguments the proposal that 'a tunnel under the English Channel would be highly detrimental to Great Britain'. Now, on the beach, thick coils of barbed wire were unravelled by soldiers, a final, unambiguous hint to the determined paddler that the holiday was over.

Pleasure piers on other resorts were blown up or dissected by sappers' dynamite, but fortunately South Parade and Clarence piers were spared, having been deemed unlikely to be of any use in landing enemy troops. 'Palmerston's Follies' in the Solent rediscovered their *raison d'être*. Practice firing from Spitbank, Horse and Noman's Forts began to punctuate the days and nights, with prior warnings appearing in the local press. This was a precautionary measure to avoid the kind of panic and hysteria witnessed in London when a thunderstorm was mistaken for a German bombardment. The guns at Southsea Castle were also regularly exercised by the Royal Garrison Artillery, while dozens of Territorial Army volunteers, finding themselves surplus to requirements in defending their home port, were despatched on their bicycles to Lincolnshire where they proceeded 'at all speed' to defend the east coast. If all else should fail the members of Portsea Rifle Club were putting in extra hours.

One of the more whimsical orders of the first day of war was received by troops stationed at Fort Rowner, Gosport. The leaden drawbridge, which had remained undisturbed for some sixty years, was required to be raised – a feat which took 200 soldiers a whole day of sweating and straining to achieve. This heavily symbolic act was neither appreciated nor repeated.

Public concern over a possible invasion manifested itself most overtly in a zealous hatred of what was perceived to be 'the enemy within' – people of 'alien' origin – who were allegedly 'preparing the ground'. All foreigners and Britons with Germanic names were suspected of undermining the country's preparations for war. If there was no proof, then this fact was further evidence of their cunning.

Searchlights sweep the Solent from Southsea Castle and Spitbank Fort before the war.

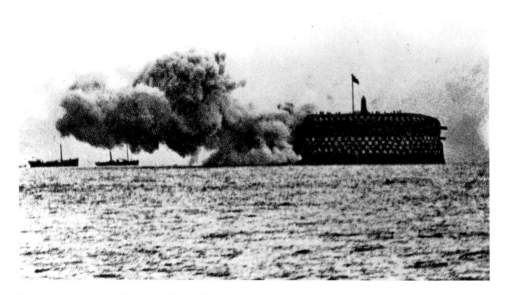

Rare pre-war view of practice firing from No Man's Land Fort in the Solent.

Walking a daschund, buying sausages, ordering lager and listening to Mozart became activities likely to raise a suspecting eyebrow or a bristling hackle. And after a lady complained of being 'hustled' by three foreigners in Grove Road South, a writer in the *Portsmouth Times* urged his patriotic readers to 'communicate the name, address and presence of every foreigner to the police'. This suggestion had been preempted by the British Secret Service, which had already compiled a list of resident 'aliens' using information gleaned from friendly, neighbourhood postmen.

The first Alien Restriction Order, passed on the first day of war, seriously curtailed the movements of all people of foreign birth. Under this act Portsmouth and Gosport were highlighted as 'specified areas' in recognition of their military importance and so restrictions were especially tight and applied with rigorous efficiency by an enthusiastic local constabulary. There was, however, some initial confusion when the Secret Service communicated the names of two or three suspected German agents to Portsmouth Police. They were promptly arrested and charged but when they appeared before local magistrates it became clear that normal judicial procedures did not apply. The cases were dismissed and the alleged spies were taken away by the military authorities.

This new act required all 'aliens' to report to a police station for registration and fingerprinting. Those deemed 'enemy aliens' were told to 'clear out of town within four days' unless they could convince the Chief Constable that they were genuinely employed in business. In the first week of war only seventeen or eighteen local residents were able to do this, a further fifty or sixty having to leave the area.

On the outskirts of the 'specified area' in close-knit, rural communities any stranger became the subject of immediate, suspicious attention. One man, visiting a nearby village to attend the funeral of a relative, was arrested by soldiers while leaving an evening church service. As he was escorted away under armed guard he disconsolately remarked, 'I had not been to church for fifteen years and this does not give one much encouragement.' Such mistakes could be laughed at and shrugged off. Others could not. A naval tailor of Polish origin who had run a respectable business with his wife in Queen Street for many years was unceremoniously expelled from Portsmouth. On his arrival in London he was arrested and imprisoned in one of the many makeshift internment camps that had been established. Released on bail but unable to return to his wife and home, he penned this letter before hanging himself:

> Dear L,
> I have made up my mind. I cannot go through the ordeal of arrest again for nothing. My love lies for England and no other country. I have had ten months of worry and persecution, and will not stand anymore, so goodbye and God bless you all.

Such persecution was not unique and neither was it confined to 'aliens'. A Midhurst watchmaker, member of the Parish Council who had been born and

bred in England, became the subject of 'tittle-tattle' and was 'chaffed on several occasions about being a German'. He, too, hanged himself. The coroner recorded a verdict of temporary insanity.

Xenophobic spy mania was not solely the product of British propaganda efforts, but was common to all countries at war. In Germany, stranded English tourists were also ill-treated and threatened, many being interned in Spandau Fortress as enemy agents. A seventeen-year-old Gosport student, Gwen Kyffin, who was in Bonn when war broke out, was 'subjected to many indignities and insults from the enraged Germans'. After some weeks she was allowed to return to England.

> The journey home was beset with danger. During part of the train journey she was in a carriage with five drunken German soldiers, and when passing through a tunnel a bayonet was pressed against her chest, while a guttural voice demanded to know whether she had a particular desire to live any longer. The plucky young lady laughed the incident away.

In Britain wild stories were attached with utter conviction to certain occupations that were associated in the public mind with 'aliens'. Waiters and hairdressers were regarded as opportunist eavesdroppers and therefore provided an ideal cover for the 'Hun' spy and saboteur. The *Daily Mail* ordered its readers to 'refuse to be served by an Austrian or German waiter. If your waiter says he is Swiss ask to see his passport.' The popular Swiss Café became unpopular, except with the police who raided the Gosport High Street branch on several occasions. In London everyone, but everyone, knew of an 'alien' waiter who, on being asked the sudden question, 'Well, Fritz, where are you due to report to when the invaders arrive?' would leap to attention, click his heels and say 'Portsmouth, sir'.

The popular national press was the source of many colourful scaremongering stories which were met with widespread belief by a population that had been taught what to expect by spy novels, the theatre and the cinematograph. Garrison towns, especially, were to attract vivid descriptions of sabotage attempts, with salivating German barbers carefully sharpening their razors to slit the throats of unsuspecting recruits, while shifty waiters noted down troop movements before slipping poison into the last course of a careless customer's meal. Some Portsmouth hairdressing establishments inserted cards prominently in their windows bearing the life-saving information, 'English House' and an anonymous correspondent in a local newspaper urged 'loyal Englishmen and women' to 'support the English hairdressers in this town, instead of the detestable aliens'. This advice prompted the local representative of the Guild of Hairdressers to point out that 'it is not the look of a name that makes a citizen. All these hairdressers are naturalised subjects who have long enjoyed the confidence of their fellow townsmen. I make a strong plea for fair play and facts'.

But fair play and facts were at a premium. Many well known and respected businesses found themselves boycotted or forced out of the area, while their trade was presumably seized by anonymous letter writers. Hundreds were arrested,

presenting the authorities with a unique logistical problem – where to put them. Space in police cells and Kingston Prison was limited and so makeshift repositories had to be found urgently. Elsewhere in the country, derelict warehouses, factories and racecourses were requisitioned, while on the Isle of Man a holiday camp was converted with only minor modifications. But the local solution was both effective and cheap, involving the incarceration of hundreds of 'enemy aliens' in commandeered passenger ships lying in Portsmouth Harbour. This method of dealing with undesirables had a long tradition dating back to the Napoleonic wars, when French prisoners were kept in rotten hulks afloat in the harbour.

But this arrangement was not without its critics, though they were far from being motivated by humanitarian concern. The popular Portsmouth MP, Sir Charles Beresford, was moved to write to Prime Minister Asquith asking

> whether these alien enemies can have a full view of the proceedings in Portsmouth Dockyard and Harbour, as well as all signals made; whether other matters useful to the enemy could be observed by these prisoners; whether he can see his way to remove such a danger from the precincts of our first Naval port and arsenal.

The First Lord of the Admiralty, Winston Churchill, replied on the Prime Minister's behalf and was able to give Sir Charles some reassurance:

> The objections to prison ships lying in Portsmouth Harbour are admitted though I am informed that, owing to the precautions taken, the amount of information that can be acquired by observation is not likely to be of any value. Owing to the large number of prisoners that had to be dealt with at short notice by the military authorities, no other arrangement at that time was possible, but steps are being taken to find other accommodation with as little delay as possible.

Up to 4,000 civilians were temporarily imprisoned in three vessels, of whom several hundred were released after a few months when it was established to the Chief Constable's satisfaction that they posed no threat. Though they were deemed to be 'friendly aliens' this did not prevent the exercise of circumspection in Portsea's pubs and cafés. 'If a stranger gets into conversation with a Pompey man in a pub,' remarked Fred Jane in his weekly newspaper column, 'and asks him how many soldiers he thinks there are in Portsmouth, the odds are that the Pompey man will follow him home and tell the nearest policeman.' This was typical Jane, dispensing advice sugared by an imagined observation.

On the streets naval uniform had become a rare sight, so much so that people would stop and point it out. With the Fleet steaming on course for the North Sea it was the turn of 'Tommy' to receive the cheers and pats on the back from a grateful and patriotic population. The more reserved middle classes organised motor car excursions to review developments in local defences and to survey the newest army camps which were mushrooming around Portsdown Hill and the countryside beyond.

The public were warned to keep away from barracks, camps and other areas guarded by troops, especially at night. One reservist stationed at Haslar wrote home to his sweetheart: 'There are armed guards everywhere; you have to mind you don't get shot.' This danger was very real. Any person not answering promptly to the challenge 'Who goes there?' was liable to be killed, and under martial law there were no supplementary questions to be asked. With every rifle and revolver permanently loaded and every trigger finger itching to pot a spy, it was perhaps inevitable that accidents would occur. Before very long, a young soldier guarding Priddy's Hard Royal Ordnance Depot was killed, the first of several tragic military fatalities in the area.

The first deaths of local men caused by enemy action occurred within hours of war having been declared, when HMS *Amphion* was sunk by a German mine just outside of the Thames Estuary. Casualty lists were posted on notice boards outside the town hall in Portsmouth and Thorngate Hall in Gosport, while the leading article in the *Evening News* went under the poignant headline, 'The widows' tears'. Few people could imagine the scale of death yet to be unleashed or the oceans of tears yet to be shed.

The first few deaths received prominent press attention, with individual instances being properly accorded the status of human tragedies, a luxury that could not and would not last. Angry reaction to the news was directed at 'aliens' who were most visible, well known tradesmen with prominent shop premises. A bakery in Arundel Street was surrounded by a large, volatile crowd. Edwin Cleall, then a pupil at St. Luke's School, remembers the window being smashed by a stone-throwing mob, uncontrollable and violent, bent on destruction. One woman was arrested on a charge of wilful damage, her defence being that she had not cast the first stone. The owner of the shop explained that he was from Russia, one of Britain's allies and prudently dropped the charges.

On the same night similar damage was caused to another Russian's shop in Charlotte Street and, later, another attack was reported in Fratton Road. In the House of Commons a few weeks later Sir Charles Beresford used these incidents to urge that more stringent measures be taken to intern foreigners. Like the brick-wielding mob, Sir Charles believed that 'friendly alien' was a contradiction in terms, and warned the House that 'in Portsmouth there is a suggestion of making vigilance committees to take the law into their own hands'. The Home Secretary replied that he would consider such actions 'very deplorable' and pointed out that 'a very large number of unfounded rumours have been circulated in regard to German spies'.

Unfounded rumours were not confined to the subject of traders with foreign sounding names above their doors. The early days of war brought news of a terrible naval defeat with considerable loss of life. But faith in the invincibility of the fleet, together with the influential advice of the curate of St. Mary's, the Reverend Cyril Garbett, put many fears to rest. 'Rumours will be plentiful and alarming,' he predicted, 'and the wise will disbelieve nine-tenths of them and thus avoid unnecessary anxiety.' But there was always that tiny, inextinguishable element of doubt.

One practical antidote for anxiety, which many women and schoolgirls took up with a frantic fervor, was knitting. Miles and miles of wool were fashioned into socks, gloves, balaclavas, scarves and jumpers for their men folk at the Front or on the North Sea. Communal knitting circles were organised in local halls where women could share their experiences and fears, while knitting in public – on trams, in the picture house or park – became almost a patriotic duty. It did not matter that many of the finished efforts were amorphous garments of uncertain function.

Another voluntary initiative in the early days was the house-to-house collection of magazines for the many gunners, night-sentries and searchlight operators stationed at Southsea Castle and along the beaches. Light literature was welcomed as a relief from the tense and exhausting concentration needed to scan the horizon for hours on end for an unfamiliar silhouette and to survey the expansive, moonlit waters of the Solent for the tell-tale wake of a U-boat periscope. All was calm until, one night: 'In the beam of one of the searchlights the officer on watch (at Southsea Castle) saw a small shining object moving harbourwards in the deep water Channel. 'A periscope, by (God)!' he shouted. 'Poke your rifle out of the window and take a shot at it; no, wait a bit!' He called for the gunner officer on watch, who had better binoculars, and together they focused on the object. 'A biscuit tin coming in on the tide' was the verdict.

According to one source, the German War Staff had been considering various plans to invade, though biscuit tins did not figure prominently in their optimum strategy. This involved the use of torpedo boats which could 'make a rush past the forts at Sandown, Spithead and Gilkicker' in an attempt to enter Portsmouth Harbour and torpedo all war vessels at close quarters. Meanwhile, troopships escorted by cruisers would emerge from south of the Isle of Wight, entering the Solent from the west, passing the Needles, 'and sail into Southampton Water, disembarking troops on the Hampshire coast'.

Portsmouth and Gosport experienced invasion scares of a more serious nature when several houses were damaged after being shelled from the sea. The first missile exploded on the croquet lawn of an unoccupied house on the corner of Spencer Road in Southsea, causing considerable damage to surrounding properties. Officers from Lumps Fort arrived on the scene and a large crowd that had assembled was happily reassured by the news that a British shell had been responsible.

Several months later, in the terraced houses of numbers 70 and 74 Sydney Road in Gosport, the Byng and Gray families were just sitting down for their midday meal when their kitchen ceilings collapsed upon them. Mrs Byng's daughter exclaimed: 'It must be the Germans!' and Mrs Byng thought her 'last hour had come'. Mrs Gray was too upset to speak while Mr Ball at number 78 proudly displayed the foot-long shell which had passed through his neighbour's house before finally coming to rest in his flower bed. Fortunately it did not explode and there were no casualties; another shell fired at the same time landed in a field in Melville Road and exploded leaving a crater 'large enough to bury a horse'.

The practice firing of guns from Solent defences was not always so inaccurate. One still August night, two weeks into the war, a German merchant steamer chugged along the western approach to the Solent, apparently in a bid to surrender. 'They're firing at a ship' said someone,

> and out we all rushed to the nearest vantage point, and even as we ran another gun went off and again the fog-horn answered with its bleat. The searchlights were striking great shafts of light along the Solent, and far away their beams outlined the shape of a big ship. She was still advancing on her course. Bang! Another violent explosion shattered the night. We went to our beds that night with a feeling of perfect security.

The captain of the ship, who had evidently not given much for his chances of making it back to Germany, was now equally unsure of the wisdom of his decision to show the white flag. But the order was given to 'cease fire' and the harassed ship was escorted into Yarmouth, where a shaken crew was transferred to a government tug and landed at the Royal Clarence Yard in Gosport.

They appeared delighted that, for them, the war was over:

> The prisoners were all in civilian attire and looked typically Teuton. They seemed to be very happy and contented with their lot, and as they passed through the large crowd which had collected near the guardroom of the New Barracks (St. George's) they smiled and several of them waved their hands.

Searchlight emplacement near Tower House, Old Portsmouth (right). This was the home and studio of the artist W. L. Wyllie. His studio was used as a store for Red Cross medical supplies.

Soldiers from the barracks formed a strong military guard and, with fixed bayonets, marched the 120 men to Fort Elson for incarceration. The crews of other continental pleasure boats and merchant ships apprehended in the Channel were similarly dealt with, many having been attracted to the area by Cowes Week, which had been cancelled at the last minute when war become imminent. With their traditional regatta spoiled, many 'enemy' aristocratic yacht owners and their crews found themselves up a creek without a paddle. On one occasion sixty Germans were arrested and escorted to Winchester Prison, where they complained of being kept 'in damp, dirty cells with plank beds and bread and water'. A spokesman explained that 'it is not a Ritz but a prison'.

In the midst of the long summer school holiday local children, too, found that many of their traditional leisure pursuits had been curtailed or suspended altogether. Waste ground which had previously served as play areas was now endowed with military importance and placed out of bounds. Picture houses were also considered unsuitable venues of entertainment by mothers who found they had to count the pennies more carefully than usual because of rampant inflation. Many comics ceased publication due to a sudden paper shortage. There were many alternative methods of killing time that were more in tune with a nation at war. While sisters' needles frantically clicked, their younger brothers' toy guns patriotically popped at invading armies. Older brothers queued up to enrol as cadets in the Hampshire Regiment, the object of the corps being 'to train boys over thirteen and under seventeen in military drill and shooting'. Boy scouts had an especially exciting time. Upon war being declared scoutmasters had been summoned to Portsmouth and Gosport Scout Association headquarters in Twyford Avenue and Stoke Road to be told that, in true Baden-Powell spirit, their troops were now under military orders. Their contribution to the war effort was soon recognised, dispelling a popular pre-war perception of the new movement as cranks who practiced strange rituals:

> In Portsmouth they have relieved soldiers of sentry duty at various places…and have been instrumental all over the country in causing the arrest of suspected persons. The greatest credit is due to the boys, too, for their readiness to assist, and their pluck (for it takes some pluck to be on guard at two or three in the morning in a railway siding or wood, with every shadow an imagined spy.)

The local movement was promoted and organised by Fred Jane, who often penned his column for the *Hampshire Telegraph* while perched in Hilsea signal box or crouched on a nearby railway siding with three or four sleepy scouts by his side. Armed only with his whistle and fountain pen, he recorded his thoughts under the light of the moon and in the reflected beam of a distant searchlight. Jane's imagination thrived in these conditions: 'Ping-whizz-bang! Half a mile away a sentry has fired a shot at someone – probably someone trying to poison the Portsmouth water supply.'

It was easy in a nervous, uncertain atmosphere of fear, thick with rumour and heavy with hatred, to half-believe and then become convinced that a shot in the dark or a shifty side-glance from a stranger had sinister and deadly implications for

Portsea Parish scouts with the Vicar of Portsmouth, Cyril Garbett, in 1919.

Britannia's defence and the course of the war. The public had, after all, been urged to exercise vigilance 'to frustrate the efforts of the large body of raiders who are known to be in the country with the object of striking silently at our security'.

One particularly hardy rumour which gave credence to this threat concerned the activities of a tenant of an attic flat in Marmion Road in Southsea from whose sea-facing window long and rapid flashes of light were observed. He was, according to the rumour, promptly arrested by the authorities and shot, it having been surmised that he was sending messages by Morse lamp to U-boats in the Solent. Tales of summary executions flourished and grew. A man living in Aldershot recorded that by September 1914 'some hundreds of spies have been shot since the opening of the war, though not a single one has been in the papers'.

Rigid censorship lent plausibility to such stories. Newspaper editors found themselves liable for arrest if they contravened the Defence of the Realm Act (DORA) and had every incentive to gain preliminary clearance from a newly established Official Press Agency for any stories that were doubtful or reflected badly on the British war effort. Not surprisingly, some people began reading between the lines. The editor of the *Evening News*, however, defended the government's policy, arguing that false rumour given credence by publication would cause great harm.

With the latest war news having displaced the weather as the most popular topic of conversation, it was inevitable that half-truths, distortions and totally false reports would circulate, with the drama being cranked up on each telling. Heavy fines and imprisonment under DORA were no deterrent as gossip passed over the wash-line and beer-pot with equal enthusiasm. A local baker was arrested on his rounds after mentioning to a customer that four British battleships had

'gone down'. In his defence it was stated that he had merely repeated what a dozen other people had told him that morning. Unfortunately, the recipient of this 'news' had a husband serving on one of the ships. Such rumours, however careless and inconsiderate, appear to have been simple expressions of popular concern, which, in the absence of any real news, grew to alarming proportions.

In the first few months, official war news centred on the invasion of Belgium, with prominence given to lurid descriptions of alleged atrocities suffered by its population at the hands of the 'Hun'. One story told of how a priest had been tied to his church bell and used as a live clapper, another how a British nurse had her breasts cut off by the bloodthirsty invaders. When doubts as to the authenticity of these stories reached the ears of Fred Jane, he suggested that anyone who did not believe them had German sympathies. 'Personally,' he wrote in his usual succinct and personal style, 'I believe every one.' The story of the mutilated nurse was later exposed as the fabrication of a 'hysterical adolescent' girl whose intention was 'to alarm the public', but many others are attributable to official sources, created for recruitment and propaganda purposes. A more reliable first-hand account of the situation in Belgium was made by Gosport soldier G. H. F. Lewis in a letter home:

> We saw sights that were pitiful in the extreme. Poor old men and women with their daughters and their children, and people of every class running along the road, terrorized and crying pitifully with what belongings they could possibly carry.

For the population at home who shared Jane's certainty, the dominant, dreadful thought was whether such abominable things could happen to them. An appeal was set up for funds to send to 'the brave Belgians in their hour of need', but it soon became clear that money alone was insufficient to meet their worsening plight. With their country a scarred battlefield and their homes in ruins, a million dispossessed Belgians sought refuge in neighbouring countries, with more than 100,000 embarking at once for England. In Gosport the Revd Henry Tanner, Vicar of St Matthew's in Clarence Square, organised an appeal for provisions, clothing and furniture to equip and prepare accommodation. In a magnificent effort all classes of the community rallied round, with the better-off providing money, tradesmen tendering linen and bedsteads and the poor offering their personal help in cleaning and preparing rooms. In a matter of days the Victoria Temperance Hotel in North Street and a large house adjoining the vicarage in Clarence Square were transformed into 'plainly but comfortably furnished rooms', presenting a 'very homely appearance'. The preparations had aroused considerable curiosity and so, with charitable enterprise, the vicar imposed admission charges to view the rooms. Outside, the Union Jack and the flag of 'brave Belgium' were unfurled, while on the pavement below hundreds of people assembled to greet the Belgian families.

A party of sixty landed at Gosport Hard where another crowd of two or three thousand 'appeared at a loss to know whether to cheer or sympathise with the outcasts'. The party of sixty refugees, drawn from 'the peasant or industrial class', carried small bundles representing all that remained of their possessions. With their

clogs stuffed with straw 'to give a little ease and a better fit' the solemn group, comprising mainly women and children, made their way to their new homes with locals lining the route. Atrocity stories had led the crowd to expect handless, tortured children, but that these refugees had suffered hardship and loss was beyond doubt. One man in the crowd spoke for all with the shout, 'We are proud of you all,' though for the Belgians, tired, confused and unable to speak English, the reception itself proved an ordeal. One man was so dazed on his arrival that he was astonished to be told that he was in England. Through interpreters it was established that most of them came from the badly-shelled city of Louvain where, notwithstanding the false atrocity stories, fifty civilians had been massacred and the University Library burnt down.

As they settled into their new homes it seemed that their immediate problems were over. They had been fortunate to arrive amongst such hospitable and charitable people. But they knew nothing of a cruel and capricious maiden called DORA who appeared deaf to reason and blind to justice. After all, according to the Defence of the Realm Act, they were 'aliens' residing in a 'specified area' and in hostels from where the traffic in Portsmouth Harbour was visible. With this in mind the 'dear, brave, plucky' Belgians were ordered to leave the area.

Eighteen months later Gosport's former guests were living in tenements in Winchester employed in 'building hutments for the military' or working as domestic servants and shop assistants. Assimilation was painful and difficult, with some Belgian women stubbornly refusing to conform to the British fashion of never going hatless, while men were reported to be 'given to chewing quids of tobacco and spitting elsewhere than in their handkerchief'. Having upset the sensibilities of their hosts, the status of *'les braves Belges,'* went from that of a pampered kitten to that of an unwanted stray. It soon became a joke amongst those who had patriotically employed Belgians as domestic servants to enquire, 'How are your Belgian atrocities?' One outraged Southsea lady complained that 'the most undesirable women' were being 'dumped' on Britain. Many of the men returned to their unrecognisable homeland to fight in the trenches, where it did not matter a spit where one spat.

By the end of 1914 the war in Europe had reached stalemate and fears of invasion began to subside. The long-awaited great naval battle had not yet happened and the population was urged in popular catchphrases to 'Carry On!' their 'Business as Usual'. But the domestic complacency engendered by this campaign was rudely shaken when a German cruiser shelled Hartlepool, Whitby and Scarborough, killing 150 civilians. The nation was stunned; it seemed unbelievable that an English servant girl could be killed by Germans while polishing her lady's doorstep. Then, on Christmas Eve, the first bomb ever to be dropped by an enemy aircraft fell on Dover. Suddenly an illustrated article that had appeared in the locally produced *Pinks Pictorial Magazine* five years earlier assumed an ominous and frightening credibility. Under the title 'The Bombardment of Portsmouth' the writer warned of what the twentieth century might bring in terms of modern warfare. A supporting photo-montage depicted 'a bombardment of the ships in Portsmouth Harbour by a fleet of airships'. Far from being 'over by Christmas', the Pandora's Box of modern warfare had only just been unwrapped.

CHAPTER FOUR

Tickled to Death to Go

At Portsmouth Hard, tired and grimy 'dockies' emerged from the yard, many having completed war-time shifts of up to fourteen hours. Meanwhile, the sauntering, promenading of the carefree tourist had been replaced by the purposeful, striding gait of the eager soldier as he passed the notorious pubs and hotels of the Hard. Down in the mud, the traditional activity of mudlarking continued – children begged and entertained and competed to retrieve the odd coin tossed into mud or the sea, depending on the tide.

A military band struck up, brassy and loud, with a marching drumbeat and a portable platform was hastily erected as the band finished to hearty cheering and applause. Local MP Charles Beresford mounted it, surveyed the growing crowd and cleared his throat into a gigantic, riveted tin loud hailer. 'Roll up!' His voice carried far. 'Roll up and join the Army my lads! This is going to be a fight to the finish, with a clean and fair knock-down blow. And we are going to give that blow!' The cheers could be heard across the harbour where a similar procession with equal volume proceeded down Gosport High Street, led by the Royal Marine Band with boy scouts bringing up the rear, thrusting handbills into onlookers' hands: 'Grand Recruiting Meeting. Thorngate Hall. Today. Follow the Band.'

Inside the Thorngate Hall a large Union Jack was suspended prominently above the platform while patriotic arias succeeded in rousing the growing audience into a 'high pitch of enthusiasm'. Local MP Arthur Lee addressed a packed hall. 'The white flame of peril and suffering through which we are passing,' he asserted 'is having a fine tempering effect upon the steel of the national character, and we have purged ourselves of much of our uncleanness and selfishnesss...Let Gosport send a contingent to maintain the patriotism which has always been shown here.'

With the war widely regarded as both a 'great game' – as in Beresford's boxing metaphors – and a wonderful tonic for the nation's ills – as in Lee's allusion to purgatives – the task of recruitment required a minimum of effort in the very early days. The initial response was so overwhelming that Beresford confidently estimated that it would take only a day or two to raise the 1,100 men necessary to form the Portsmouth Battalion.

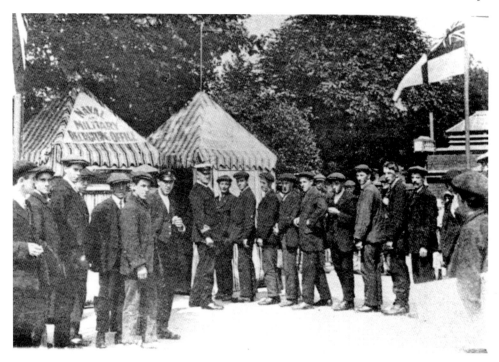

Men queue outside a makeshift recruiting office in the town hall square.

In an area proud of its long naval tradition, where Lord Nelson was a hero and the Duke of Wellington only a soldier, the call to join the Army was met with some mixed feelings. With the fleet fully manned, naval recruitment had been halted, causing considerable frustration to many eligible young men with brine in their blood. Britain urgently needed men to augment the Regular Army, which was preparing to prevent the German advance through Belgium. Parliament had ruled out conscription as an extreme measure, alien to the British way of life, being associated more with autocratic military regimes like the Kaiser's.

That was a view shared by members of Portsmouth Grammar School's Debating Society where the idea of conscription as being 'opposed to the spirit of Englishmen' was passed. It was necessary to beat the enemy with honour and without resorting to his methods. To this end Prime Minister Asquith shrewdly appointed as Minister of War the universally popular soldier-hero Lord Kitchener, who immediately set out to raise a new regular force of 500,000 men. Retired Admiral Charles Beresford swallowed his pride, replaced his prized naval uniform with khaki and jackboots and offered his services to Kitchener to drum up recruits for the sister service.

The regular recruitment drives in Portsmouth and Gosport were steered by a local committee under the chairmanship of Mayor Corke with the compendious title 'The Citizens' Patriotic Recruiting Committee for Portsmouth and District', which included representatives from all political parties and most religious denominations. Makeshift recruitment centres were established in private houses and business premises. The surveyors, auctioneers and estate agents Hall, Pain &

Goldsmith, was just one of many establishments to register recruits for Kitchener's Army. Defying a paper shortage, many hundreds of recruiting posters were printed and distributed by eager boy scouts to anyone with a prominent site and a paste pot. In bay windows prized aspidistras were relegated into the shade of large bills urging male passers-by to 'Rally round the Flag' because 'Your King and Country Need You'. The frosty eyes and accusatory pointing finger of Lord Kitchener dominated hoardings, windows, notice boards and pillar boxes.

But his Lordship's steely glare fell, more often than not, on men who were 'doing their bit' in another vital but less obvious way. As a correspondent in the *Evening News* pointed out, 'out of every ten young men seen in the streets of Portsmouth, probably six or seven are employed in the Royal Dockyard'. Immediately war was declared, the dockyard and other government establishments had begun absorbing all skilled and most of the available unskilled male labour in the town and its environs, removing within a matter of weeks the problem of unemployment that had appeared so intractable in peacetime. With no statutory 'dole' payments it was left to charities to attempt to alleviate the widespread distress, and while their efforts had helped a few deserving individuals, the overall pre-war situation for a sizeable proportion of the population had been one of poverty, malnutrition and bad housing. Equally widespread was the belief that poverty was a fact of life resulting simply from a weakness of character. But now that there was work to be had in the dockyard, Gunwharf and munitions factories, such theories began to collapse, like so many other comfortable beliefs, with necessity proving to be the mother of government intervention. But while men flocked into the dockyard to meet local exigencies there were, as we shall see, relatively few remaining to answer Kitchener's call.

There were no promises of excitement or glamour attached to the call for women volunteers to prepare and clean suitable buildings for the reception and treatment of sick and wounded soldiers. In Francis Avenue, passers-by were met by the sight of 900 desks stretched like a wooden blanket across the Council School playground, while inside dozens of volunteers armed with scrubbing brushes, disinfectant and elbow grease vigorously transformed the hall and classrooms into wards and operating theatres. More than 100 beds were installed and a Red Cross flag was proudly hoisted on the roof.

Half a mile away, the girls' secondary school in Fawcett Road was rapidly converted into the headquarters of the 5th Southern General Hospital under emergency plans drawn up by the Territorial Army before the war. Within a matter of days the 500-bed hospital, complete with nursing staff and medical personnel, was fully operational. Confidence in this arrangement, combined with a conviction that the war would last only a few months, led to Francis Avenue School being restored to its original function. The flag was brought down without ceremony and the desks returned to their places, the headmaster grateful that his school was now deemed surplus to war requirements. He resumed occupation of his study, one of his first duties being to record in the school log that the Attendance Officer was absent – having joined-up.

A rare photograph of Kitchener smiling. It was said to have been prompted by sight of the arrest of his photographer, Stephen Cribb of Southsea.

Reasons for joining-up were usually personal and immediate. Young men were inspired by the promise of adventure and excitement – here was a chance to escape from the dreariness and monotony of everyday life. And the Army offered comradeship, a need which was rarely met by civilian life. Not least, many men felt a genuine patriotism and considered it their duty to enlist.

At Portsmouth Grammar School, the editor of the school magazine, *The Portmuthian*, proclaimed that 'throughout the Empire patriotism has been born again, for men have received a revelation of its strength and its glory'. He urged that more boys join the Officer Training Corps. The Headmaster backed the call, proud of the success rate of recruits in gaining the initial certificate which demonstrated that they were able 'to handle a company in ordinary drill, musketry and tactics'. A member of the debating society put forward the view that the war 'had been sent as a judgement upon the slackness of England', but Portsmouth Grammar School showed no sign of slackness; a running total of former pupils who were serving in the armed services began to be regularly featured in the magazine and by December 1914, 513 Old Portmuthians were fighting for King and Country, 'acquitting themselves in a way which reflects credit on themselves and their School'.

The recruitment rally became a regular event in the Hard, in the town hall square and on Southsea Common, but to maintain interest and provide some extra colour the organisers often arranged for famous individuals to appear and address the crowd. Music hall artists, actors, comedians and politicians did their bit by talking others into doing theirs. Potential recruits were swayed by the opportunity to shake hands with the likes of Harry Lauder, famous for being Scottish and singing about it ('I love a Lassie, "Roamin'" in the Gloamin'). Another attraction was Horatio Bottomley, persuasive orator and editor of the magazine *John Bull*, who spent the war encouraging men to fight and accumulated nearly £80,000 in appearance fees. While the celebrities earnestly exhorted, a pack of motor cars ticked over nearby with 'recruiting service' emblazoned on their windscreens. Their role was to 'give intending recruits quick transit to the town hall, where, without delay or preamble, they could be attested for military service'. Timing was of the essence. The emotional impact and commitment whipped up by a professional orator might so easily give way to vacillation and doubt, as it did for one man, a locksmith in the dockyard:

> In 1914 I took the King's shilling, signed up, got the shilling and 1/9 for a day's ration money. A month later I had the call-up papers (which read) 'If you are in a reserved occupation take this to your foreman.' Well, I was, so I took it to him. He said, 'Do you wanna go?' I said 'Not a bit anxious.' He said 'Well you're not bleedin' well goin' in any case, you're stayin' 'ere.'

Most male civilians, in reserved occupations or otherwise, appear to have exercised discretion and avoided these flag-waving, drum-thumping carnivals in the knowledge that speakers were in the habit of picking on individuals who were not clad in khaki or naval uniform. An added deterrent was the prowling recruiting sergeant who 'passed encouraging words to likely young soldiers' his offer was irresistible if the young man had an adoring young lady on his arm. Not surprisingly the crowds at these rallies were made up mostly of women, who must have experienced something of the atmosphere that their men folk enjoyed at Fratton Park each Saturday – except that everyone was on the same side. Even Councillor MacTavish, who had campaigned against the war, mounted the platform to deliver rousing speeches calling men to arms.

But the preponderance of women provoked acerbic comments from some speakers. One MP scanned the assembly and opened his address by saying that he would stand a better chance of getting Red Cross nurses than of getting soldiers. The emphasis on these occasions shifted from one of direct recruitment to an indirect appeal through women, whose new role Beresford defined as 'influencing their young men to enlist'. He suggested that every woman who succeeded in persuading a man to join should be rewarded with a special badge as evidence of her patriotic sacrifice. An elderly Southsea resident wrote to the *Evening News* to advise how best a woman might go about persuading her man:

Go to the man of your choice and whisper in his ear – say that as much as you love him, you love your country more, and will spare him for its service. Then send him forth with your kiss upon his lips and the hope of many such as reward when there is peace in the land again.

Scorning such subtle inveiglements, a Southsea vicar preferred to attempt to shame the apparently indifferent and selfish youths who

hang about the pier with their hands in their pockets and their feet encased in marvellous and wonderfully coloured socks...In Belgium men are...facing death in order that these over-socked emasculated specimens of femininity may lounge about at the seaside.

But concern for 'common fairness' prompted one bold spirit to point out that many men engaged directly on government work in the dockyard and elsewhere 'may be seen in their spare time on the seafront or about the town...There is no question as to the patriotism of these men.' This inconvenient fact did not interfere with the self-righteous wave of militancy which afflicted some ladies, who took it upon themselves to 'confer the Order of the White Feather'. As a symbol of cowardice the white feather had been made familiar in a popular novel (A. E. Mason's *The Four Feathers*, 1902), but was now presented indiscriminately to young men who were reckless enough to appear in public in civilian attire. These

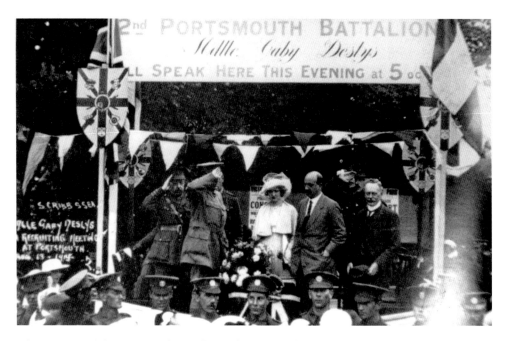

Glamorous French actress Gaby Deslys took time out from performing at the Hippodrome to appear at a recruitment rally in August 1915.

respectable women, laden with heavy weights of white feathers purchased from Southsea's fashionable milliners, stalked the promenade in search of the 'shirker' or 'lounger'.

> A Dockyard worker who had been kept 'hard at it' ever since the war began, working late every night, and sometimes all through the night, went for a week-end stroll along the seafront at East Southsea, and, being tired, sat down on one of the seats. A 'White Feather' young lady came up and politely handed him a white feather as a hint that his proper place was at the seat of war.

The dockyard worker proceeded to explain 'in very plain terms' his position, 'with a hint that the lady would do well in future to mind her own business'. This was no time or place for the sensitive individual who worried about what other people thought. Another dockyard worker who had attempted to enlist, but was one of a smaller number rejected on medical grounds, became very distraught after reading a letter in a paper under the heading 'Loafing and Shirking'. He slit his throat and bled to death, another casualty on the Home Front.

Another recipient of the white feather was a frail victim of tuberculosis who had been wasting away for four years. This incident prompted the Vicar of Portsea, the Reverend Cyril Garbett, to write a strongly-worded protest in the parish magazine. Apart from the fact that gross injustices were inevitable, the practice was 'stupid, for the man who is frightened by a taunt is not the man who is required to fight for England's honour on the battlefield.' Even Charles Beresford found himself unable to approve of the practice, perhaps mindful of the suggestion that some young ladies were ridding themselves of unwanted boyfriends by this method. But Fred Jane defended any means of getting at the 'blue funk slackers who are afraid to risk their own dirty skins'. His target was a breed of young gentlemen who styled themselves 'knuts', for whom everything was 'absolutely too much bally-fag, what?' These 'knuts' evidently spent their leisured lives 'spooning' with their girlfriends, playing tennis and joy-riding on noisy motorcycles. Jane stopped a particularly arrogant example one night in Hilsea while on scout patrol in search of German spies. The 'knut' told Jane curtly that he would 'probably hear from his solicitors'.

Attempts at shaming men into the Army were not confined to this highly visible but small minority. Commenting on Pompey's professional football team and their continued training for the 1914–15 season, an anonymous correspondent in the *Evening News* was offended by 'the spectacle of brawny Englishmen in active training to kick a bladder of wind hither and thither, while from every paper, every hoarding comes the clarion call, "Your King and Country Need You"'. Four thousand supporters disagreed at the first match of the season at Fratton Park, paying three pence at the gate to enjoy a 'capital game ... after a particularly exacting time at the dockyard and other business establishments'.

The Vice-Chairman of Portsmouth Football Club, Bruce Cornford, attempted to stem a tide of similar complaints by pointing out that two of Pompey's best players, one an international, had already joined up and that all proceeds taken at

the turnstile would be donated to the War Relief Fund. Cornford was a popular and influential character who also spoke up for another religion as Vicar of St Matthews. But his argument that the tradesman's maxim 'Business as Usual' should also apply to sport, because it provided a means of escape from the state of tension and long hours put in by war workers, was met by a storm of protest. Direct appeals were made to the Pompey players themselves:

> Suppose in years to come you meet a stranger … The conversation touches on the great world war that started in 1914. He asks what part you played in that great game, when empires were staked and principalities and powers thrown into the melting pot of nations. If you follow Mr Cornford you will have to say "Oh, I did my bit for the old country. I was one of those who stayed at home and played football."

'Surely,' argued another recruiter, 'sport is a means to an end, not an end in itself.' The 'end', it was asserted, was to build up a nation of hard and sturdy men, strong and alert, ready for 'the day'. This came as news to men who played football for the simple reason that they enjoyed the game and found they could make a humble but honest living from it. Somehow, Fratton Park seemed an improbable military training camp.

It did, however, prove to be a moderately fruitful venue for recruiting, being a traditional and uniquely all-male occasion. Though protective of his club's players, Cornford believed the punters were less indispensable and mounted the recruitment bandwagon strategically parked at the junction of Frogmore Road and Goldsmith Avenue. As the cloth-capped crowd spilled out after the final whistle, the Vicar had before him, quite literally, a captive audience. After one match the rally opened 'in a happy manner, for no sooner had the Revd Bruce Cornford risen to his feet on a lorry than a man pushed his way through the crowd, shook hands with the Vicar of St Matthew's, and said he wanted to join'. A notorious strategy employed by street traders, the use of a 'dummy' to set the ball rolling, was also one of many tactics in the recruiter's game plan.

Later a national 'Sportsman's Battalion' was established to encourage those active in outdoor sports, shooting and hunting to devote their energies to the 'great game', though members were to be drawn from the 'upper and middle classes only', which disqualified the 'thirty-bob' a week Pompey players. A supplementary 'Footballers' Battalion', though, attracted several members, while the remainder served in other regiments or worked in munitions factories. The men who stayed at home were stripped of their professional status but continued to play at Fratton Park, unpaid and for the love of the game, before record crowds made up of off-duty servicemen and 'dockies'. A poem was written by one supporter in tribute, the chorus to be sung to the tune of the 'Pompey Chimes':

> God bless the lads of Pompey
> The boys in red and blue
> Who, one and all rose to the call

To see Old England through
We're proud of every Briton
From near and far away
But we're extra proud of the little crowd
Of Pompey boys today.
(Chorus): Hallo! Hallo! Play up Pompey, Kaiser must go 'Off side' is he.
They're mighty fond of football, They bubble o'er with fun,
But when their country calls them They quickly shoulder gun.
Hallo! Hallo!
etc.

Fratton Park was only one of many entertainment venues where the potential for recruitment was quickly recognised. An audience at the King's Theatre was enjoying the delicate and subtle skills of a troupe of Japanese equilibrists when, midway through the performance, an appeal was flashed on to the screen behind:

Your King and Country Needs You
Lord Kitchener Needs You
Come and Enlist

While the audience was taking in this unexpected message, a sergeant-major stepped on to the stage and delivered a short speech, the evening ending in a rousing climax with the singing of patriotic songs. The use of a brusque and loud sergeant-major unversed in the measured art of persuasion was a temporary stopgap, to be later replaced, as we have seen, by the professional performer and celebrity. In the music halls, women were considered to be especially effective. The curious popular attraction of male impersonators was fully exploited as plump, monocled actresses strutted the boards clad in khaki, throwing out taunts and planting sticky kisses on likely lads as a reward. They were led away in batches, stirred by the good humour and camaraderie, the drink and the dense atmosphere of unashamed jingoism. The most popular and famous male impersonator of this period, Miss Vesta Tilley, adapted her act for this purpose and made several appearances at the Hippodrome in the war years. One of her biggest successes, entitled 'The Army of Today's All Right', was rendered with patriotic gusto in an ill-fitting subaltern's uniform:

Boys, take my tip and join the Army right away,
The money's good – not much, but good! – who knows,
Perhaps you'll be a general some day!
Remember chaps I said perhaps.
But though we're in need of you,
Don't think any old stuff will do,
In the Army, for the future, there will be,
Only big strong chaps like me! What?

So it's all right, it's all right now
There's no need to worry any more
I saw the army wasn't strong
Everything was wrong
Till the day I came along
And then the band played
They all hooray'd
'You've saved us!' said Kitchener with delight.
I joined the Army yesterday,
So the Army of today's all right!

The ironic reference to the Army Medical was not lost on her audience, who had seen posters everywhere helpfully pointing out that 'Standards Have Been Lowered'. If Miss Tilley could pass, anybody could.

But while perfunctory medical examinations facilitated recruitment, the meagre army wage for a private was a very effective deterrent. The standard rate of a shilling a day (5p) compared dismally with the average building labourer's wage of 26s a week (£1.30), a situation which many people felt was a disgrace. A local chemist wrote to the *Daily Express* calling for an immediate increase and pointing out that the last thing the fighting man would be worried about was whether he could afford to feed his family back home. A local woman, whose husband had joined Kitchener's Army, pointed out that many errand boys received better money. 'I have three little children,' she explained, 'two of whom have lately been ill and need nourishment that I cannot give them.' Labour Councillor MacTavish put the case for higher pay with some eloquence in an objection to some of the more distasteful methods of the Recruiting Committee:

The spirit of adventure is so general that, given the payment be decent and the comfort of dependants secured, more men can be had than is required. The whole difficulty is due to the fact that we want a cheap army, and all appeals to patriotism are simply a cloak to hide that fact. The patriotic contractor does not reduce his prices from patriotic motives. Neither do the equally patriotic armament firms. Why should we therefore ask the working man to make sacrifices of home and family that we are not prepared to ask those better able to afford it?

In response to the suffering of soldiers' families, and not least to its effect on recruiting, the Government adopted an increased allowance for Army dependants drawing solely upon the coffers of various charities. With ruling opinion strongly against interference in the free play of the market, this situation was to cause considerable bitterness and resentment in the Portsmouth area. The vast majority of men who enlisted in Kitchener's underpaid Army were single young men who had no responsibilities or ties. Nineteen-year-old Fred Barker, of Lake Road at Landport, was one of the first to go. Fearing that it would all be over if he hesitated, Fred wrote to his employer, George Gray, who ran a furniture business in Castle Road:

> Dear Sir,
>
> 29th August 1914
>
> I hope you will not mind me not coming in again after today as I have joined "The Hussars" and have to leave for Bristol on Monday, so I must apologise for not being able to give you a week's notice in the usual way.

In normal times such inconvenient behaviour by an employee could result in him receiving a court summons, as leaving an employment without notice was grounds for the employer to claim damages. But, under the circumstances, George Gray patriotically waived his right to compensation:

> Dear Barker,
>
> 30th August 1914
>
> It gives me great pleasure to excuse the usual notice on this occasion ... I wish that more of us were able to follow your example, as I believe that at the present time "to be a soldier" is the most vitally important thing an Englishman can be.

Few employers, however, appear to have been able to guarantee reinstatement upon the hero's return. Pinks, the grocery chain, combined patriotism with self-promotion by pointing out to its customers that by continuing to shop there they were ensuring that there would be jobs waiting for them 'when they came back victors in their country's battles'. Pinks was one of several large local employers actively to encourage its workers to enlist, with a total of thirty in the first month. 'Probably, within a few days,' the editor of *Pinks Pictorial Magazine* confidently predicted, 'as many more will go.'

Another major local employer, Sir John Brickwood, released a similar number from his Portsea brewery, while Messrs. John Dyer Ltd offered financial incentives and granted time off work to attend recruiting rallies. Not to be outdone, a total of twenty-three students from Portsmouth Municipal College abandoned their studies and a further sixteen handed in their resignations at the Landport Drapery Bazaar, all within the first few weeks of war. Meanwhile, it was estimated that 60 per cent of former members of Portsmouth Grammar School's Officer Training Corps were on active service.

Another less likely source for recruits proved to be the local law courts. The magistrates of Portsmouth, who were not renowned for their pioneering attitudes to penal reform, adapted their sentencing policy to answer the nation's call. One youth who stole a magnifying glass from Smitherman's furniture shop in Hanover Street was told: 'Go and play the man and fight for your country, and you will hear nothing more of this'. The charge was dropped and the weekly tally of recruits on the front page of the *Evening News* edged closer to the target of 1,100 needed to form the Portsmouth Battalion.

Word appears to have spread through the local criminal fraternity that the beaks had gone soft. After smashing the window of Thomas Webb's stores in Elm Grove and making off with twenty-six watches, three lads appeared before magistrates

claiming with a well-practiced sincerity that, 'at the time they committed the offence they intended to join the Army the next day'. The magistrates proceeded to demonstrate equally genuine sympathy for their plight.

One considerable incentive to enlist in the Portsmouth Battalion, as opposed to the many others on offer, was the promise of a comradeship based on common citizenship and a guarantee that life-long friends would experience the 'great adventure' together. It became known as the 'Chums Battalion', a description actively promoted by the recruiters, who wished to convey the impression of a cosy social club about to embark on a mildly incommodious but ultimately jolly works' outing. To the Citizens' Patriotic Recruiting Committee for Portsmouth and District under the auspices of Mayor Corke, the burden of persuading men to accept the King's shilling was one of both parochial and national importance, with aggressive patriotism jostling beside intense civic pride. After all, it would be a source of eternal shame if Portsmouth proved unable to match what so many other towns of similar size appeared to have achieved with relative ease.

But, as we have seen, such feelings took no account of the unique history, traditions and role of the Portsmouth area, in which nearly all resources were geared to the manning, maintenance and arming of the fleet. This fact was lost in the heady and emotional optimism of the early days of the war. Once a man had decided to join up, whether by the exercise of what is understood to be free will, or otherwise, the processing of the recruit was carried out with efficiency unmatched by any other bureaucratic procedure:

> At one end a gentleman was taking particulars from half a dozen recruits and as each one signed the necessary form he was passed along behind a curtain, where Dr Corcoran was waiting to conduct the somewhat rigid (sic) medical examination. If this proved satisfactory, the recruit was passed on and formally attested. This completed, the badge of the Battalion – a red, white and blue ribbon bearing the words 'Portsmouth Battalion' – was pinned on to his breast.

This rosette served to display the wearer's patriotic commitment and to repel the wearisome white feather pests until a uniform became available. It also guaranteed the proud bearer a drink 'on the house' in any Portsea pub. After this had been consumed, grateful and envious locals, too old to answer Kitchener's call themselves, ensured that the fresh-faced new recruit need not break into his newly acquired King's shilling to consummate his bold decision.

When the uniform arrived it proved something of a disappointment. A national shortage of khaki meant that suits were cut according to the cloth available which, in Portsmouth, was blue serge. Once kitted out the recruit was introduced to a discipline last experienced at school, with drill taking place every day, morning and afternoon, on Governor's Green in the shadow of the Royal Garrison church.

An inquisitive crowd pressed their faces against the perimeter railings under the watchful eye of a boy scout standing guard by the padlocked gate. The sight that met their gaze was unprecedented and hitherto unimaginable in a society

divided by rigid class barriers. 'The sons of gentry, young men of refinement and education, and, side-by-side with them, men of the labouring class, accustomed to the harder side of life.' There was neither fear nor favour, as each and every man 'practiced saluting, first with the right hand then with the left', formed fours and responded in unison to the commands of the drill instructor.

Similar scenes were reported outside barrack blocks and on available areas of War Office land in Portsmouth and the surrounding countryside, as dozens of other battalions prepared themselves for battle. While some soldiers perfected their salutes, others groomed and polished their horses. On mobilisation the British Army had some 25,000 horses but fewer than eighty motor vehicles. Finding this woefully inadequate, Army chiefs made full use of the extensive powers given to them under the Defence of the Realm Act and commandeered what they felt they would need. But the seizure of horses from local tradesmen and farmers presented serious problems, many being 'at their wit's end to know how to distribute their goods'. The *Portsmouth Times* reported their plight sympathetically, suggesting they might replace their loss with a motorbike and sidecar. In the event many of the larger firms invested in delivery lorries for the first time, enabling them to carry on 'business as usual', at least for the time being.

On Southsea Common, the sight and smell of thousands of horses provided a peaceful, pastoral contrast to the synchronised drill and echoing bark of the parade ground. Nearby, in Murdoch's Rooms in Palmerston Road, a meeting of the local branch of the Anti-Vivisection Society urged the Army authorities to exercise humanitarian consideration for 'our dear equine friend', pointing out that the horse was a highly sensitive beast.

With the onset of winter, murmurs of dissatisfaction began to surface concerning the treatment of troops during their training, and the primitive living conditions they had to endure. Highlighted by the press, this became a major embarrassment not least because of the detrimental effect, it was perceived it might have on recruiting. That winter was especially severe, and the situation was exacerbated by the dearth of Army blankets. It was left to relatives and the charitable to ease the problem, as shops like Morants, John Dyers and Handleys offered blankets for sale at reduced prices for the wealthy to purchase and pass on to the War Office. With a blanket costing more than a private's weekly wage it was beyond the means of many to provide such necessary extras.

One cause for complaint was that men were compelled to sleep under canvas when so many permanent buildings could be utilised for their accommodation. In Gosport, Forts Brockhurst and Rowner were used as transit camps in which units were kitted up and prepared prior to embarkation from Southampton. But the relative comfort afforded by the forts was the exception rather than the rule. The majority of men slept in the standard canvas bell tent until their departure. Rows and rows of these white domes dominated the landscape at Hilsea, on the slopes of Portsdown Hill and on Browndown, like regimented mushrooms waiting to be picked. Between 25,000 and 50,000 troops were stationed in the Portsmouth area at any one time during the war. For many, this sojourn was their last in Britain.

A less than critical view of what life was like in a typical Portsmouth encampment was published by the *Evening News*; the precise location of the camp was suppressed, though it appears to have been recognisable by its resemblance to a bed of roses. The visiting journalist described the day's menu: 'This consisted of either bacon or dried fish for breakfast; a pound of meat per man with two vegetables and bread for dinner, and a substantial tea, which included preserves.' The reporter then describes an encounter with a recruit, who claimed: 'We don't want any huts. We are as snug as bugs in rugs in these tents, and can sleep as well as if we were in the Hotel Metropole.'

Not long before this alleged encounter 'a certain number' of soldiers were admitted as 'wounded' to the newly established Military Hospital in Fawcett Road suffering from the effects of exposure, pneumonia and rheumatism contracted while guests in the Portsmouth encampments. This 'certain number' included one of the first men to die at the hospital. But complaints about conditions were given short shrift by a local Staff Officer who pointed out that there was a war on. The irony was that these appalling conditions were an excellent initial preparation for the trenches, though the War Office was eventually persuaded to finance the building of new barrack huts in Portsmouth which, upon completion, were described as 'almost palatial considering they are part of war equipment'. Such luxuries were justifiable by the first rule of military logistics, which required that men be delivered alive to the German machine-gunners.

With the salute perfected, the recruits of the Portsmouth Battalion progressed to drilling in 'sighting and musketry', though they were hampered by having to share rifles, one between three. Suggestions that a public charity fund be started to provide the Battalion with its own machine-gun took second place to an appeal for band instruments, organised by the *Evening News*. 'A regiment of soldiers without a band,' wrote one contributor, 'is like machinery without lubricants.' All classes contributed, the rich making individual donations while the poor clubbed together. Staff at Bassett's Restaurant in Commercial Road sent in 16*s* (80p) with the hope that 'we shall soon hear the Portsmouth Battalion band playing "It's a long way to Tipperary" as they pass'. Others hoped that martial music might aid recruitment.

After four long, hectoring months the Portsmouth Battalion reached full strength, made up of men from Portsea Island, Gosport, Fareham, Havant, Titchfield, Stubbington and Wickham. Members of the recruiting committee breathed an extended sigh of relief, packed their loud-hailers away and joined in the celebrations, heady with patriotic fervour and luminous with civic pride. One early volunteer, Lance-Corporal Debenham, penned a poem to the 'Chums':

We go route matches,
Through the town,
And feel quite lads in our blue and brown,
Our brass band playing tunes of the while,
The townsfolk wave,
The maidens smile …

THE CITIZENS' PATRIOTIC
RECRUITING COMMITTEE FOR
PORTSMOUTH & GOSPORT.

A MASS MEETING
TOWN HALL, PORTSMOUTH,
THURSDAY, SEPTEMBER 3rd.
THE MAYOR,
Alderman J. H. CORKE, K.L.H.,
in the Chair.
To support the Government in this Crisis
and to Facilitate Recruiting.

SPEAKERS
LORD CHARLES BERESFORD, M.P.
MR. ROBERT HARCOURT, M.P.
THE RIGHT REV. BISHOP INGHAM.
THE REV. W. MILES.
MR. THOMAS KERSEY.
Doors open at 7.15 Chair to be taken at
8 o'clock.

Recruitment rally notice in the
Portsmouth Evening News, 1914.

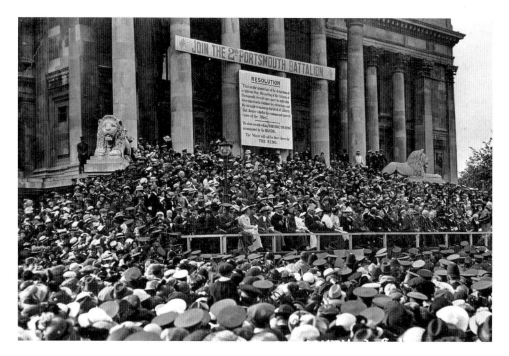

100,000 people attended a morale-boosting event in the town hall square on the first
anniversary of the outbreak of the war.

The impressive sight and sound of 1,100 of 'Pompey's Own' marching through the main thoroughfares became a familiar and stirring reminder of the war and of the sacrifices many families were making in the nation's cause. Flags waved, hearts throbbed and the band played on. Amid the jubilation and tears, the patriotic hopes and human fears, the announcement was made that Lord Kitchener wanted 'more men and still more' and had invited the town to form a second battalion. The recruiting committee had won the first battle, but not the war.

With a stoical nod of acceptance the celebrations resumed, culminating in a grand military inspection performed by the portly Member of Parliament and master of recruiting, Charles Beresford. On a wintry November morning the retired admiral proudly meandered up and down the columns of recruits neatly paraded on a windswept Southsea Common, his rolling, nautical gait conspicuously at odds with the khaki uniform and Army jackboots donned in his country's hour of need. Before him was proof that the Portsmouth area, despite its long-established naval traditions, had also answered the Army's call. He addressed the battalion in characteristic style, his voice travelling on the wind.

> You will maintain, I am sure, the traditions of the British Race ... I am satisfied that you will add to the glory of Portsmouth, to the traditions of the Army, and to the glorious name of the British Empire ... I wish you all good luck.

In April 1915, the 1st Portsmouth Battalion was given a hearty send-off, with seemingly the whole population turning out to line the streets from Southsea Common to Hilsea. A 5-mile flurry of white handkerchiefs was broken many times where tears were shed, while the cheering continued unabated. The polished brass of the band struck up with the rousing 'Fall in and Follow Me', but later gave way to the evocative and nostalgic 'It's a Long Way to Tipperary' as they marched out of Portsmouth.

Within six months, a further 1,100 men had fallen in and followed them to the front where conditions in the trenches earned them the nickname: 'The Mudlarks'. But as soldiers in the First Battalion discovered, the consistency and smell of the trench mud at the Somme was altogether different from that which separated the Hard from the sea on a hot summer's day in August.

CHAPTER FIVE

Faith, Hope and Charity

Stirring romantic scenes of men going away to war became a common sight in the area, so much so that a recommendation was made to the Southsea Advertising Committee that they could provide an additional attraction to boost the tourist trade. The spirit of 'business as usual' knew no bounds, but not everyone welcomed the martial activities. For one well-to-do lady resident of Clarence Parade, the passing of the vulgar tripper was now a matter for regret; his loud exuberance on the Common opposite had been bliss compared with the piercing calls of the Army bugler which, she bravely complained, was 'a source of torture to shattered nerves'.

The departure of troops was a routine sight in Gosport, where the New Barracks (later St George Barracks) was used as a transit camp through which many thousands of men passed before being transported by rail to troopships docked at Southampton. Ten-year-old Trevor Rogers, who lived in Elm Grove, a house overlooking Gosport railway station, witnessed many units leaving:

> Almost daily troops would march from the barracks to the station headed by a military band and accompanied by crowds of cheering people, many of them wives and sweethearts of the soldiers, who had come to stay in Gosport and wanted to see them off from the station. So great was the crush that as soon as the last of the troops entered the station yard the gates were shut against the crowds trying to get in ... As the train pulled out, the band would play Auld Lang Syne and everybody joined in and sang ... so desperate were the women to see their loved ones off that our garden would be invaded until the fence was lined with people, some cheering, but many in tears and breaking down. We soon learned to accept the situation and mother would often make tea and try to comfort the broken-hearted.

A comforting cup of Pink's Special Blend was just one of a million small, informal and everyday gestures of sympathy and gratitude shown by ordinary people living in extraordinary times. But it is in the nature of things that a kind word or a shoulder to cry on, or any number of expressions of common humanity, pass unsung and unrecorded, while the presentation of a white feather by a frustrated harridan dramatically gains the attention.

The most conspicuous expression of concern, sympathy and pity was through organised charity, many of the multitude of worthy causes being promoted by local newspapers. There was a burgeoning of war charity committees, working parties, flag days and door-to-door collections, all of which received popular and generous support. But the lack of state-organised provision for the health and welfare of the population as a whole was to highlight the ever-increasing importance and ultimate failure of philanthropic efforts alone to prevent dreadful hardship, especially, as we shall see, amongst naval families whose breadwinners were away fighting the country's war.

In August 1914, a National Relief Fund to relieve distress caused by the war was set up by the Prince of Wales. Represented locally by the Mayor of Portsmouth, J. H. Corke, and the Chairman of Gosport District Council, George Dukes, the fund was supported by the *Evening News* which publicised subscribers' names as an incentive to others. The response was immediate and magnificent. But the needs of the many suffering hardship were substantial and long-term, aggravated by the dependency of the poorest families on traditional industries, most prominent of which was the corset industry.

Portsmouth had, for some years, been as closely identified with the humble corset as it had with the not-so-humble dreadnought. In the nineteenth century several enterprising men had established small businesses in the area drawing on the huge reservoir of naval wives who had 'much energy, no means and were pitifully eager to better a miserable lot'. With no naval allowance for dependants, work in a 'sweated trade' was, for many, the only respectable alternative to destitution. In the immediate pre-war years more than 11 per cent of the working population in the town relied on stay making as a source of income, though the exhausting drudgery of sustained stitching was rewarded with a maximum wage of less than a third of what men might expect. The deafening cacophony as hundreds of women stood hunched over their machines in a busy Portsmouth factory was described by an observer:

> The whirr of wheels, slap and click of driving belts over pulleys ... the snapping bite
> of shears, the punch and clamp of eyeleteers ... the buzz of a thousand machines
> fascinates. Unceasing, it rises and falls in volume like tide on a shingle beach.

When war broke out the tide ebbed and then there was silence. Orders were cancelled as people hoarded food, inflation raged and a dread uncertainty about the future all but stopped the purchase of non-essential goods. In response, local traders began to advocate what they called 'practical patriotism' or 'business as usual'. 'Generally throughout the town,' they complained, 'there is a disposition to live on the narrowest margins of expenditure.' This, the argument went, was profoundly selfish and unpatriotic because it 'reduced to want thousands of people who are dependent upon the even flow of business'.

Some of the first casualties of cautious thrift were domestic servants, many of whom were unceremoniously 'let go'. Their erstwhile mistresses similarly

released themselves from their painfully fashionable bondage and sales of corsets plummeted. Thousands of women were put on short time or thrown out of work altogether. At one of the largest factories in the area the lucky ones who had not been dismissed had to sit idly at their benches awaiting work. As they were on piece-work they 'were not earning enough in a week to pay their lodging money, let alone their keep'.

The editor of the *Evening News,* William Gates, described the ensuing poverty as the most serious problem the borough had to face and suggested that the Relief Fund be boosted by a systematic deduction at source from the wages of those in work. This idea quickly caught on and group donations from the staffs of businesses and shops, rather than rich individual contributors, began to be represented on the published lists of donations. But a further suggestion that the Borough Council or the Government itself should subsidise the afflicted industries until demand resumed was roundly rejected. Market forces remained sacrosanct. It was to take another World War and the sacrifice and vision of another generation to bring about a Welfare State in which abject poverty was abolished.

To the hungry and desperate, movements in the market had no other meaning than the mobile stalls in Charlotte Street where rotting, discarded vegetables could be extracted from the muddy gutters. For some, scavenging was preferable to begging. The Relief Fund was administered by two self-appointed committees that established themselves in the town hall and Gosport's Thorngate Hall. Outside, queues of desperate applicants shuffled their feet awaiting assessment by society ladies whose 'indelicate questioning' and 'loftiness of manner' caused considerable offence.

Not surprisingly, many naval wives felt bitterly humiliated by this experience. Unlike soldiers' dependants, there were no allowances for the families of sailors and marines, who represented a considerable proportion of the local population. Traditionally, this situation contributed to the decline into prostitution of many wives. The tragic drift now highlighted by the war was less a case of 'when the cat's away' than it was of the desperate art of survival.

Now, with local industries closing down and thousands of wives thrown out of work, the matter was raised with urgency in the House of Commons by one of Portsmouth's three MPs, Mr Bertram Falle: '... these poor women are absolutely unable to earn a penny. What is the consequence to them? They can seek charity, they can starve, or there is another alternative, which I will leave to the imagination of the House'.

Some women were fortunate in having relatives with means and so went door-knocking. One penniless woman, met on a country road near Portsmouth wheeling a pram, described how she had been evicted by her landlady because she owed two weeks' rent and was now on her way to her mother's. Her husband was with the fleet and she had received no money since he left. Another woman, a widow whose son was serving, also faced eviction having had her weekly wage as a stay maker cut to 1s 6d (7p) from 9s (45p), when the rent for her lodging was 7s 6d (37p). These examples were by no means unique. In an attempt to prevent

wholesale destitution, William Gates strongly urged that landlords act with more consideration and directed women in distress towards the Relief Committee.

In the first three weeks the Committee heard 2,203 applications made on behalf of 6,480 dependants. But this was a humiliating ordeal for those with nothing to chew and swallow but pride. One observer wrote:

> It is galling for hungry women to look on and see these merry ladies (the Relief Committee) feeding when they themselves have not the means of buying even a dry crust, and often are sent empty away and have to return to little mites crying out for food they have not the means to buy. Surely it was never the intention of our fellow citizens who have so generously given this money that the wives of their brave defenders should suffer such indignities, and the sooner this money is bulked together and allotted evenly by the Government, the better for the peace of the country.

Bertram Falle endorsed this view and pressed the Government to introduce a state system of separation allowances immediately. It was, he pleaded, a moral issue that should not be the subject of political dogma:

> It is necessary for these men who are probably going to fight during the whole of the long cruel winter in the North Sea, to know that their wives and children at home should be looked after by this great country, and not go through what they are going through now in Portsmouth– absolute starvation – because these women can get no work.

Falle's emotional appeal to the House struck a chord. After all, what were the men fighting for? The moral argument was won and an allowance was granted which proved just sufficient to prevent starvation. Meanwhile, in the corset factories the hum and click of stitching machines began to be heard picking up momentum. The campaign urging consumers to 'carry on' was paying dividends. Some factories diversified into the production of soldiers' haversacks and kitbags. Local tailors were allotted contracts to run up uniforms for the Portsmouth Battalion, while unemployed seamstresses picked up their needles, this time to make shirts for the brave soldiers.

Initial guilt about enjoying oneself at such a time gradually dissolved as people returned to the picture houses and theatres, with a vengeance, at Christmas. It was decreed that 'all young people, aye, and old ones too, must banish care on entering the realm of fun and frolic that is pantomime'. *Babes in the Wood* at the Theatre Royal promised to 'chase away the darkest cloud overlooking one's spirit.' Included was a 'delicious medley', the words of which were published in the *Evening News* with the advice that those who wished to join in the chorus should learn it beforehand:

> Sister Susie's sewing shirts for soldiers,
> Such skill in sewing shirts our shy sister Susie shows;

Some soldiers send epistles, Say they'd rather sleep in thistles,
Than the saucy soft, short shirts for soldiers sister Susie sews.

While virtuous Susie sewed, her fallen sisters sympathised with soldiers and sailors. Portsea's brothels flourished as thousands of servicemen ensured that their last days in Britain, if not on earth, were good ones. Others preferred the charms and attractions of the Young Men's Christian Association, which began to establish itself in purpose-built huts sited in or near barracks and camps. One of the first YMCA huts, erected at Hilsea Barracks, was built, equipped and furnished by public appeal, its aim being to 'influence the men by the provision of wholesome reading matter and healthy recreation during their leisure hours'.

On dark evenings, when a 'Tommy' might be most susceptible to the temptations of Portsmouth nightlife, the YMCA committee pulled out all the stops to ensure that 'a higher tone of morals' was promoted and that their guests were entertained and educated. The wooden huts came to life as vocal recitations, arias and wholesome monologues were delivered by prim ladies who glowed with satisfaction if they elicited a response as extravagant as a tapping foot. The climax of the evening arrived with the hot cocoa and milk.

The bluejacket's equivalent of the YMCA, the Royal Sailors' Rest, run by the indomitable Miss Agnes Weston, had opened its doors in Buckingham Street to allow distressed sailors' wives some respite from the crisis. Limited assistance was provided to wives able to flourish a marriage certificate. The sailor's traditional 'common-law' wife was not recognized by Miss Weston's staunchly Christian regime of temperance, purity of thought and chastity. 'Aggie', as she was affectionately and fearfully known, offered sailors vermin-free bedding and a hearty meal in exchange for their soul, a price that many very willingly paid. The Sailors' Rest was seen as an oasis in a desert of vice.

Miss Weston, too, offered 'clean entertainments' that she personally vetted lest they corrupt her angelic charges and was not averse to physically stopping the show on account of doubtful jokes or lyrics that had escaped her notice at rehearsal. Not surprisingly many anecdotes of dubious origin are connected with her:

She had converted this roughneck of a stoker and after he had done a long trip he went straight round to Aggie's. She greeted him by saying, "Hallo Jack, how are you now?" He said "Absolutely fine – Remember that crowd I used to swear with – gamble with – drink with? ... finished with 'em all ... shower of bastards!"

The reaction of Miss Weston, who had a heart of gold but the countenance of a battleship, went unrecorded, but her patriotic commitment and tireless devotion to the welfare of sailors during the war receive a glowing tribute in her autobiography, *My Life Among the Bluejackets*.

With such a plethora of good and worthy causes it was inevitable that established charities unconnected with the war would suffer a drop in income. The

Royal Portsmouth Hospital, the Eye and Ear Infirmary, the Surgical Aid Society, the Portsmouth Soup Kitchen, Workhouses and the Boot Fund were all affected in this way. Casualties on the Home Front were indirect and unexpected. Commenting on the 'precarious financial position' of the Royal Hospital, William Gates urged a policy of 'municipalisation' which would 'impose upon every inhabitant the payment of his fair share towards the maintenance of the institution'.

Ideas of communal responsibility rather than individual whim were beginning to take root in a small way, with Gates favouring a happy medium. His pet charity, the *Evening News* Boot Fund, had been established several years before the war to provide decent footwear for very poor children of elementary school age, a problem which had been highlighted by deeply concerned teachers. By 1914 the School Medical Officer estimated that nearly 2,000 youngsters in Portsmouth were in urgent need of help. 'To a poor child, shivering with damp feet in the cold and wet,' wrote Gates, 'happiness and comfort are typified by a new pair of sound boots.' Aware that any charity that lacked a patriotic dimension would fail, Gates provided one for a cause in which he passionately believed: 'Remember it is to our sailors and soldiers that you owe the present immunity from danger,' he wrote. 'Now, Jack and Tommy, great-hearted fellows that they are, just dote on children and love to make them happy and comfortable.' No such tenuous associations, however, were found for the Eye and Ear Infirmary, which experienced a drastic drop in subscriptions and fell into debt in the first year of war.

In a similar way the 'deserving' status of the Portsmouth Soup Kitchen dropped as people's priorities were rearranged, though demand increased during the bitter winter of 1914/15, especially among women and children. A queue of the poor and hungry lined the pavement outside the Central Soup Kitchen in St Vincent Street, eagerly awaiting the shot of the bolt and the glorious smell that emanated from the steaming, bubbling coppers within. The doors were pushed open and upon payment of a penny (that had, perhaps, been begged on the street or extracted from a pawnbroker), the starving mother, child, disabled or elderly person received a ticket. Shuffling forwards, this was exchanged for a basin of scalding broth, ladled out by volunteers. Together with a piece of bread, 'the staff of life', this comprised the main if not the only meal of their long, miserable day, consumed quietly in a large spartan hall under the watchful eye of the Superintendent.

The central kitchen had the capacity to make 4,800 pints of soup daily, most of which was served at St Vincent Street, the remainder being sent out to ten smaller branches in church buildings scattered throughout the town, including the Wesleyan church in Queen Street, All Saints' church, St George's Institute (Portsea), and St Stephen's (Buckland). Independently, the Gosport and Alverstoke Soup Kitchen distributed 'good, wholesome soup' on a smaller scale, financed by charitable whist drives.

Ragged, barefoot children aimlessly wandering the streets and hungry crowds congregating outside church halls had been everyday sights in Victorian and Edwardian Portsmouth and were not unique to the war period. Along with the Landport slums, they were an embarrassment to local civic leaders whose

political ideology dictated that they should not interfere. The cramped, back-to-back houses of the notorious Voller Street area were a familiar haunt of off-duty Servicemen and 'two-bob-a-go' prostitutes plying their miserable trade in lodgings where doors hung off their hinges, windows were broken, paper hung off walls, ceilings bulged and floorboards were dangerously rotten. The places 'swarmed with vermin, both large and small'. Hardly a setting for a romantic encounter, the area was one of Portsmouth's uncelebrated visitor attractions.

Unsanitary conditions and overcrowding were problems shared by all working class areas, a fact of which the local coroner was only too well aware. At an inquest on a ten-month-old baby, the son of a sailor living in Cumberland Street, evidence was given that death was due to pneumonia and was 'probably hastened by the absence of pure air through six persons sleeping in the one room'. Malnutrition, too, took its toll. Of every seven babies born in the Borough of Portsmouth, one had died before reaching the age of twelve months.

Chronic distress afflicted many and seemed an immutable feature of haphazard welfare provision based largely on the casual vagaries of charity. And recipients of help were never allowed to forget their place, some feeling keenly the 'taint' of charity. For the very poor, then, it was 'business as usual', though, as we have seen, many unemployed men did find work in the Royal Dockyard and Gunwharf which mitigated some of the effects of the lay-offs in other industries.

Religious faith in the pre-war years had been widespread and deeply held. When war came, the Revd Cyril Garbett, Vicar of Portsea, called the town to prayer and the response was in keeping with the exaltation of the times. Throughout the war churches were well patronised as some worshippers 'lay the needs of the nation before God' and others sought reassurance, comfort and spiritual solace while praying for their loved ones who were fighting and dying.

The Church provided the motivating force and organisational resources for many war-time charities, providing material and spiritual help. In Gosport, the Vicar of St Matthew's, the Revd Tanner, who had organised help for Belgian refugees, set up a recreation room for soldiers' and sailors' wives in the vacant Victoria Hotel. His aim was to provide a 'counter-attraction to the many public houses with which this neighbourhood abounds' where wives could share their fears and problems between 'evangelistic services'. The Portsmouth Mothers' Union, based at St Mary's, offered similar spiritual help at its twenty-four branches where tea was dispensed and members engaged in 'mutual prayer, common counsel and common sympathy'. Church authorities also took advantage of a decision made by Portsmouth Licensing Justices to close the 'Abyssinian Arms' in Marylebone Street and quickly converted the premises into a Christian Social Club, where prayers, companionship and strictly 'non-alcoholic refreshments' were enjoyed. Shortly after its conversion, however, a former patron 'who was slightly inebriated, strolled into the place and wished to make himself comfortable'. His wish was not entertained.

These wives' refuges enjoyed an immense popularity, providing a unique opportunity for the quiet exchange of hopes and fears away from the trading

of patriotic platitudes and state-of-play war banter that characterised everyday conversation. Friendships flourished, especially between wives whose husbands were quite literally 'in the same boat', sharing the same daily dangers in the build-up to the imminent, titanic clash of the fleets. The wives of officers and men, however, were expected to continue to respect and reflect their husbands' differing ranks and so socialising across the divide was taboo. Meanwhile, in thousands of homes, from the cramped terraced slum of Landport to the spacious mansion of Craneswater, thousands of mothers anxiously shared the common experience of waiting. That experience, and the mood of the time, is captured in a poem published in *Punch,* whose serious reflections on the war were becoming more frequent. Entitled 'Portsmouth Bells', it appeared in the spring of 1915.

A lazy sea came washing in
Right through the Harbour mouth,
Where grey and silent, half asleep,
The lords of the oceans keep,
West, East and North and South.
The Summer sun spun cloth and gold
Upon the twinkling sea,
And little t.b.d.'s* lay close,
Stern near to stern and nose to nose,
And slumbered peacefully.
Oh, bells of Portsmouth Town,
Oh, bells of Portsmouth Town,
You rang of peace upon the seas
Before the leaves turned brown.
A greyish sea goes sweeping in
Beyond the boom to-day
The Harbour is a cold, clear space,
For far beyond the Solent's race
The grey-flanked cruisers play.
For it's oh! the long, long night up North
The sullen twilit day.
Where Portsmouth men cruise up and down
And all alone in Portsmouth Town
Are women left to pray.
Oh, bells of Portsmouth Town,
Oh, bells of Portsmouth Town,
What will ye ring when once again
The green leaves turn to brown?
* torpedo boat destroyers

Perhaps it would all be over by the following Christmas. Knitting was resumed, the methodical needles inexorably ticking away the enemy called time.

CHAPTER SIX

Port in a Storm

The Reverend Cyril Garbett awoke before dawn on the cold, damp morning of 22 September 1914. The disruptions and demands of war had prompted the conscientious Vicar of Portsea to begin his working day an hour earlier and it had become his custom to spend that time offering prayers for the thousands of men from his parish who were serving their country in its hour of need. He knew many 'jolly jacks' personally, having been a frequent visitor to parishioners' homes as part of his pastoral duties.

Gathering up a candle and a box of matches he shut the door on his vicarage and hurried across a deserted Fratton Road to St Mary's, its pitch black silhouette dominating the blue-grey sky. Garbett refused to light or heat the church on grounds of war economy, a characteristically frugal measure that complemented his generous spiritual nature. He knelt in his personal stall, illuminated by the one, single candle, his head solemnly bowed. He commenced his silent prayers at 6.30 a.m., just as dawn was breaking.

Three-hundred miles away, off the Dutch coast, U-boat Captain Otto von Wettigen peered intently through his submarine periscope. He had observed three British armoured cruisers steaming off the Hook of Holland, their unmistakable silhouettes set against the red dawn sky. At precisely 6.30 a.m. he carefully aimed and fired a torpedo at the middle one, HMS *Aboukir*, and watched the unsuspecting vessel with bated breath. There was a fountain of water, a burst of smoke, a flash of fire, and a tremendous explosion. She sank within minutes. Within the next hour von Wettigen sent five more torpedoes towards the remaining cruisers. The first hit HMS *Hogue*, which 'lay wounded and helpless on the surface before she heaved, half turned over and then sank'.

HMS *Cressy* tried to zigzag to safety but was hit twice and sank with a loud noise 'as if from a creature in pain'. The surface of the sea was alive with two thousand men swimming for their lives. A survivor described the scene:

> Strong swimmers were dragged under in the frenzied clutches of weak swimmers or men who could not swim at all. The cries for help were loud and full throated at first, but they gradually subsided into a low wailing chant and fell like surf on a distant shore.

At 7.30 a.m. the Revd Cyril Garbett extinguished the candle and emerged from his church into bright daylight to begin his pastoral duties. In the hour that he had been at prayer 1,459 British sailors had died in one of the most dreadful feats of destruction ever achieved by a submarine.

Hundreds of local families were plunged into mourning. To a population brought up to believe in the invincibility of the Royal Navy, the news was met with horror and incomprehension. Few people had recognised the destructive potential of the submarine. Winston Churchill remarked that the precipitation of death on such a scale by the motion of one man's finger was 'an episode of a peculiar character in human history'. A delighted Kaiser recognised this fact and awarded the Iron Cross (First Class) to von Wettigen amid national celebrations. Meanwhile, in the corner of a Portsmouth newspaper there appeared a small, dignified, poignant appeal: 'To survivors of the *Aboukir* – if anyone saw the last of Reggie Day, canteen assistant, would they kindly communicate with his sad sorrowing parents. They would be extremely grateful. 10 Vernon Road, Copnor.'

Two months later HMS *Dreadnought* encountered von Wettigen's U-boat off the coast of Scotland. The mighty stern, which had failed to break its christening bottle at Portsmouth Dockyard, rammed the submarine with such force that it was sliced in two. Von Wettigen and his entire crew perished.

The grainy, flickering black, grey and white image of Horatio Nelson mouthed silent orders to open fire. The cannon of HMS *Victory* boomed audibly while the pianist improvised thumping chords to accompany the rapid puffs of smoke that spat out from the gun deck. Simple captions with illuminated borders broke up the battle action. Admiral Nelson stood on the quarterdeck proud, determined and resplendent in full dress uniform. But the pianist warned of a French sniper perched on the mizzen top of an enemy ship. A silent white cloud from the musket and the deed was done. The mortally wounded hero was carried below to heart-rending melodies plucked from the pianist's wide repertoire. The death scene was painless and clean, interspersed by patriotic homilies that fell silently from Nelson's lips. It cost tuppence for the cheapest seat in Arundel Street Picture House in Portsmouth to experience the drama of battle and lingering pathos of the modest epic *The Battle of Trafalgar*.

It was a typically patriotic film of the type that was coming into its own in these stirring times and had been taken off the shelf in late October 1914, to coincide with Trafalgar Day, the annual remembrance of Nelson's victory over the French. On Monday 1 November, while the first house sat reliving this past, glorious victory, the Portsmouth-based HMS *Good Hope* was attacked by a German heavy cruiser in stormy seas off Chile. There was a terrible explosion, her funnels were blown into the air and flames rose to a height of 200 feet. A moment later the black hull turned and was gone, taking with it the entire crew of 900 men. The victor in this encounter was none other than the *Scharnhorst*, the ship which had accompanied the Kaiser on his visit to Portsmouth seven years earlier. German sailors who had heroically helped put out a serious blaze in the dockyard were now awarded Iron Crosses by a jubilant Kaiser, reported to be 'in seventh heaven'.

The news of the appalling loss of life took several days to reach anxious relatives in Portsmouth, alerted by contradictory reports in the press. 'Is the Good Hope Undamaged?' speculated the *Evening News,* while an uncomfortable admiralty official pondered on how best to present the information that he had been sitting on for days. When the worst was eventually conceded, the mothers and fathers and widows and orphans began their grief, holding on to their last cherished memory of their loved ones lined up on deck as they waved them off in August. They had worn straw hats while a Salvation Army Band on Gosport Hard had played 'Nearer My God To Thee'.

It is not known what music the band on board HMS *Bulwark* was playing at 7.53 a.m. on 26 November, three weeks after the loss of the *Good Hope.* Breakfast was in progress while the band played that unknown tune when an accident in the cordite store caused an almighty explosion which simply 'rent the ship asunder'. Out of a ship's company of 800 men only twelve survived, the vast majority of the dead coming from Portsmouth and Gosport, including many marines from Forton Barracks.

At the subsequent coroner's inquest a nightmarish catalogue of burnt, headless and disfigured bodies presented problems with identification, which were partially overcome by the examination of what remained of victims' tattoos. Normally such grim detail of death in war was shunned by the press, but in this instance *Bulwark* had sunk in home waters, and individual members of the crew were subjected to a public inquest. It took little imagination to apply the ghastly descriptions of mutilated corpses that emerged to all the other men who were losing their lives at sea, but whose mourning relatives were comforted by the news that they had simply 'gone down' or had been 'lost'. But for the relatives of the crew of the *Bulwark*, there was to be no such solace. In later years they were to find this tragic episode absent from accounts of the war, the loss of the ship an official embarrassment because it sank by accident rather than as a result of enemy action.

On 2 June 1916, Mrs Stalkarrt of Victoria Road South at Southsea, cast-off and put down her crochet hook, surveying with warm pride the elaborate and decorative thirteen feet of crochet border that had taken her twenty-eight days to complete. The evening outside was cool and unsettled.

At 6.58 p.m. a warning tick from the telegraph receiver in the *Evening News* offices in Stanhope Road gave notice that a message was imminent. There was nothing unusual in this; as a means of distributing officially sanctioned information from the War Office and Admiralty, the telegraph system had come into its own. But, on this occasion, 'a momentary hush of expectancy' preceded receipt of this message, flashed from London: 'Great Battle in North Sea'.

Any initial rejoicing that the long-awaited day of naval reckoning had arrived was quickly scotched as an unusually frank admiralty despatch revealed terrible loss of British lives and ships in a battle off the Danish coast. When the Jutland fog and the smoke of guns had cleared, all that remained was a black, oily sea, its surface broken by a flotsam of dead fish, dead men and charred, empty hulks.

News of what was to become known as the Battle of Jutland spread out on to the streets in a matter of minutes while newspaper typesetters began preparing a special war edition. When the dreadful, but, for once, reliable, rumours were confirmed, women broke down weeping in the streets before being helped into their homes. In Commercial Road two women fainted after reading of the extent of the losses in a newspaper bought from a vendor, while men assembled in small groups on street corners gravely discussing the dreadful toll. Seemingly endless casualty lists were posted outside the town hall in Portsmouth and Thorngate Hall at Gosport, while onlookers shook their heads silently. There were few streets where at least one household had not received a telegram – in some there were four or five, conspicuous by drawn curtains and pulled blinds.

Doris Loving, a schoolgirl, whose father managed a butcher's shop in Twyford Avenue, looked out of the window one day to see a telegraph boy knocking on the door of the house opposite. 'The lady opened the door and immediately fainted at the sight of the dreaded yellow envelope.'

In his account of that tragic time, George Henry Dunbar remembered that many of his school friends at Penhale Road lost their fathers. One weeping boy was consoled by the teacher and sent home to comfort his mother. There were 6,097 yellow envelopes delivered by post office boys over the next few days containing the standard, terse message 'Deeply regret to inform you that ---- was killed in action'. Some mothers received several telegrams at once, with sons and fathers serving and dying together in the same ship. All that remained were photographs on the mantelpiece and memories.

A scan of the Roll of Honour, an impacted mass of small print running to several pages in the *Evening News*, tells the tragic human story:

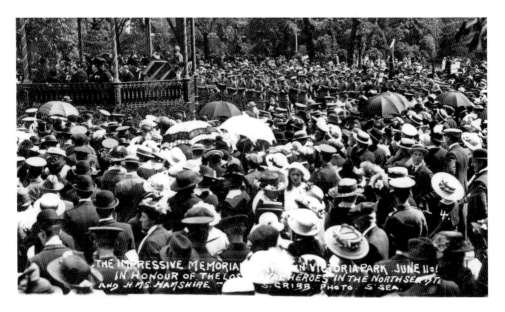

Battle of Jutland and HMS *Hampshire* memorial service in Victoria Park, 1916.

CHAMPION – On 31st May 1916 Henry C. Champion R. M. A., HMS *Invincible*. From his sorrowing wife and babies. 15, Asylum Road, Milton.
FROOME Harold, gunner R. M. A. Killed in action May 31st, HMS *Lion*. From his devoted sweetheart, Emma. 55 Station Street. Until we meet again.
HAYES – In ever loving memory of our darling dad who lost his life on HMS *Fortune*, May 31st, 1916. With love, Herbert, Grace, Gladys and Billy. He died a hero. Thy will be done.
TAWNEY Cyril, aged 15, killed in action on HMS *Black Prince*. Bugler boy. One of the best.

Cyril was not only 'one of the best', but one of the youngest local sailors to die, aged fifteen. In the trenches, one of the youngest soldiers to be killed was Ernest Lancaster from Southsea, who enlisted as a private in the Hampshire Regiment and was promoted to Second Lieutenant at the age of sixteen after being recommended for a commission by a retired colonel who was a family friend. Ernest later served in the Dorsetshire Regiment and then the Machine Gun Corps. He died in the Battle of the Somme at the age of seventeen.

One week after Jutland, Mr Stephen Cribb, the Southsea photographer, captured a grim-faced Lord Kitchener as he was about to embark on a mission to Russia aboard HMS *Hampshire*. The Portsmouth- manned ship had survived Jutland unscathed. Three hours later she struck a mine off the Orkneys in heavy seas. Lord Kitchener and all but twelve of a crew of 655 men drowned or died of exposure. While a shocked nation mourned the loss of an adored hero and symbol of Empire, a local population grieved over the loss of the anonymous crew. By now there was 'scarcely a family that does not mourn the loss of husband, son, brother or friend' according to the *Evening News*. 'But,' its editor William Gates observed, 'in human sympathy there is great comfort.'

The sense of community and the support of neighbours and friends were no stronger than in working class areas, though for many bereaved families the loss was exacerbated by financial worries. Extra volunteers were taken on by the Relief Committee at the town hall to help meet the immediate demands of sudden widowhood. Their records show how some of the bereaved were able to be helped, all examples here being from the Milton area:

Mrs C. – Ill from shock, special allowance for medicine and nourishing food.
Mrs H. – In distress as she could not afford to continue special arrangements for the education of delicate child. Fees paid.
Mrs M. – Previous delicacy greatly increased by shock, help over several months given for medical expenses and nourishing food.
Mrs P. – Had had high ambitions for clever boy, help given to continue advanced education.
Mrs B. – Six children. Children ill with infectious diseases, help given during illness.
Mrs R. – Delicacy increased by shock, paralysed child, nourishing food and medical expenses given. Spinal chair for child to be given.

Mrs B. – Posthumous child arrived in winter. Help with expenses of confinement and for nourishing food before and after baby's birth.

Perceptions of the nature and meaning of the war were inevitably changing as romantic notions vied with the reality of personal experience. The arrival of thousands of wounded soldiers from Kitchener's decimated army spoiled the illusions of many. On the Western Front the casualty rate was of such a terrible magnitude that losses at sea were a tragic but inconspicuous drop in the ocean. The traffic of hospital ships crossing the Channel was outnumbered only by the number of troopships delivering their human cargo to the trenches. Once there the common hope was of receiving a 'blighty wound' of a degree that was not too serious but that warranted a return ticket on the hospital ship back to 'dear old blighty'.

One of the largest centres for the reception of the wounded was established at Southampton, where batches of 'lucky blighters' were dispersed by rail to civil and military hospitals throughout the South. The 5th Southern General Hospital was an umbrella term to cover hospitals in the Portsmouth and Gosport area which had been placed under military control on the outbreak of war. Under the command of Dr. John Kyffin, of Gosport, it originally comprised the Alexandra Military Hospital at Cosham (Q.A.), the infirmary at Milton (St Mary's) and the converted girls' secondary school in Fawcett Road. As we have seen, Francis Avenue School reverted to its original function, such was the climate of optimism in 1914.

But as casualties mounted the 5th Southern was augmented by premises provided by prospering local businessmen. Oatlands in Kingston Crescent, Brankesmere in Queen's Crescent, and Brookfield House in Alverstoke became convalescent homes run by St John Ambulance Brigades and the Red Cross. The National Children's Home in Gosport was also commandeered, and run by members of the Alverstoke Women's Nursing Voluntary Aid Detachment (VAD). Appeals were made for blankets, sheets, towels, bedsteads and clinical thermometers as the need arose. In addition, the Royal Naval Hospital at Haslar was provided with supplementary facilities on Whale Island, in Flathouse Road and at the Brodrick Hall in Clayhall Road.

The 5th Southern expanded as more and yet more blinded and limbless men were deposited on platform 2 of Fratton railway station to await transport by borough police ambulance to Fawcett Road. Meanwhile the walking wounded were met with cheers from onlookers lining the pavements of Goldsmith Avenue and Fratton Bridge. But while the returning hero with his arm in a sling was a publicly acceptable image of war, the scenes of men, hardly recognisable as such, being lifted from ambulance to hospital, were to prove profoundly shocking for those who witnessed this routine but unvaunted traffic:

Someone said in the crowd, 'Let's give 'em a
cheer!' But when we saw, there was a groan.
oh my ...

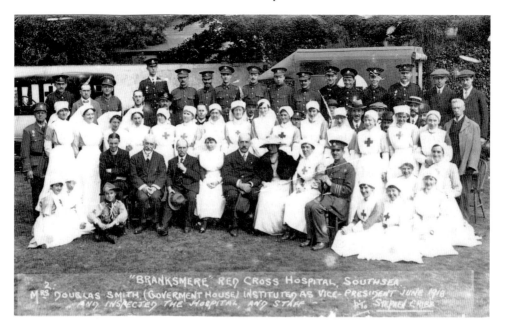

The staff at Brankesmere Red Cross Hospital, 1918.

War casualties arriving at Fawcett Road military hospital.

The horrors of war were brought closer to home to a population whose impressions of battle had been gleaned from impersonal 'eye witness' newspaper accounts and reconstructed official war news footage viewed at the local picture house. For twelve-year-old George Dunbar, the sight of the 'bloodied effluent from the carriages' stayed with him for the rest of his life. The 'Great Game' was becoming less remote, less glamorous and less of a game.

On arrival at Fawcett Road, the wounded and dying were carried past the khaki-clad janitor on guard at the outer gate and through glass-panelled folding doors into the main ward, a large draughty room which had served as the school hall but was now occupied by hospital beds, neatly arranged in four rows. Around the walls, twenty feet above, a balcony provided space where visitors and convalescents could promenade before retiring to the recreation room for a smoke. As the war continued, the space between beds steadily diminished while the number of converted classrooms multiplied. By 1916 the initial provision of 500 beds had been doubled.

The arrival of the first wounded German prisoners of war provoked curiosity and excitement, though an *Evening News* reporter expressed disappointment that they did not appear at all fearsome or terrifying, noting that 'they wore peaked caps, not the spiked helmet which one usually associates with the German soldier'. Their sheep's clothing, it later emerged, was no disguise. The nurse assigned to their closely guarded quarters in a remote part of the school revealed that 'they gave no trouble, are very grateful, and glad to be where they are'.

Large crowds regularly congregated outside the hospital, causing disruption to local traffic. A petition signed by local tradesmen was handed to the Chief Constable, complaining that their premises were obscured 'by the very great crowds of people who gather every evening for a number of hours gazing at the hospital'. The long wait was made worthwhile by a friendly wave from a window – though it did not matter precisely who it was acknowledging their presence. Piles of books, magazines, linen and cigarette cartons were delivered to the door by generous townsfolk, while the Southsea Horticultural Society sent in all their carefully nurtured fruits and vegetables after having measured them first. One woman contributed a large box of eggs with a note attached explaining that they had been 'laid by my own chicken with deep sympathy'. Complaints about the noise of traffic trundling past on the granite cobbles disturbing the patients were silenced by the simple expedient of cork matting, giant rolls of which were donated by a local firm. This did not, however, prevent one soldier from jumping out of his ward window to his death on the street far below.

While the physically wounded hero could be assured of a hearty welcome, his less fortunate severely shell-shocked brother was deemed a 'lunatic soldier' and quietly hidden away in the Borough Lunatic Asylum at Milton (now St James's Hospital). The Asylum Guardians protested, arguing that it was 'very undesirable that men whose mental faculties had become deranged while serving the country should be classified as pauper lunatics'.

Fawcett Road School was not the largest branch of the 5th Southern but the novelty of its new role and its conspicuous presence in a busy residential area and commercial thoroughfare tended to attract public and press attention that

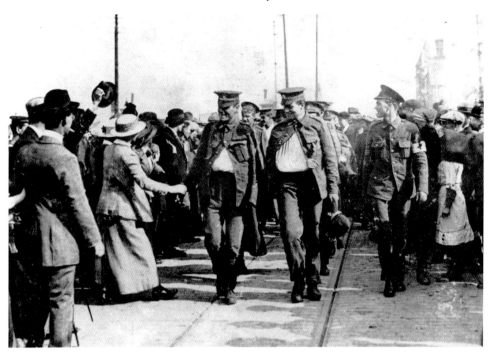

Reception of the walking wounded in Goldsmith Avenue in October, 1914. Bugler Clark of the Dorset Regiment (right) carries a German helmet as a trophy.

Wounded soldiers take the air with the help of members of the Portsmouth Town Guard. The *News* set up an appeal for bath chairs for the wounded.

other hospitals did not. Large groups of war-wounded were regularly detrained at Cosham for transfer to Alexandra Hospital, while in Gosport thousands more were transferred from the railway station into the Clarence Victualling Yard to await carriage by steam launch to Haslar. This busy traffic supplemented another, more direct service provided by a fleet of converted London omnibuses which made 'continuous trips that seemed to last all day'. By 1916 the volume of this grim traffic was such that proposals were made for the construction of a hospital railway service on the outskirts of Gosport which would enable delivery of the wounded and dying directly into Haslar hospital grounds. This, it was reasoned, would alleviate the discomfort caused by their travelling through the densely-populated town centre.

The first of the fatally wounded to die in local hospitals were announced in the press and received individual tribute before their polished coffins, garlanded with wreaths, were transported to the bereaved family in some distant village or home town. With an admirable even-handedness the first German to die of his wounds at Fawcett Road was buried with full military honours in Highland Road Cemetery. But within a few months this chivalry and respect for the enemy had ended; atrocity stories and mounting British casualties had forced a reappraisal. Fred Jane typified this new realism in his column in the *Hampshire Telegraph*:

> If we are going to win this war, we shall do it only by the skin of our teeth, and only by killing Germans as we would kill vermin ... We must chuck all blithering ideas about humanity. The time has certainly come when we should drop all old-fashioned ideas about 'the rules of the game' and so on. Instead we should realise that we are

The Borough Lunatic Asylum at Milton where shell-shocked servicemen were sent.

up against pestilential vermin for whom no trick is too low. And vermin should be treated as vermin, whether at sea or on land. It is up to us to remember that the life of one Briton worth that of several scores of Germans.

On the Western Front, General Sir Douglas Haig displayed little of Jane's enthusiasm for differentiating between the respective values of British and German lives. His promotion to Commander-in-Chief coincided with the arrival in France of the 1st Portsmouth Battalion (known as the 14th Battalion of the Hampshire Regiment), fully trained and eager to 'do their bit' in the trenches. Haig gave them their opportunity in the Somme where they were used in a 'diversionary operation', namely, attempting to take a German position regarded as impregnable. At dawn the whistles blew and they went 'over the top' in three waves, being met immediately by what one eye witness described as 'the fiercest kind of resistance ...the Huns put up a perfectly murderous fire with machine guns ... and his creeping barrage was murderous'. The first line faltered and fell, then the second, then the third. The dead and dying lay scattered in no man's land like beasts in a sordid, medieval shambles. Survivors rescued as many of their comrades as they could and crawled back to their trench which, in the meantime, had been heavily bombarded, with further loss of life.

On the first day of the Somme offensive, 1 July 1916, the British Army sustained 60,000 casualties, the equivalent of the combined wartime populations of Fratton, Buckland, and North End. By November, after twenty terrible weeks of fighting, the number of corpses rotting in the Somme mud far exceeded half a million. As one observer put it:

> The very multitude of names killed, wounded or missing does something to blunt the sharpness of sympathy. Death on the battlefield has become so much a matter of course as to deprive it of some of its terrors.

The War Office was anxious to deprive the battlefield of its terrors but at the same time wanted to suggest something of the ordeal faced by 'Tommy'. It was decided to release selected footage of films taken during the Somme battle for public consumption. This, it figured, would go some way to explain the appalling scale of death without adversely affecting morale. The result reached the picture house in Commercial Road in September 1916, while the real, uncensored battle continued just 200 miles away. The film was recommended by a local newspaper for its 'vividness' and, even though all scenes of pain, horror and death were absent, it was remarkable for its day, revealing something of the conditions in which the war was being fought. Now the pianist improvised to real life scenes of men going over the top. The reality, however, was neither sanitised nor accompanied by a civilised melody.

At the Front a Pompey bobby put pen to paper. Constable B. W. Rogers was one of several local policemen serving 'somewhere in France'. He was writing home after a sixteen-day stint in the trenches. 'The people of England,' he recorded with simple stoicism, 'cannot imagine one atom what this war is like'.

CHAPTER SEVEN

Voices of War

The voices of war that make up this chapter have been extracted from letters, diaries and accounts of men – and one woman – who were on active service and lived in, or had some connection with, the Portsmouth area. In common with all similar compilations, voices of articulate junior officers are over-represented. The rank and file were often badly educated and, in the main, only functionally literate; their experiences have, alas, gone largely unrecorded.

The voices that can be heard speak unconsciously of resilience, fortitude and great courage in the face of appalling conditions and horrific experiences. Few, however, had the will to convey directly the reality of suffering or carnage. One soldier explained, 'everyone out here considers it only fair to one's womankind to hush up the worst side of the war.' This 'worst side' was often hidden behind a simple, cheery, good humour that bound men together, maintained their morale and helped negate the day-to-day dangers and horrors of their common struggle. 'The trenches are really quite comfortable,' revealed one soldier, 'except for the mud and the people who live opposite'.

Diary entry on 27 July 1914, one week before the declaration of war by Lt Commander Cecil Talbot of Submarine *E6*:

> Summer leave was to have started in the evening, but in the afternoon it was cancelled owing to the strained international situation. I tried to get torpedoes and warheads into the boats, but no one in authority seemed to think things were serious.

Letter from an anonymous Royal Marine Sergeant, sent from Gosport on the day war was declared:

> My Dear Nell, We arrived here at twelve-thirty midnight. All the stations along the line were crowded with soldiers, sailors and marines on the active list, and pensioners and reserves joining their divisions. Also, crowds of civilians leaving the different seaside resorts to go back to their homes, and foreigners going back to their countries. Sometimes it was quite funny to see some of the old pensioners hurry back dressed in all sorts of clothes, half uniform and half civilian clothes on. One marine

at the Union Jack Club was sitting down to his tea with all uniform on and a bowler hat on his head!

Extract of letter sent by W. R. Davies, RN, a former pupil of Portsmouth Grammar School, serving on HMS *Invincible* in the Dardanelles, dated March 1915:

It is indeed a fine sight to see us bombarding, when we shell the forts at a range of about 5,000 yards. There is a terrific concussion as the gun is fired – a pause – and then an answering explosion on shore as the shell bursts. The burst is accompanied by dense clouds of brown fumes, and masses of earth and brickwork are shot into the air. When the enemy gunners have been killed and the forts silenced, demolition parties are landed, and the guns totally destroyed, with guncotton. Only a day or so ago we were shelling a fort, and in the town behind it the enemy had lodged themselves. The demolition party met with stubborn resistance on landing, and the town was shelled in consequence. In a very short time, all that remained was a heap of blazing ruins, forming a very fine sight at night time. Naturally in our operations we have not gone unchallenged. The mountainous shores offer unique facilities for the concealment of hostile batteries, and we have had several narrow escapes from heavy howitzer shell, but we have not been actually hit. In this respect I consider we have been exceptionally lucky, and can only attribute our escape to the poor shooting of the enemy.

A few days later William Davies was killed.

Lt. Commander Norman Holbrook, a former pupil of Portsmouth Grammar School, became a local and national hero in December 1914, when he dived his submarine *B11* under the minefields of the Dardanelles and sank a Turkish cruiser. He was awarded the Victoria Cross for his bravery. This is an extract from a letter sent to his sister, a Mrs Nicholson of 53 Saxe-Weimar Road (soon to be renamed Waverley Road) Southsea, written two weeks before his daring exploit:

Thank heaven for its mercies that I have last got a day in and a little food and warmth. I've just had a shocking week of it. The weather has been awful. For eight days we have been at it hammer and tongs ... Our food for the last four days has been ship's biscuit soaked in tea and some chocolate which I had been sent me. You can imagine my joy to arrive in harbour and get a night's rest and some food.

Extract from a letter written by J. H. Bishop, a Portsmouth policeman serving as a Royal Marine in the Dardanelles dated 19 May 1915. The letter was sent two months after his ship HMS *Ocean* had been sunk by a mine:

It was terrible out there. I hardly know which is the worst; on ship or land. It was bad enough on my old ship, but it has been absolute slaughter on shore ... We have got a great obstacle in front of us – a very high hill. It is heavily entrenched and well fortified with guns. It is going to be a great struggle to capture, and the lucky ones

who come out safe and sound will deserve a well-earned rest. I am very sorry to say that since last writing we have lost another vessel – the Goliath. Several of her marines were transferred from the Ocean and they were local men who left Eastney Barracks with me. Whether any of them were saved I cannot say, but I am afraid they were not from what I have heard. While I and two others were retiring to a base-hospital we were fired on my machine gun They try very hard to hit and kill the wounded and I can tell you I saw some terrible sights. They do not take prisoners. They get rid of them somehow.

The poet Rupert Brooke is probably best remembered as the author of the sonnet series *1914*, which includes those memorable lines that characterised the idealism of his age: 'If I should die, think only this of me, that there's some corner of a foreign field, that is forever England.' Like so many of his peers, Brooke joined up immediately when war was declared. He obtained a commission in the Royal Naval Division and, within a few weeks and completely untrained, he took part in the brief and abortive Antwerp expedition. On his return he was sent to Portsmouth as acting Adjutant of the Nelson Battalion, a position he held for two weeks before being transferred. In a letter written from the RN Barracks, Brooke congratulates Rosalind Murray (Mrs Arnold Toynbee) on the birth of her son and describes his feelings during Antwerp. The letter is dated 20 November 1914:

What shall I tell you about it? I tried to notice the points of literary and psychological interest at the time. But actually I was thinking "When will the men – and when shall I – get our next meal?"

When they told us at Dunkirk that we were all going to be killed in Antwerp, if not on the way there, I didn't think (much as I'd expected) what a damned fool I was not to have written more and done various things better and been less selfish. I merely thought, "What hell it is that I shan't have any children – any sons." I thought it over and over, quite furious for some hours. And we were barely even under fire, in the end!

I hope I'll get through. I'll have such a lot to say and do afterwards. Just now I'm rather miserable: because most of my school friends are wounded, or "wounded and missing" or dead. Perhaps our sons will live the better for it.

In another letter Brooke describes how he passed his time in barracks:

My face is burning, I've been on the range with Maxims, for four hours, in a wind far more unkind than human ingratitude. That never made my blush so – not even my own. I wish you could come and cool my cheeks. We're "standing by." Do you know what that means? Nobody has leave, I can't go, tomorrow, to lunch with people a few miles away. For at any time we may be called to ... Norfolk, to repel the Germans. They're expected hourly. My best school friend was 'wounded and missing' yesterday ... A 100 years hence they'll say "What an age that must have been! What'll we care? Fools!"

Brooke's concern that 'our sons' should benefit from the sacrifices of war, together with the deeply felt loss of life-long friends, found expression in the third and fourth sonnets of the *1914* series that he was working on while at Portsmouth. They were entitled 'The Dead'. Brooke died five months later on his way to Gallipoli and is buried on a Greek island.

Arthur Ferrett joined the Navy in 1912 and was involved in many of the most famous actions of the war including the battles of Heligoland and Jutland:

> I can see it now, when the battle cruiser *Indefatigable* went up – a terrible explosion – and there was one of her picket boats hurtling through the air, up in the sky. When we passed through it was as if a dust cart had emptied its contents on the surface of the sea. Only two men were picked up out of a crew of over 1,000.

Arthur Ferrett died in 1991.

Reported account by a surviving marine who took part in the famous Zeebrugge Raid of April, 1918:

> I volunteered for this particular job because I lost two brothers at the Front in six months and I wanted to get my own back ... but I don't want to go through that lot again. It was hell while it lasted. As we steamed into [Zeebrugge] harbour the place was suddenly lit up with star shells. Then the fun started. Ahead of us we saw a large German destroyer, evidently in the act of getting under way. We rushed at her full speed and rammed her and cut her clean in half. She sank and we passed over her. We then sheered alongside the mole, and as silently as we could we "out gangways" and got onto the mole ... On the other side lay another German destroyer. This vessel we destroyed and we knocked on the head all the men who opposed us. We then received the order to charge and we rushed along the mole to the shore. We bayoneted and shot all the men we came across. The noise of the firing mingled with the shouts and cries of men was terrible. It was fair slaughter.

Another survivor, based at Eastney Barracks, wrote to some relatives to let them know he was safe. The letter, dated 26 April 1918, is signed 'Bill':

> Just a few lines to let you know that I arrived back safely after boarding the Zeebrugge mole, there is only half of us left of Pompey Company and most of them are wounded. How I escaped God only knows for the first shell that hit the *Vindictive* which our company was on killed dozens, and set them all aflame. All the lads around were blown to bits, and I was flung between her funnels. My tin hat was shattered and so was my rifle, but I soon found some more. We then had the order "Steady, Pompey Company." We were just going alongside the mole, our section was the first to land what there was left of us, and we were very lucky too, for no sooner were we on top of the wall than the German machine gunners had the range and were playing hell with us. Then their heavy guns fired point-blank into us, but we still advanced and soon silenced them. It seems so strange in the room here now, only five of us left out of twenty-three, and only me and the Corporal without a scratch.

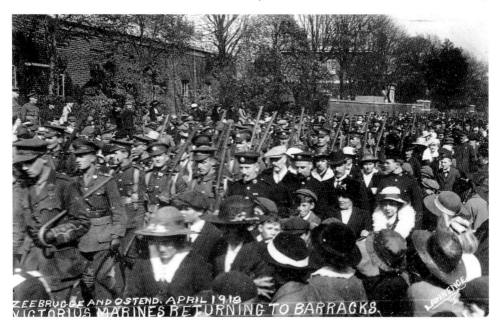

ZEEBRUGGE AND OSTEND. APRIL 1918
VICTORIOUS MARINES RETURNING TO BARRACKS.

Survivors of the Zeebrugge raid return to Forton Barracks in Gosport.

Diary entry made by Corporal Albert Saunders, RMA, of Portsmouth, describing the scene on board HMS *Princess Royal* during the battle of Jutland, 31 May–1 June 1916:

> Below decks the sight was awful – just gaping holes, decks flooded with water, dead and wounded everywhere and an awful smell where the shells had burst. It was a never-to-be-forgotten sight and one that one never wishes to see again. As you walked round you heard of familiar names that had paid the supreme penalty. You looked down at a burnt, battered mess of what was a few hours previously a splendid specimen of British manhood, and now you could only tell who it was by a label tied on the coat. The remains of some were awful.

Albert Saunders survived the war and died in Portsmouth in 1971.

Extract from an account of the Battle of Jutland by Percy Blanch, who served as a writer in the Navy:

> I saw several ships go up but you didn't know whether they were ours or whether they were Germans. We got our packet at night time. One salvo made us like a pepper pot – we lost just a third of our seamen. It washed out the searchlight crews – I feel sure we made a bloomer there. We switched on the searchlights and they were ready for us. As soon as they went on – bang! – they put out every searchlight in the ship. My little messenger boy was there. I'd give some people medals as big as frying pans. He had both legs off and didn't know it. The decks were all running with water, open-ended fire-pumps were going and he laid on the deck. I went along

and in the light of the fires that were burning on the upper deck – we had cordite fires on the upper deck and fire parties attending to them – by the light of that I could see my little messenger fellow. He was a member of the searchlight's crew and had had both legs shot off and had fallen from the searchlight platform onto the deck.

"Hello Chief"

"What are you doing down there?" I looked and I saw he had no legs. "Come here. Let me have a look at you."

I had a hypodermic syringe and I took my jacket off, rolled it up and put in under his head. I cut his sleeve with a penknife and gave him a good pump of this cocaine stuff, whatever it was, and said. "Right ho! Now lay there quietly. They'll come and pick you up presently."

"My foot hurts!"

"That's all right. I'll send somebody up to look after you.

He sat up then, and he looked and he saw that he had no legs at all. We had no safety chains on so he rolled himself over and over until he rolled himself over the side. I can't tell you what I felt about that.

Percy Blanch survived the war and later became Mayor of Gosport (1957–1959). He died in 1978.

Undated postcard message, written by Charlie Frankham of the Royal Warwickshire Regiment, stationed at Albany Barracks, Newport, Isle of Wight to his sister, Miss Dolly Frankham, of 24 Malins Road, Mile End, Portsmouth:

Just a line hoping you and your mother and father are still quite well. Had ten teeth out last week and got to have some more out on Wednesday so I don't feel very grand. Plenty of soup for dinner...We have had plenty of drill up to now, forming fours and right and left turn and with rifle and bayonet they get you trained in about ten weeks for the Front. Charlie. Xxxxxxxxxxxxxxxxxx.

Extract of letter written by Bombardier Reed, writing to his parents in Shadwell Road, North End, Portsmouth, dated November 1914:

Everything in the parcel is just grand. The jersey I did not expect, but it makes a vast difference at night as the weather is very cold. I wrapped myself well up in the muffler and with my jersey and greatcoat on I was like a piece of toast on guard.

The shortbread was lovely: it was the real thing. I can tell you we fancied ourselves eating chocolate and shortbread with our late tea. It was like home again...We have milk in our tea now. The cows are roaming about near our guns and so we get hold of one and milk it. I am becoming quite an efficient dairymaid. We are living quite high. I found a pig which had been killed by shrapnel. I cut off its two forelegs – someone had been before me with the hind – and we have been living on pork for a couple of days. It was grand. We have had two positions and have sent over to the Germans plenty of Beechams*. We saw an aeroplane brought down yesterday, and we heard

rumours this morning that 300 Germans had been captured by our infantry. So far everything is smiling, and we shall soon have them in Germany, and let them have a taste of things in their own country.

*Beechams pills: colloquial term for shells or bombs.

Extract of letter written by the Revd E. F. Edge Partington, a colleague of the Vicar of Portsea, Revd Cyril Garbett, who left Portsmouth to serve as an Army chaplain at the front. Dated 18 August 1915:

We reached our destination early in the evening and now for the first time we began to learn the real meaning of war. The town has been badly shelled, a town not much smaller than Portsmouth, and is still shelled a little daily, and as we arrived an aeroplane was being shelled just over our heads.

Here we are situated about one-and-a-half miles behind the trenches, and at present our work consists in marching up in shifts to within a few hundred yards of the first line trenches to dig supports to the reserve line. Parties are at work day and night. The first night I went up to look on and lend a hand. I remember that march up; I think we all possessed that feeling of uncertainty which encourages extreme alertness, makes it easy to be quiet, and helps you to question every sound.

We arrived safely at the appointed spot, although we had to cross some open ground which might have been dangerous. We found designs of trenches which the Engineers had mapped out and which it was hard to see in the dark, and still harder to dig, for no lights were allowed. These we set to work on; I lent a hand now and again with pick and shovel. It is in this sort of situation that it is easier to work than to idle; it stops you from thinking.

It was now that we experienced for the first time what it felt like to be under fire. I had been digging and was standing up on some raised ground with my sleeves rolled up, sweating a bit for the moment forgetful of where I was, when suddenly somewhere in front a shot rang out. It seemed quite close, and a bullet whizzed past my head. I don't think I have ever moved quicker than I did then. Curiously enough my first desire was to get properly dressed; to be shot at in my shirt sleeves seemed improper. I also must confess for a bit I had a very queer feeling inside. Bullets came over in intervals, but they were too high and too few to do any harm. The effect they had on us was to make us work harder I think, in order that we might get deeper into the ground. The next day I had to bury our first casualty.

Extract from letter sent by George A. Curtis of Portsmouth serving with the Hampshire Regiment at the Front, dated March 1915:

I am sitting down in the trench to write to thank you for the cigarettes which I can give you my word I enjoyed because they were Woodbines. We get plenty of smokes but not many Woodbines, which are the smokes soldiers and sailors like best. There is plenty of fun here, what with ounces of lead and "Jack Johnsons" and "Little Willies" flying about, nearly putting us to sleep. But still we all keep a brave head in

this Regiment, and I can tell you that we have done some fine work, and never get mentioned in the papers. Even now as I am writing this letter the shells are flying over our head.

Private Curtis was later killed in action.

Extract from an interview given by Frank Stringfellow or 'Stringie', a popular local footballer who played inside-right for Pompey before the war. At 5 feet 5 inches tall, he was one of the shortest players ever to play for Pompey. 'Stringie' served in the Machine Gun Corps in France:

> We went over, about twenty-eight strong, at daybreak we had to approach through a ravine, and made our way in the face of a veritable hail of machine-gun fire, with which Jerry was sweeping the ravine. We took what shelter we could as we progressed in convenient shell holes but we got awfully cut up. We lost our officer, two sergeants and twenty-three men, with the result that only five of us were left. An infantry regiment likewise fared badly when it came over and we saw the remnants dash back. I lay in a shell hole in 'No Man's Land' for three hours. We saw one of our fellows laying out but could do nothing for him. We then decided to make a dash for it back to the line. On our way we came across a Wiltshire man who had lain wounded and helpless for three days and three nights. He was too weak to shout for aid. We managed to reach the line, and at night the five of us returned up the ravine and had the satisfaction of finding him and bringing him in on a stretcher.

In 1918 'Stringie' received a Blighty wound in his right foot. 'I thought my football days were over' was his immediate concern, but within a couple of months the war was over and he was back at Fratton Park. 'His speed, cleverness, dash and kicking have not been impaired, apparently, one iota,' commented one spectator.

Extract of letter, dated December 1914, from Mr C. W. Hearn, a Portsmouth town hall employee, serving in France as a Lieutenant in the Royal Army Medical Corps:

> We went down country immediately on arriving. We have been and are still as near the firing line as it is our duty to go, but of course we sent our parties out every night to bring in the wounded from the trenches. I have been out myself and cannot say it is very pleasant. It has been one incessant roar of guns since we have been here. We have had some fearful cases to deal with, but I am pleased to say our fellows carry out their work admirably. When this war is over I don't think I shall want to take part in any other. I was at a place called [deleted] when Major Harman was killed and Captain Powell badly injured by a shrapnel shell. I brought in Major Harman's body and he was buried soon afterwards. The place was awful to look at, the beautiful old church and all the town being razed to the ground. I was glad to get clear of the place as the Germans had the range a treat. They were trying to bring down the remains of the church tower as they suspected it was being used for observation.
>
> Whilst I passed through [deleted] a German airman flew over and dropped a few bombs. It was very cheerful! A few men (nine British) were killed and eleven

wounded: but the aeroplane was eventually brought down. The night before last it was like a Christmas party – everyone pulling crackers – and it also reminded one of a mock night attack at Spithead (I should like to be there now).

You mention about the various kinds of clothing the Portsmouth Battalion are wearing. I don't know what you would think of us. We wear skin coats of all shades, and look like a lot of wild cats let loose. By Jove it has been cold. One does not sing 'It's a long, long way to Tipperary' out here. It's all taken out of the men after being in the trenches. I don't think it possible for anyone at home to realise what the men look like after they have been in them for a few nights. But still there is that good old British bit of pluck left in them, and they bear all the discomfort and wounds right down beautifully.

Extract from a letter, dated March 1915, sent by an unnamed old boy of Portsmouth Grammar School, an 'officer in charge of machine guns 100 yards from the German trenches':

Really our hardest game is not the fighting, but the waiting, in safety, but in cold mud and sleet or snow for hours at a stretch, for no reason at all that we can see. Everybody growling, everybody frozen, pack weighing a stone more every minute, fingers caked in frozen mud, the day's ration gone to pulp. My men think that I look on the whole thing as the scream of my life. Everybody grins as I go to visit the machine guns. One has to make horrible jokes – doesn't matter how bad … If you ask for a lifebuoy when it's ankle deep, you are rewarded by a smile, and if you yell for the ferry when it's over your knees, and curse the company for not sending it and keeping you waiting, you get a laugh, and it is worth gold to your men.

Letter sent from local police constable B. W. Rogers, serving as a Corporal in the Gloucestershire Regiment in Belgium, to the Chief Constable of Portsmouth, Mr Thomas Davies, dated February 1915:

After doing sixteen days in the trenches up to our knees in mud and water, we were moved back for a hot bath and a complete change of underclothing, which I can tell you were badly needed, the troops being literally caked in mud. Here the men experienced the effects of frostbite, through continually being in the water, and the weather turning to frost at night. After three days' rest we were ordered to relieve another part of the line, where the men were in as bad a state as we were. And here we are still. The ground here is very low-lying, which makes it very hard for us to dry trenches, for after going a few feet down, in comes the water.

Corporal Rogers was killed in action nine months later.

James Gray was brought up in Brockhurst, Gosport, and attended Anns Hill Road School. His father joined up on the outbreak of war, expecting it to last a few months. Three years later, at the age of seventeen, James followed his father into the Hampshire Regiment (3rd Battalion). After ten weeks of training at the New Barracks (St George) his unit was marched to the railway station:

There were about sixty of us. A band played but when we arrived there was no train waiting for us, so we had to hang around for an hour. When it finally did arrive it picked up lots of troops on the journey – none of us had any sleep that night. Something I won't forget was the terrible sight of gassed horses sprawled all over the place with bulging eyes and massive, flared nostrils. I was disgusted to hear the men in charge of the horses were ordered to put gas masks on their animals before they put on their own.

When I was hit the doctor at the dressing station near La Bassie assumed that I'd been in a gas attack because of my watery eyes. When I said I hadn't he asked if I had turned over a corpse because when a gassed man was turned over to get his identity disc the trapped gas rose and affected the person above. It was a shell splinter in the eye. I was sent to the town of Bethune for one night until the shelling stopped and from there to the sixty-first casualty clearing station for an operation. Then to Boulogne for convalescence before being sent back up the line again.

The officers were popular – one was very angry with me when he found me and some mates dismantling a shell to remove cordite to use as rat poison in the trench. Lice were very common, too. I had them all over my chest. They left a nasty rash. I lost the sight of my left eye. As a marksman it ought to have been the right one for they might have sent me home.
You had to be there to know the horrors of that war.

After enjoying a long retirement, James Gray died peacefully in his sleep at a Fareham nursing home in July 1989.

Reginald Rundell joined the 13th Hampshire Regiment in December 1914, and went to France as second in command of the 10th Trench Mortar Battery. An ex-pupil of Portsmouth Boys Secondary School (in Victoria Road North) he maintained correspondence with an old school friend, Jack Clayton, who worked in the dockyard throughout the war.

We sleep in the loft of a farmhouse (dry if nothing else) and our mess is a small room in another farmhouse. The place consists of four large farms – very large – everything going on as usual. Cattle, fowls, ducks, doves, horses everything belonging to a farmyard. We have sampled one or two of the fowls and are looking forward to a nice duck for Christmas! Live well while you can!

Saturday 29 January 1916:

Sorry to hear about your uncle's accident in the (Dock) Yard – hope he is getting on well now. As you say it's a wonder he wasn't napoohed.* I suppose you are going on the same as ever – the Yard can't do without you.

*napoohed: killed, from the French *'Il n'y a pas de plus fini'*

Thursday 24 February 1916:

We are in a pretty hot sector of the line being only 240 yards from the Boches so that we get all the "small stuff" (sausages*, oil cans*, rifle grenades) as well as their "hows"* ... we retaliate for them sending over three or four sausages, which make a hell of a bang and a crater with twenty of our best with fondest love, dropping them on their favourite machine gun emplacement ... Last Saturday morning early we saw smoke rising from one of the German trenches – evidently a Hun cooking his brekker or lighting his pipe! We plonked over ten love-drops on the smoke, which soon stopped. Glad to get your letter old man – don't get fed up with the war – it'll be over in time!

* sausage: German heavy trench mortar bomb (from its shape)

* oil-can: 10 inch diameter trench mortar shell filled with high explosive

* how: familiar abbreviation for howitzer, a short large-calibre gun which lobbed big shells.

Friday 21 July 1916:

I suppose from your letters that your life is much the same as before, work still work. We were in the line on the day of the show...we were stopped just as we were going over with our guns. Had some exciting time, I can tell you. The Boche evidently concentrated his ideas (and guns) in our part of the line and gave us absolute hell with a machine gun we had unfortunately not knocked out. My jingo, it would have done your heart good to have seen our fellows going over – as steady as a rock and, my word, they did damn well too. The old Boche put up a jolly good fight – his guns were excellent, but we had the weight of metal undeniably, thanks to Lloyd George!

Wednesday 13 September 1916:

We are well catered for when we are "out". One division runs a cinema, a fine large hall with a balcony for officers' "teas" – divisional brass band plays all the music – damn good show. Our own division runs the "follies," a concert party of the good home type. They are awfully good and while touching on the slightly "blue" occasionally (for the delectation of the ranks!!) they are a great source of delight to all. Especially after the push, back in the next village, were they appreciated – where they played on a stage rigged in the bare rectangle formed by the four walls of a roofless chateau?

Have had one or two gas attacks but our appliances are excellent and are not so much feared now. We had several "tear" shells over while we were trying to push down S. Reminded one of the "chemmy lab"! Relieving across the open from the trench is a great stunt. Make a noise and up goes a Boche flare, during which you must stay stock still or flop on your tummy in a pool, perhaps while a machine gun goes overhead. As soon as that stops, on you rush, again to get as far as poss. before the next goes up. As you can guess it's a pretty tedious biz. especially now when the numerous shell holes are full of water – still once you're wet, what does it

matter? I suppose you will always be busy until the end of this affair now. There is no doubt about it the old Boche can bite still – anyway where we've felt him! Still we are hoping for great things shortly if reliable rumours can count – so keep your eyes open for us. Well, old man, I must really close now, hoping you're not too bored with all this "shop".

26 December 1916; a description of Christmas Day in a dug-out, shared by 'the fatigued four':

Breakfast-time approached bringing with it another gift from our gunners of half hour's duration and no bacon for us (the careful cook had put our rations on the wrong limber coming up the previous day). Having satisfied the immediate pangs of hunger with Bread, Maypole "overweight"* and "plum and apple", we smoked. Our candles and oil having "gone west" with the rations, we were without illuminant (one of the four's attempts to write a letter by the light of a cigarette end proving fruitless).

A few attempts at carol singing in "Round Robin" fashion fell flat and the morning passed with memories of "Last year at – in –, etc. Lunch time was gilded by the appearance of some preserved meat and vegetable rations, a product of Mr Maconochie's*. We really began to get quite cheerful and then it began. "It" was a little retaliation by the Boche, who playfully landed 5.9's on the road close by. It is not yet known ("Eyewitness's"* report not yet having been published in the Daily Mail) as to whether the Hun was seeking the road or the batteries. It is known, however, that four "Mudlarks" sat for four hours with a few sheets of corrugated iron between them and "Promotion to Glory"*, listening and feeling correspondingly cheerful. Songs died away from the men's shacks as those of the birds when a hawk is overhead.

Bang! – Road again, Sh-sh-whirr-r-r! BANG!!! – Hold hard Fritz! – (lumps of earth fall on the dugout steps) – and so on. Slop! Slop! Slop!! – someone in waders is coming down the muddy steps, and the blanket door is pulled aside to disclose the Post Corporal. "Anything doing today, Corporal? – couple of official letters, I suppose and that's all!"– and then the mysterious sandbag is opened. "Parcel for you, sir!" and into my hand is plumped a sacking- covered package. "Um! that cake from home, I suppose!" The light from the match disproves this and the cutting and unpacking is proceeded with in great haste – everyone else (this was the only parcel) lighting matches in aid. Was it cigarettes, tobacco or a box of neckties? No one wanted either. However, the peeling off of wrapper after wrapper proceeded and finally a match disclosed a huge box of the most perfect chocolates one could wish to see (even in daylight) covered with a chit bearing the superscription, "To Reg, From Jack".

Nothing could have been more delightful than to hear from such an old chum in such surroundings. Who cared then if we had no light or the Boche shelled? Chocolates are easily handled in the dark and remarks of "Theesh are good, Reshie" proceeding from mouths full of succulent sweet broke the darkness. The ice seemed

broken. The Quartermaster-Sergeant arrived shortly after with candles and oil rations and the remainder of the evening was spent in light harmony smoking and eating, none could have been happier than the "Four". Anyway it was the chocolates that "did" it and I'm writing you these few lines to thank you most sincerely for them and your good wishes. The Post Corporal once again awaits our letters, so I must close for this time. Will write again soon. Hope you'll have a decent time at Xmas. Please remember me to all at home. Once again, many thanks. Ever your old chum Reg.

*Maypole 'overweight' – a brand of margarine
*Maconochie – term for tinned rations, from the name of a supplier
*Eyewitness – ironic reference to an infamous press propagandist
*Promotion to glory – euphemism for getting killed

This was to be Reginald Rundell's last Christmas. Four months later he was killed by an exploding shell. His mother died two weeks after receiving the telegram.

An account given by Mr P. King of the 60th King's Royal Rifles while being treated at Milton Infirmary in January 1915.

My pioneer sergeant and myself had been detailed to build a bomb-proof shelter for the Colonel, which occupied us very nearly all day. After finishing, we went back to the road where our transport was, and laid on our backs in our dug-out. The pioneer sergeant said "I think we had better dig this out farther", as the shells of the Germans were dropping a bit too close to be comfortable. The words were scarcely out of his mouth before a shell came down the road from a different position. I was blown up into the air and found when I alighted that my right foot was off. My chum picked it up, with the boot on, in a gutter nearby. About seven of us were hit by the shell. A Lance-Corporal next to me had his head blown off, and others were slightly wounded. A comrade carried me in his arms half a mile, while we were being peppered with shrapnel, to a field hospital, where it was found that my left leg was broken in four places. I was conscious throughout until chloroform was administered at the hospital.

This, from an unnamed reservist being treated at Fawcett Road Military Hospital for shrapnel wounds received during fierce fighting at Mons, September 1914.

We had the satisfaction of knowing that while our losses were heavy the Germans must have suffered far more terribly from our rifle fire. It was impossible to miss the Germans. They came up in a solid block formation, and any kid with a rifle could knock them down. We were told to take no prisoners, but one young German prisoner we took could speak English as well as I can. He said he was not sorry to be taken prisoner. We were rather badly let down. We were expecting assistance, but it did not come for thirty-six hours, and all that time we were pluckily holding our own against formidable odds, and perfectly hellish fire from shrapnel which seemed to shriek immediately over our heads, and swept all along our entrenchments.

Gladys White was born in North End, Portsmouth, in 1883. Her father, a prominent local businessman, named Gladys Avenue after his new-born daughter. She was destined, however to make a name for herself. After training as a surgery nurse, Gladys volunteered for war-service and was sent to France. She recorded her experiences in a war-time diary.

December 1914: Very busy admitting each night, all bad cases. This week has been awful; it's not surgery but butchery.

September 1916: A horrid week of amputations ... barges kept coming with the badly wounded – difficult to keep pace.

20 May 1918: It's awfully trying, getting to know RAF boys and then getting them in smashed up ... You feel each time you say goodbye to one that you will probably not see him again. It's a dreadful life for such young boys.

November 1918: We went right down the Menin-Ypres road. It was the most awful spot in France and passes all description. Miles and miles of slush and mud and derelict war material. Not a foot between shell holes and full of water ... There are tanks everywhere looking already like prehistoric animals with their noses buried deep in the mud ... One could pick up lorry loads of helmets, water bottles, rifles etc. It's impossible to understand how men have ever fought and lived in such country, the scenery alone leaves me so depressed you don't feel like speaking.

Gladys White was one of the first war nurses to be awarded the Albert Medal. She died in 1963.

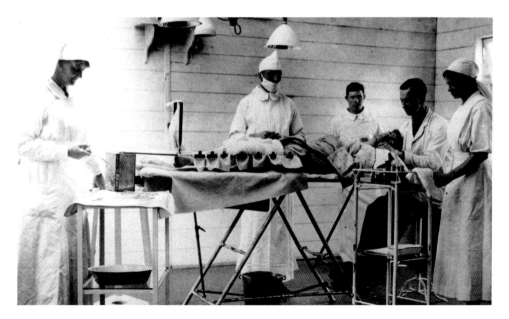

Gladys White (left) and her surgical team working in a makeshift operating theatre at Calais in 1917.

CHAPTER EIGHT

Coming to Take You Away

'Next!' The young man faltered then stepped over the threshold of the dark, wooden-panelled banqueting room in the town hall one July afternoon in 1916. His parents escorted him to the chair which stood, isolated, before a solid polished table. Eight stern faces fixed on the young man. He began to tremble and then shake, uncontrollably, like a delicate leaf caught in a violent storm. He fell to the floor in a faint.

One stern face directed his parents to take him out. The mother apologised humbly, explaining that her son had suffered from nervous fits for years. But a medical board of five doctors at Winchester had decided that this applicant for exemption from military service was fit and healthy. He was, it was ruled, suffering from 'hysteria, rather than a fit'. 'The tribunal's decision,' the chairman announced, 'is in accordance with this view.' He must go into the Army. 'Next!'

By the beginning of 1916 the 'wastage' of men at the front was running at 15 per cent per month and demand for replacements far exceeded the supply of volunteers. In Portsmouth mass meetings were held in the town hall and Portland Hall and resolutions were passed calling for the Government to introduce immediate conscription. 'We believe that in this matter,' predicted William Gates, editor of the *Evening News*, 'the voice of Portsmouth will be that of the country tomorrow.' And so it was.

With the passing of the first Military Services Act, many an anxious eye turned to the local press to study the exemption clauses. The *Portsmouth Times* paraphrased and clarified the grounds on which exemption might be granted:

i) That it is expedient that the man should be employed in other work than military service.
ii) That he is suffering from ill-health or infirmity.
iii) That he is really the support or stay of parent or other dependant.
iv) That he has a conscientious objection to the undertaking of combatant duties.

The machinery of conscription, primed and ready, was not slow on the uptake. In the first week of February young, unmarried men began to receive War Office Form

Notice warning men that they might as well volunteer because conscription was on the way.

W3236 directing them to join up immediately or be dealt with as war-time deserters. On 8 February the question of the formation of a Military Service Tribunal appeared on the agenda of an otherwise routine meeting of Portsmouth Town Council.

Ideally, it was suggested, the tribunal should be 'fully representative of the local community' and there was general agreement that all political parties put forward one nominee. A move to include two women for consideration met with hostile opposition. Sir William Dupree spoke for many fellow councillors when he protested on the ground that 'as women were not allowed in the firing line they should not be placed in a position of being able to send men there'. There were no reports of the same argument being advanced to prohibit elderly men from membership. The council's eventual selection: the Mayor, Mr J. H. Corke, Sir Scott Foster, F. G. Foster, H. R. Pink, J. E. Pink, A. G. Gourd and G. T. Kersey, were solid and stolid pillars of the town's political and business world and were appointed by virtue of their social reliability and unquestioned and unquestioning patriotism. Their high status reflected the importance and prestige attached to tribunal work, which was seen as a vital cog in the war-machine. It was a far cry from those disreputable press-gangs that roamed the area a century before, armed with rum, clubs, and cudgels. Their methods, at least, were more refined.

That this elite should comprise two sets of brothers reveals something of the nature of local politics at that time. As well as serving on the tribunal, the Pinks and Fosters also sat in judgment on the bench of Portsmouth Police Court

throughout the war and a large number of men who appeared before them in this capacity were charged with being 'absent under the Military Services Act' and were routinely fined 40s (£2) before being handed over to a military escort. There was no means of lodging a retrospective appeal to the tribunal. Hundreds of men were to suffer the indignity of being 'fetched' from their homes by Portsmouth's depleted police force augmented by enthusiastic volunteers known as special constables. Local gipsy camps and workhouses were raided and queues outside the Theatre Royal and the Hippodrome were accosted, while men who were 'of the genus tramp' dared not walk the streets. 'I have no liking for the Army, so I kept out of it for as long as I could' was the frank admission made by one renegade to Mr H. R. Pink before being fined and handed over.

It is at least possible that world-weariness and a jaundiced view of human nature acquired from their experience of dealing with the shameless parade of self-confessed 'shirkers' was to influence the attitude of the Pinks and Fosters to the largely hesitant, nervous and inarticulate applicants who appeared before them in their capacity as tribunal members.

Nobody foresaw just how busy the tribunal would be, how relentlessly the cog would turn. For despite the area's proud naval and military traditions and highly visible expressions of patriotism, many people were attempting to live in peaceful co-existence with the war, carrying on their business as usual, trying to 'keep their heads down'. In the currency of the time they too were 'shirkers'. Whether stricken by bad health, motivated by self-preservation, worried about dependants, burdened by business concerns, troubled by conscience or paralysed by indolence, they were all lumped together and appealed in their thousands to the tribunal for sorting.

The official guidelines issued to the new tribunals were deliberately vague. Directives such as 'the procedure of the tribunal shall be such as may be determined by the tribunal' were to do nothing to enforce fair and consistent treatment of cases. There was a general consensus that their role was one of recruitment, pure and simple – with little concern for the niceties of appearing to be impartial in the midst of a war that had to be won at any cost.

It was with this determined and single-minded attitude that tribunal members went about their duty, sitting for several hours at twice-weekly sessions in the town hall. Beside them sat a military representative, dressed in uniform, whose job was to oppose all claims for exemption and continually stress the Army's increasing need for men. He also collected information and malign gossip about applicants to discredit their characters and so undermine their cases. Thus, one man 'denied that he spent a good deal of time playing billiards' while another 'firmly denied receiving bets for his brother'. Both were sent directly into the Army.

Unlike the proceedings adopted by Gosport and Havant tribunals, the military representative at Portsmouth was not required to retire while cases were being discussed, and was, in effect, an honorary member of the tribunal. His 'prosecutor's role' was routinely usurped by other members, anxious to be seen representing the military rather than prevaricating over idealistic notions of justice. After all, there was a war on.

A large proportion of the men who came before the tribunal were self-employed and the size of an applicant's turnover and weekly profit was a major factor in determining whether he should be handed over to the military authorities immediately or given one to three months' 'temporary exemption'. If the tribunal was 'satisfied that the applicant did big business', he was granted leave to appeal back to them when his temporary exemption had expired. Providing that the nature and size of the business met with the inconsistent and whimsical criteria of the tribunal, a man could be reasonably assured of avoiding the trenches. But nobody could be absolutely certain of the verdict, except perhaps those who had ascertained from which side of the bed the members had emerged that morning: A watchmaker and jeweller, twenty-six and single, was granted two months' temporary exemption. A member of the tribunal remarked that they could not close up those little businesses entirely. Later at the same session, a second-hand jeweller, described as 'indispensable', who contributed 22s (£1.10) a week to the support of his widowed sister and her three children was refused exemption.

That any exemptions at all were granted was due, in some part, to the *Evening News* editor William Gates, who gently implied that there was, perhaps, a little more to the tribunal's function other than recruitment. On the day after Gates published his observations the tribunal granted its first temporary exemption to the manager of a tailor's business, enabling Gates to comment that 'the work is carried out with absolute impartiality'.

The Gosport tribunal, under the chairmanship of Alderman G. Cooke, held its meetings in the Thorngate Hall, where an altogether different ethos prevailed, demonstrating that concepts of impartiality were entirely matters of opinion. With 89 per cent of applicants at one session having been granted 'postponements and exemptions', the tribunal was pilloried in the press for its 'excessive tenderness' and 'lack of severity'. This particular rusty cog soon became as well-oiled and efficient as its neighbour.

Reassurances that claims would receive a just and fair hearing did not prevent an increasing number of applicants from hiring solicitors to present their cases more effectively. The presence of a man well versed in law curbed the worst excesses of tribunal members' behaviour, and a reasonable and respectful atmosphere materialised:

(The applicant) before them was of a mechanical turn of mind, and Mr Allen (his solicitor) produced two specimens of his work – a model steam engine and electric striking gear for a clock. These were inspected by members of the tribunal and Mr Allen suggested that his client should be allowed to do work at a local munitions factory for six half-days a week. The other half-days he would devote to keeping his professional work together. The applicant is under thirty-one and was married in August last, but for military purposes is single, and is in class BI.

Conditional exemption was granted, the compromise being achieved in a civilised and friendly manner not evident in the case of another man, of similar age, who was unrepresented:

A man with one eye … passed B1, was told that he must go. He was engaged as an outside porter at the railway station, and was married with three children, and he said he suffered from pleurisy. "The eye doesn't matter" remarked Colonel Boulderson (the military representative). The chairman (Mayor Corke) remarked that his wife and family would be better off with him away in the army.

The importance of a man's work in relation to the war effort was sometimes a factor taken into account, and at other times apparently considered of no importance:

A young man … indispensable for his work on Government contracts (making) roofing material largely used by the Government for their buildings for troops and stores was refused exemption.

An (unmarried) harpist … asked that he might be recommended for local service, as he was the sole support of his parents … (Tribunal members) thought that the man had acted very fairly (and granted him conditional exemption).

But the granting of exemptions was the exception, not the rule. The rule was the Exemption Clauses of the Military Service Act, the vagueness of which enabled any convenient interpretation to be applied, providing the Army had its men.

Ostensibly, the clause permitting exemption on grounds of ill-health or infirmity left no room for discretion, a man was either considered 'fit for military service' or 'unfit' as defined by the dubious criteria applied by a panel of doctors at Winchester. Local tribunals frequently referred men for examination while the newspapers reported selected cases under less than sympathetic headlines such as 'Tribunal Excuses' and 'Weeding out the Weedy.' Attendance at the medical for one man was not without its own health risks:

He appeared before the doctor at Winchester three days before he was taken ill with pneumonia. His lungs, he said, were not examined. He told the doctor he was feeling unwell and the doctor answered, "Oh! We will make you all right soon." He considered he caught a chill at Winchester.

The Chairman:

Your case will be adjourned until October the 4th so that you can be re-examined in the meantime. Applicant: I cannot go to Winchester and be stripped again!

Reasons on health grounds cited for not joining the colours were various and manifold. The family of one Gosport man received his call-up papers a year after he had died, unpatriotically, of natural causes.

Many of the 'temporary exemptions' were granted for a few weeks with no leave to appeal, the borrowed time to be spent, as one member ominously expressed it, 'putting your affairs in order'. For those granted the opportunity of an appeal there was a chance of a more sympathetic hearing before the Hampshire Appeals

Tribunal under the chairmanship of the Isle of Wight MP Sir Godfrey Baring, whose relationship with the Portsmouth tribunal was somewhat strained. He condemned their methods on a number of occasions. In turn. Alderman F. G. Foster criticised the Appeals Tribunal's judgments, remarking that 'a great percentage of cases were let off'. He considered the appeals procedure unnecessary, claiming that Portsmouth tribunal members' years of 'public experience' exceeded those of Sir Godfrey and his colleagues. 'We are,' Foster asserted, 'quite as capable of judging the rights and wrongs of a case as they are.' This claim was to be rigorously tested by the emergence of the universally despised 'conscientious objector'.

'Why is a tribunal like a heavy shower of rain?' the *Evening News* inquired in its daily column of gossip, trivia, and topical jokes. 'Because it brings the worms to the surface.' If humour had not been a casualty of war, then truth surely had. Stories emanating from an anonymous 'good authority' peppered the pages of the press, contrived to combat the growth of pacifist sentiment and maintain morale. Local newspapers dutifully published them blind, abandoning all journalistic principles. 'Invaders To Kill All English Boy Babies' was one which, despite its biblical precedent, seemed improbable. Many such stories branded conscientious objectors as pro-German traitors. A typical example claimed that 'a small batch of "C.O.s" have left for Germany to act as pilots in zeppelin raids on England'.

Prominence was also given to other unattributed, but in all probability genuine, expressions of hostility to pacifists, including this extract from a letter sent by 'an officer in the trenches': 'If you see or know any of these conscientious objectors, go and shoot 'em, also some of the members of the tribunals.' Poetry and cartoons expressing similar sentiments appeared on picture postcards, an immensely popular medium of communication. The printed messages they carried were a light condiment to the diet of propaganda served up daily in the newspapers, the sole source of information other than rumour. Gone were the sepia scenes showing the pre-war attractions of Edwardian Southsea. It was becoming hard to remember how pleasant the beaches looked before they were obscured by barbed wire.

On hearing the 'conscience clause' of the Military Service Act, William Gates expressed concern in a leading article that 'a numerous class' would make use of it to 'shirk their duty'. Perhaps mindful of the fact that around a half of his church-going readership belonged to nonconformist religions, the editor trod warily, suggesting that the clergy should be 'left to fight Christ's battles in the manner they consider to the most effective'. But if this advice was directed at the local tribunal it was to fall on deaf ears. On one occasion a practicing minister was told, 'you are staying at home and letting others do the work. Good preachers are wanted at the front'. The application was refused.

The first plea of 'conscientious objection' to be heard by the tribunal was made at its first sitting and was submitted by an employer who strongly resented having to employ 'lady clerks'. His 'conscientious objection' was to the fact that he would be forced to employ female workers if any more of his male workers were conscripted. Aware that the conscience clause was not intended to apply in such circumstances, the Tribunal refused the appeal, but later instances indicate that members

sympathised with the plight of 'masters' who would not or could not conceive of employing female servants on duties that were considered a male preserve.

A week later a bank clerk appeared claiming a 'conscientious objection to fight' but added that he was willing to serve in the Non-Combatant Corps. The War Office had just established the NCC, an army unit that would not bear arms but would be subject to normal army discipline. Non-Combatants, it was announced, would be used in the 'repair of roads and railways, sanitation and the provision of huts and baths for soldiers coming out of the trenches'.

One tribunal member drily remarked that the Sanitary Corps would suit this, Portsmouth's first, conscientious objector. But the application was refused outright, the intention being to make an example of this 'worm' in the hope that others would be discouraged from surfacing.

During the first six months of tribunal sessions, twenty-one appeals were made on the grounds of conscientious objection from men of diverse beliefs, occupations and classes. This total had more than doubled by the end of the war and included a postman, a teacher, clerks, gardeners, managers, tradesmen, a cutler and several clergymen. Many of these men were, or claimed they were, 'absolutist', meaning that they would have nothing to do with the work of the military, including the Non-Combatant Corps and the Royal Army Medical Corps (RAMC). A typical statement made by an absolutist to Portsmouth members was that such work 'makes the military machine for taking life more perfect'. Such resolve was hardened by a report that members of the NCC were to be organised in units to relieve combatant soldiers for service at the front. The absolutist argued that there was no morality or honour in refusing to pull the trigger if you had someone else pull it for you.

Tribunal members, in common with most of the population, were baffled and disturbed by the determined idealism of the absolutist, who appeared to have arrived from a different world. When one's neighbours, friends and family were fighting and dying in the common cause, it was hardly surprising that these individuals attracted bitter hostility and hatred. The local Liberal MP Sir Thomas Bramsdon, speaking at a mass meeting held in the town hall, offered a solution to the problem:

> Speaking of the conscientious objector, the reference to whom produced ironical laughter, Sir Thomas said that it was a nice comfortable position to be in. but he could not make out how ever a man could go before a body of his fellow men and tell them such a story. (Hear, hear) He almost felt that he would like to put them in front of the Germans without any way of escape and see if they would use their guns in their defence.

The men who chose to face their fellows, rather than the Germans, did so shamelessly but with a certain dignity. They were, in the main, articulate men who had clearly considered their position very carefully. Tribunal members had, accordingly, prepared themselves with an armoury of tortuous, hypothetical situations and cutting remarks with which to trap and humiliate the 'shirker'. This improbable scenario was a popular opening gambit: 'If you were off South Parade Pier, and as a result of the bursting of a German shell some people were struggling

in the water, would you help them if you could do so?' If the applicant replied that
he would, the follow-up was as predictable as it was effective:

Member: "The RAMC does similar work."
Applicant: "I do not object to the RAMC as such, but because it makes the military
machine more perfect."
Member: "Then, according to you, Florence Nightingale was wrong for going out to
Crimea to nurse the wounded soldiers?"
Applicant: "No, because she was clear of all military authority."
Member: "She was under military authority all through and had to go where she
was sent."

If, on the other hand, an applicant claimed he would not help the hypothetical
civilians drowning in the Solent, he received short shrift:

Member: "Do you mean to say that if you saw a child struggling in the water, as a
consequence of a German shell being fired you would make no effort to help it?"
Applicant: "No. sir."
Member: "Then you would be morally guilty of murder."

Both men were sent directly into the Army as combatants.

The military representative in attendance at Fareham tribunal painted equally
vivid scenarios tailored to individual cases. Thus, one man was directed to imagine
that a zeppelin was sailing over the Wickham Road intent on dropping bombs on
the chapel where his family was at prayer. This conscientious objector's case was
not helped by the fact that he was employed as a slaughter man in a local abattoir.
At Portsmouth, members came up with the economical but not inelegant, 'What
would you do if a German punched you on the nose?'

All conscientious objections made on humanitarian or socialist grounds were
rejected outright by Portsmouth tribunal, while religious belief was sometimes
grudgingly accepted as a contributory element in a 'shirker's' psychology. On
a number of occasions men who had passed a religious 'validity' test were
reluctantly allowed to serve in a non-combatant capacity.

No 'absolute exceptions' were reported to have been granted throughout the
war, in common with many other tribunals in the country. Concern was expressed
in Parliament on a number of occasions, but the climate was not conducive to
reasoned, philosophical debate.

There is evidence of an undercurrent of local opposition to conscription, the
behaviour of the tribunal and the war in general, though, inevitably, the local
press was anxious to minimise any signs of dissent. Minority organisations such
as the Anti-Conscriptionist League and factions within the local Independent
Labour Party were small and ultimately ineffective spanners-in-the-works of
the machinery of war. On one occasion, 'a dozen or so' anti-conscriptionists
'buttonholed' intending tribunal applicants outside the town hall, persuading two

men to have their cases heard in public. This caused only minor inconvenience and the cog resumed its relentless progress.

When the 'worms' turned they did so quietly, with prepared statements evoking biblical text, in particular the Sermon on the Mount: 'Love your enemies, bless them that curse you, pray for them that despitefully use you…' Socialist pacifists stated that they could not be party to a crime of capitalism and that British and German workers had more in common with each other than they had with their war-mongering leaders. Many added that they were prepared to prove the sincerity of their convictions 'by accepting any penalty which the law might inflict, rather than surrender [their] principles'.

For those who 'stuck to their guns', justice proved to be rough. Having had their applications refused, they were 'deemed to have enlisted' and taken away to barracks. On refusal to repeat the military oath and wear the King's uniform, the defector was given some encouragement to think again by soldiers who, not surprisingly, displayed no signs of sympathy for his plight. One man who refused to obey orders at Winchester Barracks was sentenced to death by Court Martial, put against the wall, blindfolded and heard the order to fire, before being told that he had been pardoned. When he was eventually handed back to civilian authority the objector found himself on the wrong side of the 30-foot-high walls of Portsmouth (Kingston) Prison, where conditions were far from comfortable: '…the prison was not heated, and the floor was of stone. In it was a wooden sheath three foot wide, with a thin mattress. Two covers were provided but they were not thick enough to keep out the cold … the food was disgusting to eat.'

Up until July 1917, nineteen conscientious objectors were imprisoned in the cells there, sharing the spartan facilities with 'aliens' of German and Austrian descent. One 'enemy alien', a Max Heinrich, aged thirty-six, of Grove Road South, Southsea, had been arrested as a suspected spy in August 1914 and imprisoned. Within four months he had developed bronchitis, contracted tuberculosis and died. A complaint about this case was sent via the (neutral) American ambassador in Vienna to the Foreign Office 'for consideration', but was dismissed by the British as a propaganda ploy. Heinrich had received 'exceptional treatment' and 'sympathy and kindness' from prison staff, it was alleged.

It does seem that conditions and treatment at Portsmouth were less unpleasant than in other prisons in the country. Of the seventy-three objectors who died nationally as a direct result of their experiences in military hands, none had been imprisoned locally. The punishment meted out to one objector at the New Barracks (later St George Barracks) in Gosport, however, 'broke his health'. A soldier who had enlisted against his convictions and under family pressure refused to obey orders, claiming a conscientious objection. He was given 100 days' solitary confinement on a diet of bread and water for the entire period, in breach of Army regulations which stipulated that punishment diets of this kind should not last longer than a maximum of three days.

But the maltreatment of one man, however tragic, cannot be plucked out of the context of the age – in the 100 days of this soldier's gradual disintegration something

like 60,000 of his brothers were killed on the Western Front. With casualties mounting, the net of conscription was remade with a finer mesh and thrown back over a broader area. The Portsmouth tribunal split itself in two in an attempt to cope with the resultant flood of applications. With fewer members to ask questions, it was reasoned, the 'cases would be disposed of much more quickly'. Any pretence of giving each case 'a just and fair hearing' was abandoned during the Somme offensive when 'the flower of British manhood' met the scythe of German technology.

The unenviable task of selecting who should stay at home and who should fight and possibly die was carried out with an efficient and unsentimental professionalism. In all, there were 199 sittings during which some 7,785 cases were heard. With an average of perhaps four or five minutes allotted per case there was hardly enough time to cross-examine applicants or consider cases in any great depth, even if the inclination to do so was there. The most tragic figure to appear before these dutiful and determined men was the tearful mother, pleading desperately to be able to keep her only or last son.

The deep sense of frustration felt by men who had grown up and grown old without having been called upon to fight for their country was the source of many bitter accusations and condemnation of the more reticent young men. These sabre-rattlers were only too aware that they were destined for the indignity and suffering of slow decline rather than the glorious and noble death on the battlefield that history had cheated them of.

The public alarm precipitated by persistent rumours of imminent invasion early in the war was met with a patriotic desire to 'do something' by men not able to enlist. The prospect of invasion was debated by pupils at Portsmouth Grammar School, but was rejected on the grounds that 'there were ten million Britons who would repel any such invasion'.

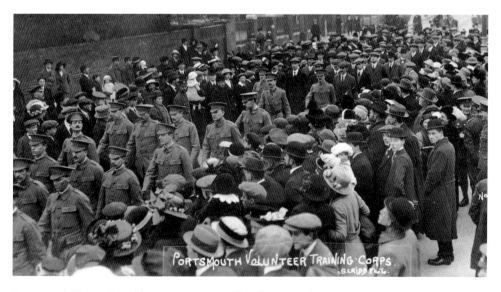

Portsmouth Town Guard leaving St Mary's church in March, 1915.

It was in this heady atmosphere that the idea of forming a 'town guard' (Voluntary Training Corps) was mooted 'to assist the regular troops in any sudden attack on the town'. The response to this call matched that witnessed when Kitchener made his first appeal, as elderly ex-military gentlemen discarded their walking sticks and, with a pronounced spring in their step, went off to enrol. 'No one who is able,' enthused William Gates, 'should miss this opportunity of fitting himself in some measure for service, real and valuable, though it may never take him within the sound of the enemy's guns.'

Drills took place in the Connaught Drill Hall near the Thorngate Hall in Gosport, and Portsmouth's Connaught Hall opposite the *Evening News* offices in Stanhope Road. 'The sight of men drilling,' wrote the Editor breathlessly, 'stirs the blood and gives reign to the imagination.' The spirit was very willing, but in some cases the flesh was tragically weak. Soon after drilling had commenced a retired army captain broke rank and collapsed. His obituary stated that his death was 'undoubtedly caused by his zealous patriotism ... the physical work of drilling with the town guard having acted prejudicially on a weak heart'.

By 1915, the Gosport Guard numbered about 100 while Portsmouth boasted 300 members, the majority drawn from the retired servicemen and the business and professional class including councillors, headmasters, solicitors, managers, publicans and undertakers. Regular manoeuvres took place at Hilsea and in the neighbourhood of Browndown Camp, where Portsmouth and Gosport Guards took it in turns to attack each other with broom handles. After one such exercise a military adviser recorded that 'most of them had one fact made patent to them – they are not possessed of so much wind as they might have imagined'. He advised them 'to go easy at the start, and then you will arrive at the trenches with sufficient wind to dispose of a dozen Huns. One of our party felt so realistically inspired that he accounted for two in a manner that would have made the heart of Sgt. Instructor Smith rejoice and even he went so far as to exercise his prerogative to swear openly.'

In spite of the enthusiasm and dedication of these men their route marches through town were occasionally met by 'sneers and jeers', though, by 1916, the Voluntary Training Corps movement had gained official recognition from the War Office. At the same time, ranks began to swell as hundreds of new recruits were referred to the Connaught Drill Halls by the tribunals; temporary exemptions were conditional on applicants' regular attendances for drilling.

By 1918 the combined Portsmouth and Gosport Corps, renamed the 3rd Battalion Hampshire Volunteer Regiment, further enhanced its reputation by the acquisition of a Hotchkiss machine gun, which, it was proudly declared, 'fires shots at the rate of 100 a minute... At close ranges the bullet will go through the front rank men, often through the second rank too, and kill or wound those immediately behind them.' The sneers and jeers stopped.

But a ground-based machine gun would have been as effective as a broom-handle against the monstrous threat dawning silently on the horizon one autumn day in 1916.

CHAPTER NINE

Zeppelin Attack!

Shafts of white light silently searched in sweeping arcs for the hidden intruder who was known to be up there somewhere. The black concealing drape of night was cut into an ever-changing panorama, a breathtaking geometrical puzzle, beautiful in its scale and simplicity. Then the spectacle was frozen. The shafts located and locked on to the intruder. Illuminated, it looked inoffensive enough – a squashed silvery moon that the heavens had decided to reject.

On the streets below a swarm of straining, pointing humanity gasped and thrilled at the eerily hypnotic *son et lumière*. A thin probing beam was returned from the head of the airship's gondola, playing on the houses and pavements below. It located the dockyard, the gunwharf and the oil fuel depot with suspicious ease. Manoeuvres were made, the order was given and bombs were sent silently but surely on to their intended targets.

In June 1914, the British airship *Gamma* left its sheltered berth in the moat of Fort Grange to circumnavigate Gosport and carry out an aerial reconnaissance of the dockyard and shore establishments on Portsmouth Harbour. Gamma had been plagued with problems from its inaugural flight but now, fitted with a new engine, things were looking up. Dummy bombs hurtled successfully on to selected targets while crowds marvelled at the advances of modern technology.

A year later, in the midst of war, the motion that 'there will be an attempted aerial raid on Portsmouth' was proposed from the debating rostrum of Portsmouth High School. It was carried overwhelmingly. It seemed only a matter of time before the Kaiser recognised the contribution of Portsmouth Dockyard to Britain's war effort and tried to put a stop to it with one or more of his zeppelins.

The zeppelin was a large and cumbersome machine nearly 700 feet long but capable of carrying only a very small bomb load. In terms of military logistics it should never have got off the ground. That it did, and was used for bombing raids, was due wholly to its effectiveness at spreading terror, disrupting industry and diverting British fighter planes from the Western Front. The horror invoked by these majestic monsters was accompanied by a strange magnetic attraction that brought thousands of people on to the streets wherever they attacked. For this reason alarm hooters that had been installed at public works throughout

Portsmouth at the beginning of the war were never used. It was felt that dimming the electric lighting and turning down the gas supplies at source would be less alarming and avoid unnecessary excitement. Key workers at Portsea Power Station and Flathouse Gas Works were put on permanent alert.

The likelihood of an attack on the nation's premier naval port was a source of unease in the mind of the First Lord of the Admiralty, Winston Churchill, who had been asked by Lord Kitchener to assume responsibility for the aerial defence of Britain. On the outbreak of war, Churchill found that Portsmouth possessed only one effective anti-aircraft gun (a four-inch). Nearly all available resources, he discovered to his horror, were being allocated to the defence of the capital. 'Far more important than London,' he wrote in September 1914, 'are the vulnerable points in the Medway and at Dover and Portsmouth … Portsmouth in particular requires attention, now that the enemy's territory has come so near. Aerial searchlights must be provided in connection with every group of guns.'

While the Admiralty was spurred into changing its priorities, the War Office received an urgent communication from Major Dowding, Commanding Officer of the 7th Wing at Fort Grange in Gosport. Dowding inquired as to what anti-zeppelin action he was supposed to take, bearing in mind that there were no suitable aircraft for repelling raids stationed at Grange. The reply he received from the War Office was less than helpful. 'If the raid takes place over Portsmouth garrison and stable machines are available,' reasoned a stony-faced official, 'such action as is deemed advisable will be taken by (you).'

The interior of a zeppelin gondola.

The defences of Portsmouth and Gosport were geared almost entirely to counter an attack from the sea and precautions issued to the population early in the war reflected this fear. Residents on the seafront were invited by public notices to 'take refuge in rooms most remote from the sea'. Lighting restrictions, too, were shaped in terms of polite suggestions rather than urgent demands, a situation which changed as the frequency of aerial raids on other parts of the country increased. But before sweet Edwardian manners had been soured by bitter realities of war, a parish poll was conducted with admirable aplomb in the village of Cosham on the question of whether 'the lighting of the village should be continued'. The result was two to one in favour, confirming in some minds that too much democracy was a dangerous thing. But in Portsmouth and Gosport, increasingly stringent lighting orders were enforced by special constables under the Defence of the Realm Act, and by 1918 all street lamps had been extinguished completely at night, confirming in the Coroner's mind that too little light was an even more dangerous thing. Pedestrians walked blindly into lampposts and there were several fatalities as people stumbled under the wheels of motor cars. Corporation workmen who had previously been employed in the shading of lamps with blue and green paint were now occupied in painting kerbs white. Restrictions extended beyond the 'Inner Defence Area'. In Havant the posts of a bridge in Brockhampton Lane were treated with luminous paint after the Council heard that 'a ratepayer who was a staunch teetotaller had driven into the bridge on two occasions'.

The special constable's familiar cry of 'Put that light out!' was met with a variable response from shops that remained 'open all hours' with an illuminated facade intended to attract custom away from competitors. Many respected and well-known businesses were prosecuted for 'having excessive light' in their shop windows. Arrangements were eventually made for a mutually agreed truce between rival firms in the shape of 'early closing' policy which also conserved energy and gave shop assistants' aching feet a welcome respite.

While giant blinds were installed in the vast windows of Handleys in Palmerston Road, smokers were ordered to refrain from lighting up in the open. But though the man on the street obliged with little complaint, one of the most persistent offenders against the lighting orders was Portsmouth Town Council. In mitigation, its habit of floodlighting the town hall was to raise money for war bonds to 'Feed the Guns'. At the same time as Portsmouth's most prominent landmark was bathed in light, the 'Pompey Chimes' went unheard, silenced lest they revealed the location of their source to enemy attackers. 'Not for one moment,' wrote one observer with blind trust, 'would I venture to challenge the wisdom of the edicts of the authorities that rule.'

In the pitch darkness a tireless battle waged. Tenacious special constables chased errant cyclists who had ignored or misunderstood regulations to shade lights. Once the pedalling miscreant had been apprehended, a notebook was flourished and a name and address inserted with relish. On many occasions the officer's triumph was short-lived, it being discovered that summonses were being issued in the names of fictitious characters who lived elsewhere than where they

had claimed. Motorists, too, were subject to prosecution and were frequently checked for lighting at road-blocks set up at strategic points.

At one sitting of the police court, a Fareham motorist was prosecuted for 'exhibiting excessive light', while the following case involved a Southsea doctor who appeared for displaying no rear lights. Exactly how much or how little light was permissible depended on the judgement of the 'special' and became a very contentious issue, especially when different regulations existed in different locations. Shaded vehicle lights permissible in Fareham became illegal when the motor car crossed the parish boundary into Gosport.

Not surprisingly the 'special' never enjoyed a high status. His popularity plumbed new depths when it was revealed in Portsmouth Council Chamber that, like the corset-makers, these agents of law enforcement were on piece-work. It was denounced as 'scandalous' that they were 'making a very good living appearing in court', collecting a 3s 6d (17p) fee each time. One productive officer picked up the princely sum of one guinea (£1.05) in just one week under this innovative incentive scheme. Inevitably, the temptation to pick apples rather than wait for them to go bad was not always resisted.

The day-to-day enforcement of what were widely seen as pernicious laws considerably enriched the 'special's' vocabulary. It was, perhaps, this factor that led Portsmouth Town Council to dismiss a proposal that women be appointed to replace men who were needed elsewhere to defend the town. This, they firmly resolved, was most definitely 'not women's work'. In assessing the threat of aerial attack, the town council decided against taking up a policy of war-damage insurance for its municipal concerns. The premiums, it decided, were prohibitive.

Both local insurance companies and estate agents had seized on the topicality of the zeppelins early in the war, the former urging home-owners and businessmen to cover themselves and their property without delay, while the latter promoted Portsmouth as a safe, bombardment-free resort where property was as safe as houses. Natural prudence triumphed over transient speculation and the insurers had a field day, though one lady from the vulnerable East Coast took up the estate agent's offer, moved into a house in Copnor and promptly died of a stroke.

While the insurance companies prayed for zeppelin-free skies, the local press published an interview with an aeronautical expert who entertained different hopes. 'Personally I think it would be a good job if they did come over here,' he asserted. 'Even if they did drop a few bombs they could not do very much harm at the most, but I feel sure that the very fact of their coming would greatly stimulate recruiting.'

Kaiser Wilhelm duly obliged and signed the necessary orders in February, 1915. Attack targets were designated as 'war material of every kind, military establishments, barracks ... and docks'. After London and Dover, the third target on the German 'hit-list' was, as Churchill had anticipated, the naval base and dockyard at Portsmouth.

Back at the Admiralty, the First Sea Lord had characteristically got his own way, his efforts making Portsmouth one of the most heavily defended areas against

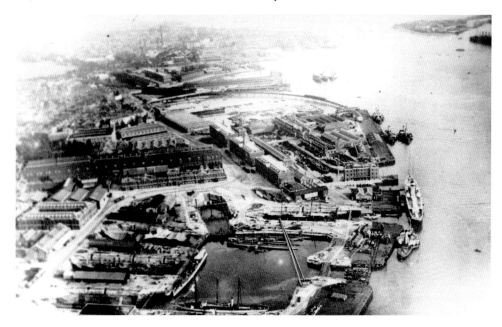

Zeppelin target – Portsmouth Dockyard. This photograph was taken from the airship *Gamma* in 1914.

aerial attack in Britain. These defences included twelve Hotchkiss six-pounders, seven three-pounders, a number of one-and-a-half-pounder pompoms and sixteen additional searchlights mounted in conjunction with the gun defences. 'The effect of the guns,' he wrote, 'will compel the airship either to expose itself to dangerous fire or to fly so high that accurate bomb-dropping would be impossible.' At Hilsea, trees were planted on the ramparts to help break up the shape of the Lines and to conceal artillery positions from aerial view.

Blackout precautions for the prime target – the dockyard – had also been initiated by Churchill back in 1913. These involved the immediate extinction of all lights by the switching off of the dockyard's independent power supply when an attack was imminent. Portsmouth was prepared.

One night in 1916, Mrs Stalkarrt was rudely awoken by a dreadful, deafening cacophony of gunfire and the sound of an aircraft was also audible between bursts from the gun defences. Was it possible that she could be killed by the 'Hun', here, as she lay snug, warm and safe under the blankets? Surely not in Southsea. The firing stopped. The lights in the sky that had provoked the alert gunnery teams had become less threatening, being attributed to 'motor car headlights on the Portsdown Hill Road'. Not tonight.

Irresponsible motorists pursued by puffing special constables were not the only recipients of this treatment. Aeroplanes were frequently used for range-finding purposes, an activity which was not without risk. One such mission ended in near disaster one misty morning when a Sopwith Baby seaplane crashed into a 446-foot-high mast that had been erected on Horsea Island as part of the naval wireless

telegraph station. The plane miraculously jammed itself in the latticed timbers of the construction, 360 feet up, throwing the pilot on to a wing on impact. Three agile seamen with nerves of steel climbed the mast and brought the unconscious pilot down to safety. They were later awarded the Albert Medal for their courage.

Bravery proved to be a quality much in evidence in the skies over Britain in the autumn of 1916. On Monday 25 September 1916, William Gates wrote a jubilant leading article on a subject that everybody was talking about that day – the weekend's zeppelin raid on London. The zeppelin had hitherto been seen as an omnipotent and invincible monster. But now,

> Two of the twelve zeppelins which came to kill, maim and terrorise non-combatants, women and children, were brought down, the crew of one of them experiencing a most agonising death. This makes three zeppelins destroyed in less than a month – a record upon which we may heartily congratulate ourselves.

While the Editor of the *Evening News* was writing these morale-boosting words, Commander Heinrich Mathy sat down in the mess of the zeppelin base at Ahlhorn on the north German coast to write a letter to his young wife. His airship *L31* had survived the weekend raid unscathed after having aimlessly dropped its bomb load on residential areas of London, killing twenty-two civilians and injuring a further seventy-five. Six of those who died had been stranded on a tram in Streatham but it was the memory of seeing his close friends and comrades burning to death in one of the airships mentioned by Gates that haunted Mathy as he wrote his heartfelt note to his wife:

> Hertha,
> The war is becoming a serious matter
> It is my earnest wish that I may survive to surround you with my love like a cloak. During these days, when you lay our little daughter down to sleep, a good angel will see you and will read what is in your heart, and he will hasten to guard my airship against the dangers which throng the sky all around.

Like Mathy, the editor of the *Evening News* displayed no complacency about the events of the weekend. 'We must not delude ourselves,' he stressed, 'with the hope or expectation that we have seen the last of these midnight expeditions.' Later that day, Commander Mathy received orders from the Naval Airship Division Command. The next attack was set for that evening: 'Attack in the South, main target London, with the proviso that caution is ordered in case of clear weather.'

Dressed in leather, fur-lined flight gear, Heinrich Mathy and his crew bade farewell to their comrades before climbing up into the gondola of their mighty airship *L31*. Just after noon Mathy gave the order to weigh-off, the engines droned and the leviathan set sail at a mean speed of 40 mph for the British coast. The words of his superiors stuck in his mind: '*Zuruckhaltung geboten sei* – Caution is ordered.'

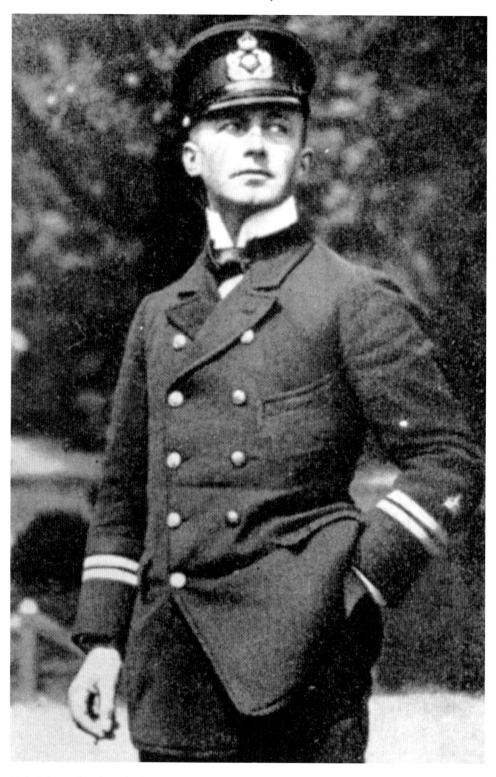

Heinrich Mathy, described as one of the most daring and respected zeppelin commanders of the war.

By evening, Mathy had set a course down the Channel. The phase of the moon was favourable for an attack on the capital. The lunar light reassuringly cast little deadly illumination on the dark superstructure. Hanging high over Dungeness, Mathy decided on his next course of action. The night sky was clear and stars shone down unscreened by cloud. In spite of the kindly moon it would be suicide, Mathy concluded, to attack the heavily defended capital. Instead they would bomb the dockyard at Portsmouth where, as Mathy pointed out to his crew, 'nobody has ever visited and it is sure to be very interesting'.

Navigating his ship down the Channel, Heinrich Mathy constantly verified his position by reference to landmarks and promontories shown on his standard issue map of the South Coast. By now an aeroplane squadron based at Dover had been alerted and was searching the skies for the intruder, but without success. By 10.15 p.m., Mathy's zeppelin was off Beachy Head, and an hour later he descended to 4,000 feet to drop a parachute flare, confirming his location over Selsey Bill. At this point two pilots took off from the Royal Naval Air Station at Calshot and the Portsmouth defences were alerted. The dockyard siren was sounded and its power generator closed down. All eyes turned to the sky. It was jewelled with stars. Gunnery and searchlight teams listened intently for a faint distant drone to intrude on the silent beauty of the night.

Rather than continue to hug the coast, Mathy ordered a steep ascent and a change of course in an attempt to confuse the Solent defences. Zeppelin *L31* stealthily broke the Isle of Wight coast, creeping in directly over Sandown and turning sharply due north, passing over Brading and a few minutes later Ryde. 11,000 feet below, an expanse of inky black sea confirmed her position over the Solent. Attack was imminent. On board *L31*, one of Mathy's engine crew, Pitt Klein, takes up the story:

Then we saw the city in the distance. The view of the enemy's fortress impressed us. Below us zigzagged newly commissioned warships. Dozens of searchlight clusters find us and fix on us. An unearthly concert is unleashed, conducted by Satan himself.

Klein is probably referring here to searchlights and anti-aircraft fire from warships and the Solent forts.

The harbour and dockyard installation was now visible. They sent a powerful searchlight towards us. Our ship was sharply highlighted against the sky making us easy meat for the fleet below us.

This searchlight was to prove critical in the events that followed. George Burtoft, a gun-layer (responsible for aiming guns) manning defences at Whale Island, describes what he saw:

At 23.50 p.m. we sighted her, a long black cigar shape in the sky some 3,000 to 4,000 feet over the harbour fairway ... She was first picked up by Vernon's searchlights,

then surrounded by beams from all round. Then everything seemed to happen at once, Guns from all directions began to fire at her – a lovely target she made.

Portsmouth and Gosport, until then a deeply sleeping couple, were rudely awoken as the intruder hung high between their separate beds. Pitt Klein:

"To the Dockyard! To the Dockyard!" roared Commander (Mathy) to the Helmsman. "We go over there, we must go over there!" The warships below us and the fort batteries fired continuously at us. We had the feeling that there was no way through, and that any moment we would be hit, whichever way we burned. We flew a detour. Up to now we hadn't dropped a bomb.

George Burtoft:

The car suspended below was hauled up when she was over the new battle cruiser *Renown*, which was in dock. It was then that the first bomb was dropped which pitched into the fairway between *Renown* and *Vernon*.

Pitt Klein:

We stayed above the forts and dropped some high explosive bombs. Their explosions were heard even above the general noise of the defensive fire. The bombarded battery was silenced, their searchlights extinguished. The other batteries continued firing. Their incendiaries came ever closer. We must certainly fly higher! Then the telegraph rang three times. "All engines on absolute full power!"

We opened up the throttle; the engines revved up to 1,500 rpm and the noise of the propeller was ear-shattering. The horizontal rudder at the front was adjusted such that the nose of the ship lifted. The airship moaned and groaned everywhere as though it was a living creature. We just didn't know how the ship could withstand it!

The airship's frame swayed against the suddenly increasing air-stream. The ship lay in an unimaginable sloping position. Although all the engines were now providing the maximum power, the ship's position hardly changed. The ice-cold wind whistled and howled through the gondola frame and its supports so making our knees shake with terror. I looked down at the ground below and determined that our position had not changed.

Once more the gondola's telegraph rang three times. "We can't do any more," we thought. "The engines are already at peak power and cannot accept more fuel intake." In the leading gondola the Commander shouted in our ears: "Higher, higher, higher! Jesus Christ. higher, higher!"

George Burtoft: 'I was then ordered to increase the range to 5,000 yards.'

Pitt Klein:

> I must turn off the rear engine; I did it in exasperation and with an aching heart. There was nothing else I could have done due to the peculiar attitude of the ship since the fuel was streaming out in a finger-thick flow from the carburettor. The exhaust valves were glowing. If the fuel vapour had caught alight we would be done for. I aimed my fire extinguisher over the carburettor. I was close to despair, believing that in such a hopeless position my engine would seize!

From the ground the zeppelin was seen to lurch. Artillerymen at Point Battery let out a resounding cheer, believing that one of the guns had found its mark. Pitt Klein:

> We changed our course, flew in a loop and prepared for a new attack. Since we were by then in a normal altitude I turned my engine on once more. I set full throttle so that it produced its full power. It provided sufficient extra propulsion to get us to the other side of the dockyard. Our first bombs were then dropped. Just as a typhoon is unleashed, so spurred on by superhuman effort the artillery from within the dockyard was let loose. The arc of fire below us intensified and came rapidly towards us. In a minute it must reach us.
>
> It did! The commander and the officer of the watch attended simultaneously to the bomb flaps. Machine gun fire crackled all around us. Within a second we dropped 3,550 kg of bombs on to the dockyard, barracks and warships that lay in the harbour. With a violent surge the airship shot higher. As the four clusters of sixteen bombs landed there resounded the typical explosions with a crash, a flame-burst, a thud and a thunder that made us believe the whole world was upside down. The innumerable return shots and explosions from hundreds of incendiaries and thousands of gunshots increased the maddening noise above the chaos of the sinking and the destruction. Removed from this, we stared down on the terrible fires, devastation and ravages; the range and tenacious, intensive accuracy of the defensive ground fire continued to find us.
>
> "Let's get out of here, away now, away! We have completed our task. The mission had been successful. Any second now we could be fatally hit!" Over towards the sea there's a cloud bank. When we have got into that we will be safe. The ground fire is still heavy and accurate. The rage and despair of the artillery intensifies their fire. We desperately throw ourselves towards the cloud bank. The damned nerves, all of our thoughts are directed towards the clouds. The clouds! The clouds! We must reach them! We must!

George Burtoft: 'After dropping several bombs she made off to the east'. Pitt Klein:

> We reach and enter the cloudbank. The worst is now behind us. The nerves now start to relax; we start to breathe more easily. Engines, cabins, the ship, the crew- all is safe! Safe!

From a terraced Gosport street there came a shout. 'Mrs Harbut! ... Mrs Harbut ... Are you all right?'

Mrs Mullins was in her bedroom at number 52, Cobden Street. Like the rest of the population she had been awoken at this ungodly hour. Mrs Harbut was her neighbour. She knocked on the wall.

"Are you all right, Mrs Harbut?"

"I'm all right," came Mrs Harbut's voice through the wall from the bedroom of number 54.

"I'm all right. Are you all right, Mrs Mullins?"

"Yes," replied Mrs Mullins, "I'm all right."

"Goodnight then."

"Goodnight."

Pitt Klein:

We now know what it really means to attack one of the most heavily protected English strongholds. That was far, far worse than over London! Those who didn't know what horror is had certainly learnt about it that night. Commander (Mathy) himself said, "Children, we will not go anywhere near Portsmouth again if we can help it. Give us London any day!"

We had a following wind; with a ground speed of 160 kph we rushed back to our home base. We had to fly along the coast and then over the Channel. Of course, for the duration we were accompanied by the raging force of the coastal batteries and warships, but after the hell of Portsmouth they couldn't change our composure. The aerial that was removed during the attack hung once more outside.

Our attack and the destruction of the dockyard and barracks of Portsmouth, not to mention the warships in the harbour, was transmitted to the Admiral of the Fleet. The Ostende station, like some other stations, after confirming receipt of our message informed us that an English fighter squadron was now criss-crossing the Channel intending to destroy us. Our relaxed nerves were once again sharpened. We climbed to 4,500 meters but the warship fire continued to follow us. We saw nothing of the fighter squadron. At six o'clock the next morning the last of our pursuers was now behind us...

On the basis of Mathy's report, an official statement was released in Berlin, signed by the Chief of Naval Staff, referring to the 'British Naval port of Portsmouth' having been 'lavishly bombarded with explosive and incendiary bombs with visible good results'. During the attack Zeppelin *L31* had, indeed, dropped a heavy bomb load of 8,125 pounds, comprising four 300 kg and fifteen 100 kg bombs, fifteen 58 kg high explosives and thirty incendiary bombs. But what happened to them all is a complete mystery. The dockyard, garrison and warships had been destroyed only on Pitt Klein's flight of fancy. With his airship having been forced to fly at an estimated height of 11,000 feet, accurate bombing had been impossible.

Zeppelin *L31* at its base at Ahlhorn.

Eye witness accounts suggest that the first bombs fell in mid-harbour. These were probably trial-bombs, normally released over the first lights that could be seen, possibly the torpedo school HMS *Vernon*, which comprised at that time three ships afloat in the mouth of Portsmouth Harbour. One of these hulks was HMS *Warrior* (1860), which served as a floating workshop and powerhouse and had been renamed *Vernon 111*. The searchlight referred to by George Burtoft, which first spotted the zeppelin, was manned by Arthur Ferret on the *Warrior*:

> I'd just qualified as a Seaman Torpedo man on Vernon and was one of the three men manning the light – one petty officer and two hands. The searchlight emplacement was aft of midships, mounted on top of a hut. I think it was a Clark Chapman searchlight, or a later version of it. We spotted the Zepp over the Solent coming in for attack. We kept her in the beam. She came right up over Dolphin, over the Harbour and then turned tail towards Portchester Creek. Rumour was that the Captain had been to Portsmouth before the war and knew the area.

Commander Mathy's official report, filed on his return to Ahlhorn, recounts how he was blinded by the searchlights as he came over Portsmouth and could see no details of the town or dockyard. He 'decided to drop his complete bomb-load' and proceeded to do so in an intense two-minute attack. Later, 'by means of four parachute flares thrown out towards the end of the attack, it was ascertained that all bombs had fallen on the city and dockyard'.

According to local rumour the bombs fell harmlessly into the harbour off Horsea Island, though no explosions were reported by observers. This suggests

that the bombs had not been fused. But Mathy's failure to hit the dockyard puzzled defence authorities who knew of his reputation as being the most daring and intrepid zeppelin commander in the entire German fleet. There was speculation that the mission was intended for reconnaissance or that his bomb release gear had failed at the crucial moment.

In Portsmouth and Gosport there was talk of little else for days. Sleepy children were granted a half-day's holiday from school to recover from their nocturnal disturbance, while excited adults exchanged colourful accounts, each claiming to have had the best vantage point.

One thing was clear. The Portsmouth defences remained hopelessly ill-equipped to counter a concerted aerial attack, despite Churchill's efforts. With the exception of a three-inch gun at Southsea Castle and a four-inch gun at Fort Blockhouse, all the guns of the defences proved useless that night. And the two aeroplanes that had taken off from Calshot both sighted the zeppelin but lacked the performance to enable any effective pursuit, let alone attack.

Within days, a squadron of fighter planes was allocated to a new base at Hove to augment the Dover air station and prevent any other enemy airship attempting a flight down the Channel. Later, another squadron was established at Fort Grange charged with the responsibility for the aerial defence of Portsmouth. Other new measures included the mounting of an anti-aircraft gun on a railway truck at Fratton, the intention being that an invader approaching from the south could be pursued as it progressed inland. Another was the mounting of a huge six-inch gun on Whale Island, though use of this was strictly forbidden after practice firing at an angle of elevation of 90 degrees suggested that using it might be counterproductive.

Back in the mess at Ahlhorn morale was low. The crew of *L31* had gloomily discussed the mounting casualties and the loss of dear friends. Talk turned to their own prospects of survival. Pitt Klein:

> It is only a question of time before we join the rest. Everyone admits they feel it. Our nerves are in pieces. If anyone should say that he was not haunted by visions of burning airships he would be lying. Commander (Mathy) acts no differently than of old, but it is only natural that his appearance should become more serious and his features be more sharply and deeply graven in his face. "We will be next, Pitt!" growls Chief Quartermaster's Mate Peters.
>
> "You're mad," I assert. "We've already made 120 successful war flights: we serve under the most outstanding Commander there is. I trust our lucky star!" He looks earnestly at me. "Pitt: you know I'm no coward … But I dream constantly of falling zeppelins. There is something in me that I can't describe. It's as if I saw a strange darkness before me, into which I must go."

Six days after the attack on Portsmouth, at exactly six minutes to midnight, the irresistible pull was initiated by a courageous fighter pilot on patrol over London. Second Lieutenant W. J. Tempest fired his incendiary ammunition directly into the

belly of *L31* at close range. Mathy jettisoned his bomb load to gain height and make his escape: the bombs fell on a residential area of Cheshunt in Hertfordshire. As Tempest fired on with dogged determination he observed his giant prey 'begin to go red like an enormous Chinese lantern.... she shot up about 200 feet, paused, and came roaring down'.

On the crowded streets of London the sight of Zeppelin *L31*, now a fire-ball, gently plummeting to earth through three miles of sky was accompanied by what a *Times* reporter described as 'a shout the like of which I never heard in London before – a hoarse shout of mingled execration, triumph and joy; a swelling shout that appeared to be rising from all parts of the metropolis, ever increasing in force and intensity'.

The crew were burned alive. Tangled wreckage fell in a field in Potters Bar. In the corner of the field a man was found half-embedded in the earth. He had chosen to leap from the plunging inferno rather than slowly burn to death. The identity disc on the body revealed the name 'Kapt Lt Mathy, *L31*'.

In schoolboys' eyes the zeppelin danger brought a novel and thrilling dimension to a war that was otherwise being fought on remote foreign battlefields and seas. The pilots of the Royal Flying Corps captured the imagination of the whole nation, many of them becoming vaunted heroes whose individual courage was tangible and easily identified with. Allusions were often made to St George and his fire-spouting adversary.

The shooting down of *L31* proved a turning-point in the war. Never again did the German Airship Service attempt an attack on London and there were no more inconvenient interruptions to the work of Portsmouth Dockyard. Later in the war a young lad at Penhale Road School proudly displayed to his friends a small section of a duralumin strut he had acquired. It was, he revealed, savouring the envy, a part of the framework of a real zeppelin – the one that had been brought down at Potters Bar.

CHAPTER TEN

The War Effort

A certain unkind and disparaging reputation has, by blind tradition, always been attached to the 'docky' or 'matey'. An old naval song makes the point with direct simplicity:

> We are the Dockyard mateys' sons,
> Sitting on the Dockyard Wall,
> Watching our poor fathers
> Doing bugger all.
> When we grow older,
> We'll be Dockyard mateys too,
> Just like our fathers,
> With bugger all to do.

As we have seen, such cynical comment, however mischievously appealing, had as much authority as a barnacle on the bottom of a dreadnought in the pre-war years, when Portsmouth Dockyard built and launched ever-bigger ships annually and often in record time. This unstinting collective effort continued throughout the war, though the results were less apparent and went largely unvaunted. Shift working was introduced for the first time in August 1914 and from that time on men toiled around the clock to cope with the increased demand on the yard's services. Many were called on to work double the normal working week of forty-eight hours. Some classes of men, whose skills were in the greatest demand, like the riggers, put in well over 100 hours.

On the stocks at the outbreak was HMS *Royal Sovereign*, destined to be the last battleship to be built at Portsmouth. Her launch in April 1915 went unaccompanied by the exuberant displays of patriotism by 60,000 plus crowds that graced the inauguration of her elder sisters, though some effort was made to keep up appearances. Shipwright Edward Lane recalled:

> On the day of the launching crowds assembled to see the sight. The chief constructor escorted the dignitary who was to perform the ceremony to the platform at the bows;

the champagne bottle was broken ... Slowly at first but gradually gaining momentum she slipped into the waters of the harbour until the drag chains brought the ship to a standstill. A wonderful occasion for the spectators, but for the dockyard officials, it was an anxious time. The day before the launching gangs of shipwrights from all over the dockyard assembled with 7 lb mauls. They lined up along the length of the ship, stem to stern, to drive in the slivers (large wedges) in order to take the weight off the building blocks on which the ship was built and on to the sliding ways.

Before the ship could move (some) of the building blocks were removed by knocking out the steel wedges built into each set of blocks. The ship at this stage was in a very delicate situation – in other words raring to go. When all was ready and the ship going down the ways, the watermen in their small boats from Portsmouth, Stamshaw and Gosport would be paddling about like vultures ready to descend on their prey. For with the launch small baulks of timber or slivers made of beech were by no means unconsidered trifles.

This scene heralded the end of the great era of shipbuilding begun just nine years earlier with the launch of the mighty *Dreadnought,* followed down the slips by *Bellerophon* (1907), St *Vincent* (1908), *Neptune* (1909), *Orion* (1910), *King George V*(1911), *Iron Duke* (1912) and *Queen Elizabeth* (1913). *Royal Sovereign* marked the zenith of dreadnought-type battleships, being the largest ever built at Portsmouth. After her completion, 500 men were dispatched to another shipyard to assist in the completion of other ships, though work continued without respite on the first submarines to be built at Portsmouth. Named *J1* and *J2*, they were launched together in 1915 by the flooding of the dock, a somewhat subdued affair in the wake of the pomp and majesty of the dreadnoughts. Three more submarines followed with the equally endearing names of *K1*, *K2* and *K5*.

The dockyard workforce expanded to nearly double its pre-war number to cope with the inordinate demands on its many departments. Some measure of the sheer volume of repair, building and fitting work carried out could be observed from the non-stop traffic passing in and out of harbour at all hours, though principal movements by larger warships were carried out under the veil of night. The most conspicuous vessels were those returning from battle, torn and battered, providing a poignant contrast to the shipshape fleet that had seemed so invincible when mobilised that summer. Now, survivors of Jutland arrived back at their home port under strict orders not to discuss what happened while the *Princess Royal* was brought into harbour for repairs. With two turrets shattered and a gaping hole through her main funnel, words would have been superfluous. Typically, she received a jubilant welcome from every siren in the port.

By 1918, some 21,000 men were on the dockyard books. 'We had every available mechanic in the country,' recalled one of them. 'Anyone who could be collared was sent to the dockyard to do his bit.' But in spite of these efforts the desperate shortage of men persisted, hampering the overall efficiency and performance of the yard. Officials noted that women were beginning to substitute for men in other occupations previously thought exclusively a male preserve, and

E·A·DEPARTMENT·H·M·DOCKYARD·WOMAN
TEA AND CONCERT TO WOUNDED·FEB·24·1917·S·CRIBB·PHOTO

Women dockyard workers put on a concert and tea for wounded servicemen, February 1917.

it was with some trepidation that the first women workers were admitted through the dockyard gates in 1915 to begin unassuming clerical duties. Having been given an inch, women proceeded to take the whole yard, as described by William Gates:

> In the Boiler Shop they were engaged in acetylene welding, in cleaning, picking, galvanising and testing boiler tubes ... on lathes, and drilling, screwing, punching and shearing machines and forges. In the factory they were employed in the working of lathes, planning, shaping, milling, engraving, buffing and slatting machinery, cleaning cutting and testing condenser tubes, making condenser ferrules, cleaning air bottles for submarines and ships, and assisting the mechanics in cutting blades for condenser turbines. In the Gun Mounting Shop they were employed on drilling, shaping, screwing and engraving machines, and also in fitting and adjusting range finders. In the Coppersmiths' Shop they did acetylene welding, the repair of lamps for ships. In the Pattern Shop they were employed in making packing cases, painting patterns, turning wood plugs for boiler tubes and rollers for drawings, and also on the band saw machines. In the Drawing Office they did the tracing of drawings and worked printing apparatus. In addition ... women were employed in driving capstans for the movements of ships in basins, the driving of motor lorries, the making of overalls and flags, electric wiring on board ships, sharpening saws and assisting at the machinery in the saw mills.

This sudden influx of female labour brought fears that the wholly masculine world of the dockyard 'matey' and the traditional esteem surrounding his skills would

be burst apart like a highly-inflated but ultimately vulnerable airship. But a man's working skills were often gained after a lengthy apprenticeship which provided a foundation as solid and durable as the comradeship that existed among the men. Nevertheless, with pride at stake, the perceived 'dilution' of a worker's established trade was taken as a personal affront, striking at the very essence of his manhood.

For one sixteen-year-old apprentice electrical fitter the problem was less to do with entrenched attitudes to work: 'When the women came into the Electrical Department in 1915 it was phenomenal! I can remember them painting the insides of searchlights. I blushed all over! I couldn't bear a woman to look at me or talk to me without blushing all over.' The first women to enter this uncomfortable, unwelcoming and sometimes hostile world felt little sense of the patriotic camaraderie the authorities were trying to encourage. Some ran the gauntlet of abusive taunts, provocative jostling and pushing on their way into the yard. It was, according to one woman, as well to carry an umbrella with you on the trams 'to give as good as you received'. But eventually the taunts subsided and everyone rolled up their sleeves to fight a more pressing war.

One locksmith gained nothing but admiration for his new 'striker' or 'mate'. 'I had a woman allotted to me – Margaret. By gum, she could use a seven pound hammer!' Other aspects of this particular occupation were not without their hazards. 'I taught Margaret how to use a soldering iron – no electric then – none in the dockyard anyway. Now, I told her, now look when you go round the toilets. For heaven's sake wash your hands first or else you'll wonder what's biting you! Cos this sodium zinc chloride, if you get it on your fingers, little tiny black spots, well, they itch like merry hell!'

The new, honorary mateys' working uniforms were unattractive and therefore eminently functional. A mop cap was worn at all times to prevent hair catching in machinery, while every new war-worker was adorned with a polished brass triangular piece of costume jewellery that set off the dull, beige shapelessness of the standard overalls to maximum effect. Individualists found novel places to pin these war badges, or wore their caps at a jaunty angle. By 1917, there were around 1,750 'triangle girls' working in the yard. Initially, they were concentrated in occupations that called upon their perceived tidiness of mind and nimbleness of finger, though they were increasingly employed on hard and onerous tasks and the operation of heavy machinery. One war-worker recalls the variety of jobs she undertook:

> I worked in the torpedo shop, counting and packing torpedo parts under a very strict and stern forewoman called Mrs Sullivan. [Later] I was on the liners where the Germans were imprisoned at Flathouse, cleaning and sweeping the decks. The Germans would stand up on the bridge and watch us … and I worked in the coke stores, loading up the horse and carts and pushing skips of coke into the square.

'Can war work change nature?' a concerned columnist pondered on the woman's page of a local newspaper. 'In other words,' came the elucidation, 'can women keep

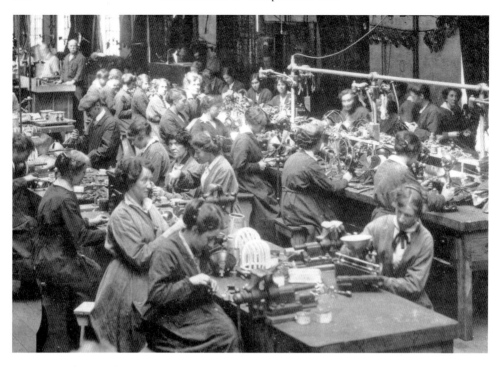

Women workers in the electrical shop at the dockyard.

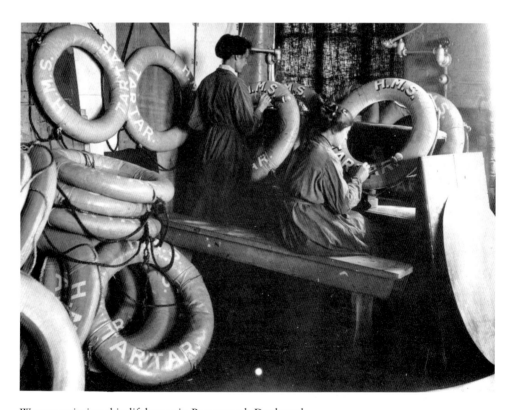

Women painting ship lifebuoys in Portsmouth Dockyard.

the inner softness while exhibiting certain hardiness to the world?' The question went unanswered. There was a war to be won. Women flocked to the munitions factories. At the front an army chaplain wrote of the latest British offensive:

> By George, it's a glorious barrage, and English Girls made 'em. We're all in it, sweethearts, mothers and wives. The hand that rocks the cradle wrecks the world. There are no non-combatants.

In 1915 the gunwharf was transferred to the admiralty while the War Office, which had previously shared its facilities, established a new armament and ammunition department at Hilsea. Together with Priddy's Hard, the Naval Ordnance Depot, these establishments employed local women and girls in large numbers, often on hazardous work such as shell and cartridge filling, work on mines and depth charges and TNT bagging.

One of the perils associated with shell-filling was toxic jaundice caused by TNT poisoning. This condition turned the munitions worker's face a repulsive yellow, earning them the nickname of 'the canaries'. For some this exposure to toxic materials proved fatal.

For the many mothers and housewives unable to 'do their bit' in the war factories, the introduction of 'War bonds' provided a means of symbolically 'feeding the guns' by dipping into their purses. War bonds were, in effect, a loan to the Government to pay for the raw materials and resources to 'finish the job'. Ever-increasing targets were set by Portsmouth and Gosport Councils and each time they were met by their inhabitants.

If rumours were to be believed the guns were not all that needed feeding. Stories began to appear in the press claiming that British prisoners-of-war were being systematically starved by their German captors. Immediately a 'comforts fund' was set up by female volunteers to pay for food parcels. By the end of 1916 there were 180 recipients of these welcome packages, including sailors rescued after the Battle of Jutland. Parcels continued to be sent in spite of increasingly serious food shortages throughout 1917 and 1918. In all nearly 17,000 parcels were despatched containing, amongst other things, Oxo cubes, tinned meat and Huntley & Palmer biscuits.

By the beginning of 1917, an increasing number of dockyard men were discovering that their classification as 'starred', or exempt from military service, no longer applied. Thus began a systematic combing-out of men whose skills could be spared. One apprentice remembered 'there were constant appeals to the dockyard authorities to release us apprentices for the Army. It wasn't until my fifth year (1918) that the Army won. And I had to go into the Army – sent to Gosport as a private in the Hampshire Regiment, Portsmouth Battalion. I didn't care. I thought I was going to die next week, so what did it matter. My friends had already gone into the war and died or disappeared.'

In 1919 the full range and extent of the dockyard's workload was acknowledged with a minimum of fuss and a maximum of understatement. From the declaration of war to the signing of the Armistice, 2,907 vessels docked there, not including a

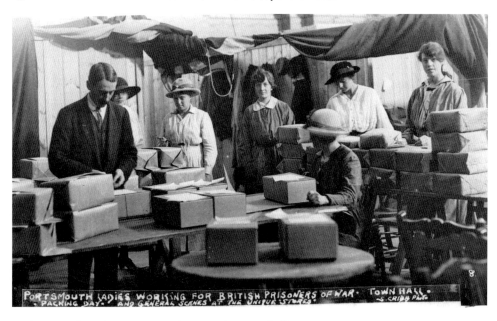

Packing comforts for prisoners-of-war at the town hall.

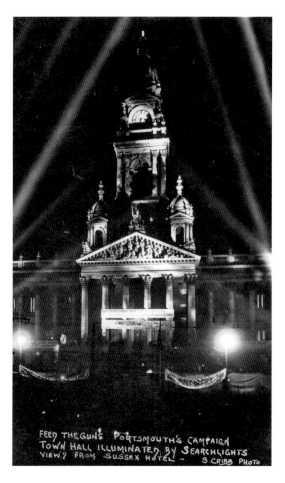

Feed the Guns campaign in a floodlit town hall square, *c.* 1917.

further thousand or more motor launches. Of this a total of 1,200 were refitted, including 400 destroyers, 40 battleships and battle cruisers, 150 torpedo boats, 140 trawlers and drifters, 25 cruisers and 20 submarines and other vessels.

Essential modifications were carried out on many ships including the removal of tall topmasts owing to improvements in telegraphy, thus reducing a ship's vulnerability to aiding enemy range finders. Kite balloons were fitted and used for observation purposes. Anti-torpedo nets and booms, fitted before the war, proved ineffective and were removed and paravanes installed to cut the cables of moored mines. Some ships were fitted with anti-torpedo bulges. Anti-aircraft guns were also mounted and other deck armour strengthened. After Jutland, all ships were fitted with screens to protect them against cordite fires igniting the magazine and Carley floats and rafts were also installed to help save lives. Deceptive painting, including camouflage and dazzle painting, was designed to confuse rather than conceal vessels. The geometric designs, credited to artist Norman Wilkinson, made it difficult for the enemy rangefinders to estimate a ship's type, size, speed and course. Merchant ships were requisitioned to act as decoys, and repainted and reconstructed to resemble battleships with the fitting of dummy funnels.

In addition a multitude of other, diverse and often urgent jobs were undertaken, including the construction of platforms for local air defences, the manufacture of searchlights and the development of anti-submarine mines. Hidden in the awesome sea of statistics were many famous names. They included Admiral Beatty's flagship, *Queen Elizabeth*, which was fitted out with huge 15-inch guns; the *Swill*, the world's fastest ship, which had just sunk four enemy destroyers in the Channel; and the cruiser *Vindictive*, which was prepared in number twelve dock for its role as a blocking ship in the famous Zeebrugge raid. The Mersey ferryboats *Iris* and *Daffodil*, which also took part in Zeebrugge, steamed into port riddled like sieves, their decks awash with blood. The curious could look over them for sixpence. Another vessel with a less heroic reputation, the 'Mystery ship' *Baralong*, passed out through the harbour boom defence in April 1915, disguised as a (neutral) U.S. merchant ship. 'Mystery' or 'Q' ships carried concealed armaments and a naval crew dressed as civilians. They were the brainchild of Admiral Sir Hedworth Meux, the Commander-in-Chief and later MP for Portsmouth. Four months after leaving port, *Baralong* was at the centre of an international diplomatic row after a number of unarmed U-boat survivors were allegedly shot in cold blood by its crew off the Isles of Scilly. One theory suggests that this single incident delayed the entry of the United States into the war, which might otherwise have been over by March, 1917.

U-boats were being used by the Kaiser to wage 'unrestricted warfare' against merchant shipping around Britain's shores. 'We will frighten the British flag off the face of the waters and starve the British people,' asserted the Kaiser with characteristic confidence. Britain's heavy dependence on imported foodstuffs and raw materials provided the Kaiser with justifiable grounds for optimism and the proven efficiency of his U-boats in sinking allied shipping further bolstered his hopes of a total and impenetrable blockade.

Meanwhile, local counter-measures were implemented, including the establishment of a base for special 'hunting' patrols for the purpose of 'harrying submarines' and the utilisation of local trawlers for intensive minesweeping duties in the Channel. But to little effect. By May 1917, British merchant shipping losses had trebled. The Admiralty, which was renowned for its innate conservatism and uncompromising distrust of new ideas, began to clutch, with all the reserve it could muster, at straws.

Unorthodox and inventive brains were admitted to the Admiralty and given free reign on drawing boards. An astonishing plan took shape. It was proposed that a line of 160-foot-high fort-like platforms be sunk across the English Channel, linked by a 20-mile-long anti-submarine net. Testy admiralty officials muttered to each other and nodded their heads in reluctant agreement.

Work commenced on the first two colossal structures in Shoreham Harbour early in 1918, using 3,000 non-combatant workmen drawn from all over the country. But, in the event, the war came to an abrupt end and the Admiralty found itself with two very expensive, gasometer-sized lumps of steel and concrete on its hands. Grey admiralty officials gazed with red faces on their rather conspicuous white elephants. Blushes were saved when one was turned, with little modification, into a lighthouse and sunk five miles off the Isle of Wight, replacing the Nab Lightship.

With the assistance of a following wind, the sound of merchant seamen meeting their deaths off the Isle of Wight could be heard by promenaders on Southsea Common, out for the beneficial effects of sea air on the constitution. During 1917 and 1918 more than fifty large ships totalling 132,000 tons were sunk by U-boat torpedoes or mines within a 30-mile radius of the island. One of the last, the S.S. *Isleworth,* was blown apart with the loss of twenty-nine lives only fifteen miles away from the Ladies' Mile, where those elegant parasols and fashionable dresses had been replaced by black mourning veils and the nurse's cape.

For leisured ladies as yet blissfully untouched by death there were bothersome pressures to tighten one's *à la mode* military-style ladies' belt, purchased exclusively from Handleys at 4s 9d. Those beastly U-boats were making cook's life an absolute hell.

With the British Cabinet vehemently opposed to any policy of compulsory food rationing, every effort was made to persuade the population to adopt a scale of 'voluntary rations'. In Portsmouth an Economy Committee was set up under the auspices of the Mayor. Food Control Campaign posters appeared all over town urging inhabitants to 'Eat Slowly' and 'Thoroughly Masticate Your Food.' Middle class housewives were urged to sign a plethora of pledges promising progressively greater self-denial while humbler folk stared quizzically at advice that 'It is necessary for you to keep within the national rations' of 'only four meals per day'. Other posters gave detailed advice explaining how targets could be achieved. Anything that moved was posted. 'Who is responsible for posting Ministry of Food Directions on the outside of the tram cars?' one breathless man demanded to know. 'The people inside the trams cannot read them and certainly one cannot be expected to run alongside to assimilate the instructions.'

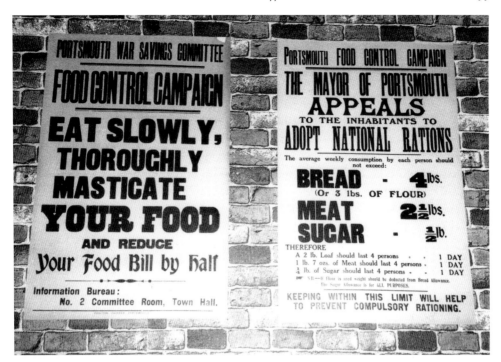

Appeals were posted around the town in an attempt to avoid compulsory rationing of food.

Having covered the trams, the Economy Committee then set about decking out their own headquarters. A 30-foot-long banner in patriotic red, white and blue was affixed prominently on the facade of the town hall. In the course of time this was to create further mutterings of vexation. 'F S I R A V R' ran the bold exhortation. 'We have a lot to learn in the manufacture of inks and colours,' remarked an observer, alluding to the drying up of the traditional source of trusty indelible German dyes. 'On a great many bills and posters displayed in various parts of town the red letters have entirely disappeared. The result in some instances is a little puzzling.'

By the beginning of 1918 it had become clear that hopes of 'voluntary' rationing succeeding were going down the drain as inexorably as soluble British ink. Demand for food was exceeding supply. Butchers' shops, besieged by customers, were hanging up 'Sold Out' signs by mid-day. At grocery shops in Commercial Road and Fratton Road queues that were ten-deep lined the pavements, attracted by deliveries of butter and margarine. Shop windows were reportedly broken in Fawcett Road and Eastney Road. It was widely believed, with some justification, that retailers were selling goods to favoured customers out of the back door while queues waited patiently out front. The editor of the *Evening News* wrote with weary resignation:

The cases of hoarding by the well-to-do and the knowledge that none but the working classes and poor are seen in the margarine or tea queues are a source of

very serious discontent, and an element of grave danger to the public order. Equality of distribution is the only effectual remedy.

In April, 1918, enforced rationing was introduced for meat, bacon, butter, margarine and lard. The queues and complaints all but disappeared.

Another breakthrough in the battle to beat the U-boat blockade was the launching of a national campaign to turn all available land over to the cultivation of food, with some measure of self-sufficiency being the ultimate aim. Arthur Lee, the local MP, soldier and recruiter, had been recognised by Prime Minister Lloyd George as a man of rare organisational and persuasive abilities, and was put in charge of a new Department of Food production. One of Lee's first acts was to grant power to local councils to commandeer land for conversion into allotments, which gave many poor urban dwellers the first opportunity to grow their own food. In Portsmouth the parks committee acquired waste ground from builders and released acres of municipal land for the growing of fruit and vegetables. Hundreds of inhabitants queued up at the town hall for an opportunity to grow carrots in Baffins Park, rhubarb on the Governor's Green and prize pumpkins in Milton Cemetery. For many of the new allotment holders cultivating was a new experience; most soon learned to differentiate between a hoe and a spade, a weed and a vegetable, a callus and a blister. But come harvest time all agreed with pride that it had been worth it.

With parks now dotted with tenaciously territorial allotment holders, children had to find somewhere else to play – the street. 'It is better for them to lose their parks than their food,' one councillor pointed out. But Victoria Park, the jewel in the parks committee crown, remained uncultivated, the chairman declaring emphatically that 'there is not enough soil there to grow potatoes'. He added, defensively, 'You might grow a few bushels in the flower beds but that is all.'

By the spring of 1918 such attitudes had become as rare as a King Edward potato. The country had only two weeks' supply of food remaining. 'This was the deadliest secret of the war at that stage,' Arthur Lee recalled, 'and to the very few of us who were in the know it was as ceaseless and nerve-racking an anxiety as the powers of hell could devise.' 'Back to the Land!' came the clarion call to urban women who had never set foot on a farm in their lives. Hundreds of women answered the call by stepping forward at 'Land Army' rallies in the town hall square, from 'the lithe-limbed hockey girl straight from school' to 'the fragile little typist, pining for the sight of green fields and the tingle of the wind on her pale cheek'.

Romantic pastoral notions did not last. Agricultural work was discovered to be hard, dirty, monotonous and back-breaking. But there were no complaints as sisterly camaraderie and patriotic commitment created a spirit that transcended the ache of exhaustion. Children, too, were involved. At Portsmouth Grammar School, thirty-two boys volunteered to spend three weeks of their holiday to work on the land at Arreton on the Isle of Wight and fifteen farms were supplied with labour. In 1918 Officer Training Corps cadets took part in harvesting at nine farms near Enford and 1,392 acres of corn were 'shocked' in five weeks.

Portsmouth women made up a half of all Land Army volunteers in Hampshire. Other local women were sent to pull flax in Somerset, lift potatoes in Lincolnshire, turn hay on the Sussex Downs and fell trees at Horsham. Dainty typists' hands became as horny and meaty as farmers' wives'. For some combatants in the Land Army this was the supreme sacrifice and many invested in cosmetic creams and lotions for the first time.

Back at the Admiralty a startling proposal was made to further extend the inroads made by women into its affairs. Hitherto, females had only encroached on important naval matters by dint of the disturbing annual statistics of unpleasant diseases that Jolly Jack contracted on his sojourns in the world's ports. But, by the end of 1917, the successful deployment of women in HM Dockyard had contributed to a new perception of their potential. The Women's Royal Naval Service or Wrens was set up and new recruits were immediately imbued with the stirring spirit of Trafalgar. 'Remember,' they were reminded, 'the Empire expects that every woman will do her duty.' Wrens were not, however, permitted to serve aboard HM ships.

The WRNS Headquarters was opened at 18 Lion Terrace, Portsea, in February 1918, but was soon extended to include other premises in Hampshire Terrace. Recruits were drilled in the hastily adapted rules of saluting issued by the Admiralty. Wrens were to salute their own officers, but naval ratings were not to salute Wren officers. Wren officers were not to salute naval officers, but were required to 'bow and smile' if they were saluted by naval officers.

By November 1918, there were nearly 1,200 smiling, bowing and saluting Wrens working in the port on various duties, including making mine nets, acting as signallers, testing valves and carrying out maintenance work on torpedoes and depth charges.

Technological advances, born of necessity, were beginning to tell in the battle to beat the blockade. High frequency sound waves were utilised to detect U-boats, while paravanes and depth charges accounted for many of the hidden hunters. An earlier admiralty decision not to sent British ships out in convoys was eventually revoked and the losses measured in shipping tonnage began to fall steadily. Though food shortages continued, the rationing system ensured that there were 'fair shares for all,' a principle that had never before impinged on the consciences of most civic and national leaders. Attitudes were changing. The tenacity and courage of so many women in filling the munitions factories, the hospitals, the dockyards, the farms and the Services created a climate in which their entranchisement became only a matter of time.

For the 'docky' or 'matey' the zeppelin visit was to represent the highest accolade possible for his contribution to the national war effort, his ceaseless toil going otherwise largely unrecognised. He sought no commendation. The illuminated sign installed above the dockyard gate on the cessation of hostilities read, with simple self-effacement, 'Peace Our Reward.'

The dockyard workers' unions made sure that their members' standard of living was improved in line with the extraordinary demands that were put upon them.

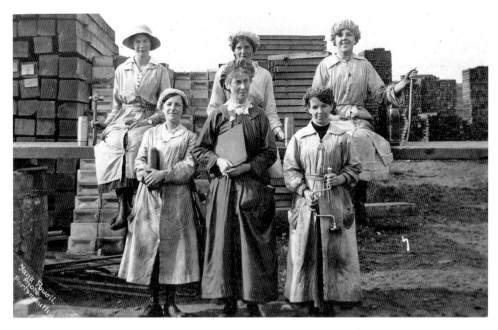

Munitions workers at Hilsea, *c.* 1917. Many women were trained to carry out war work at the Municipal College.

'With overtime being continuously worked,' wrote Edward Lane, 'it was a piano in the parlour, a gramophone or even a deposit on a house.' But while most of the men were better off and some may be said to have prospered, there were no fortunes to be made in the dockyard. These were accumulated by private firms diversifying into munitions production, and by victuallers and other government contractors who put in successful tenders for the supply of a plethora of military and naval requisites from ships' provisions to army hutments. Some idea of the fortunes and misfortunes of war, as experienced by local concerns, are now described under separate headings covering those that played a prominent role in ordinary, everyday life.

The Public House

In 1914 there were 996 premises in Portsmouth and Gosport licensed for the sale of intoxicating liquor; one, it seemed, on every street corner. Some areas comprised little else, with eight in Gosport's North Street area and ten within a few yards of the dockyard main gate. The demand was there, with beer being accepted as an indispensable adjunct to manual work, a fuel as essential as food. For others it provided the only accessible means of escape from the misery and degradation of poverty and slum life.

With husbands away, concern was expressed at the number of 'intemperate' naval wives and, later, widows. This charge was hotly challenged in the columns

of the *Evening News*. More serious was the alarming effect excessive drinking was having on munitions and dockyard workers and servicemen. 'We are fighting Germany, Austria and Drink,' proclaimed Lloyd George, 'and as far as I can see the greatest of these deadly foes is Drink.' The Vicar of Portsea, Cyril Garbett, agreed, speaking of the 'enemy within our gates'. Garbett never hesitated to challenge the many public men whom he felt were 'poisoning the well-springs of civic life' and local brewer Sir John Brickwood continually threatened to withdraw his substantial subscription to Garbett's church if the 'turbulent priest' persisted in his attacks. But the brewing industry was well served by licensing magistrates, some of whom had vested interest in maintaining the status quo. Meanwhile, in the police courts, on the streets and on the mortuary slab the human toll of alcoholism was apparent for those who chose to look.

But it was the effect of excessive drinking on the war effort that forced the Government to address the problem. In April 1915, the King was persuaded by Lloyd George to give up drink for the duration, setting an admirable example that hardly anybody followed. Increasingly drastic licensing orders were enforced under the Defence of the Realm Act to prevent 'drink-related slacking' in the dockyards and munitions factories. Licensing hours were trimmed, beer was legally watered down and the traditional practices of 'buying on the slate' (credit), 'treating' (buying a round) and 'the long pull' (serving more than a standard measure) became illegal. A man buying his wife a drink was liable to six months' imprisonment under these new regulations. But as few drinkers were likely to complain of being 'treated' or of having had the benefit of 'a long pull', special constables laid elaborate traps to gain convictions, though Portsmouth magistrates expressed disapproval of their methods. The law against 'treating' was especially despised, being a popular and traditional custom that expressed a stranger's respect for the departing soldier or sailor.

Inevitably, licensing orders had a salutary effect on the health and conduct of the population and 'slacking' was reduced to a minimum. Nevertheless, because of the considerable military presence there were countless incidents of drunken assaults, several murders and a near-riot of soldiers outside the White Hart in Bury Road, Gosport. There was also a mutiny of eight drunken seamen who refused to join their ship. This was not the first or the last time that the authorities at Portsmouth were obliged to ask themselves: 'What shall we do with a drunken sailor?'

The Tailor

The unprecedented demand for naval uniforms created by mobilisation was met with a ready and willing tape measure by local tailors, many of whom were exempted from military service or 'starred' in recognition of their vital service. Staff at Gieves & Hawkes on the Hard were expected to maintain a high standard of courtesy and efficiency when dealing with clients, as their staff manual for 1909 details:

Welcome your customers pleasantly but respectfully. Be careful in all your conversation, cultivating prudence, caution, modesty as well as good English ... Try to understand your customers' peculiarities, let them see at once that you wish to study their comfort and tastes.

By 1915 the War Office had warned all tailors to 'satisfy themselves that the person to or for whom the uniform is supplied has a good right to wear it,' suggesting that the infamous 'monocled mutineer', Percy Toplass, was not the only war-time fraud. Military and naval tailors expanded as mounting casualties maintained a steadily high demand. Gieves & Hawkes doubled its number of branches nationally to ten by 1918. Several less well-established firms did a flourishing trade in 'deceased officers' kits', promising 'Best possible prices always given. Prompt cash and clearance.'

The Bank

One Dockyard pay-day in 1914, the matey's hard earned wages were 'met with murmurs of discontent'. Instead of the solid and trusted gold sovereign there was, for the first time, a paper pound and ten-shilling note. Paper seemed cheap and ephemeral, but there was an acceptance that 'there's a war on' and that this was a temporary measure to be put right when the war was over. The loss of the pound's symbolic value was soon matched by a decline in its spending power. By 1918 the value of the pound had been reduced by 60 per cent. But in spite of rampant inflation, many families found themselves better off than ever as overtime and women's munitions work supplemented the breadwinner's normal wage. Banks began to attract a class of customer that they had previously disdained.

Another important development in terms of female emancipation was the employment of 'lady clerks' in what had hitherto been a sacred all-male preserve. Initially it was feared that women would, by nature, gossip about clients' transactions. By the end of the war they had proved to be discreet and able, so much so that they outnumbered men by five to one in Portsmouth banks. Now that the prestigious world of banking had been cracked, other doors were left quietly unbolted.

The Domestic Registry

In the early days of war many domestic servants were sacked as their masters and mistresses dispensed with anything they saw as an expendable luxury. It was not long before leisured employers discovered that they were unable to look after themselves. The demand for domestics was revived and by 1915, Mrs Spiers' 'High Class Registry', run from the post office at 41 Stoke Road, Gosport, was advertising vacancies for 'Good cooks, cook-generals, house and parlour maids,

nurses and generals.' This type of employment, however, was already losing favour with young women, many of whom were beginning to expect something more than what life in service offered. Overworked and underpaid, many were virtual prisoners. In 1913, three domestics from Southsea wrote to the press complaining that

> A servant's life on the whole is one continual round of monotony, and I do ask if every fair-minded person doesn't think we deserve more liberty and freedom in our lives as God never meant anyone to be shut away inside brick walls day after day as servants are? We think they should be allowed, for their health's sake, to go out at least an hour every day.

Work in the munitions factories and dockyard offered a greater independence and was considerably better paid. Domestic service began its decline.

The Post Office

By August 1915, Kitchener's call had seriously depleted the staff of Portsmouth and Gosport post offices. But while postmen marched away, women took over their 'walks' with an efficiency and enthusiasm that surprised Post Office management. An *Evening News* reporter observed that the 'lady postmen' showed 'quickness and intelligence' and that 'in the actual delivery they demonstrated an assurance – even to the postman's knock – that gave every confidence in their ability'. Problems that did arise were attributable to an increase in the volume of mail due to the war and to the illegibility of many addresses on letters and postcards sent from the front. Bad education was taking its toll, with many men unable to write their own address, let alone express themselves in a letter to a loved one. The importance of successfully effecting delivery in these circumstances put considerable pressure on postal staff to decipher the 'lead pencil scrawl perpetrated in a dugout at the Front'.

Women were also employed for the first time on the counters of Portsmouth and Gosport head post offices. 'Trim little damsels,' wrote the *Evening News* reporter, 'are to be seen dispensing stamps and dealing with the registration of parcels.' On top of customary duties came the additional workload of handling war separation allowances, receiving telegraphs and paying out war widows' pensions. The post office was never busier.

The Floating Bridge

One morning in 1914, inhabitants on both sides of the Harbour awoke to discover that the chain ferry or 'floating bridge' had vanished overnight. In August the Portsmouth Harbour Floating Bridge Company had been ordered to keep their

Bill-posting and cab driving in Portsmouth – women took over many jobs that were traditionally a male preserve.

vessels under steam at night for transporting troops in case of emergency. The need arose three months later when the ferry was spirited away to ferry troops from shore to ship, probably in the evacuation of Antwerp. The floating bridge did its duty un-camouflaged, sporting a conspicuous red and yellow advertisement for the local brew, 'Brilliant Ales'.

Like other local businesses, many young male employees were lost to the Army, presenting problems for the manager. In a report to the directors he complained:

> Our staff, both ashore and afloat, are composed with a few exceptions, of elderly men, boys and a few inefficient who have not been good enough for military service. While practically the whole of them are lacking in energy and fail to interest themselves in the company's welfare.

Many of these elderly men and boys did, however, find the interest and energy to work long hours of overtime in the company's workshop making shells.

The Landlord

One of the more welcome aspects of the Defence of the Realm Act was a regulation that pegged all rents at their 1914 level. With rampant inflation having effectively

halved wages, this measure went some way to preventing widespread destitution. The landlord, then, fared badly during this period.

Home ownership was almost unheard of among the working class, the costs being beyond the means of ordinary wage-earners. Most people lived in small, terraced houses rented at a weekly cost of between 4s (20p) and 6s (30p) or from 6s to 8s 6d (42p). The social distinction between these separate scales was considered very important. The landlord's weekly knock was often inaudible in some notorious areas.

The Grocery Store

The scarcity of certain provisions had a curious effect on the relationship between grocers and their customers. A local newspaper reported that self-assured ladies issuing patronising commands were no longer to be seen. They had, it appeared, learnt how to be polite and even deferential. 'Nowadays my lady awaits the shop man's pleasure and "Can I have, Have you got?" and "Will you be having?" preclude her list of wants.'

Large, established grocery chains prospered and expanded during the war, in some parts due to the monopoly created by rationing, as people registered with concerns that were able to guarantee supplies. The Pink empire, which comprised twelve grocery outlets in 1914, had added a further thirteen links to its chain by 1920. Some smaller concerns, unable to compete, resorted to overpricing and selling short measures in order to survive. The real profiteers, according to a local workers' conference, were, as ever, the 'market manipulators,' the 'patriotic gentlemen who were fattening upon the life-blood of the nation.' Portsmouth had its fair share of these people.

The Dairy

Members of Portsea Island Co-operative Society were shocked by the extent of milk adulteration and profiteering in the dairy industry during the war, and voted overwhelmingly for their movement to diversify into dairy farming. By 1918 the Portsea Co-op had possession of 325 acres of Hampshire countryside with which to produce a cheap and wholesome alternative. Butter was delivered to shops in huge slabs and cut off as the customer required, patted into shape by wooden spatulas and weighed. Such procedures compounded the problem of lengthy queues. George Dunbar of Copnor remembered waiting in line for five hours only to be told they had sold out.

One of the Co-op's more reputable rivals was the Southsea Dairy Co., which, in common with other businesses, employed women to deliver their products. Half-pint, one-pint and two-pint cans hung from the side of their handcarts or pedal cars for distribution to new customers, while established customers put the appropriate size of can they wanted filled out on their doorstep at night.

The Baker

The U-boat blockade seriously diminished supplies of imported wheat and grain. Following the King's lead, the Mayor of Portsmouth appealed to all inhabitants to sign a pledge promising to consume less than four pounds of bread per week. Later, bakers were permitted to add potato to their flour and people were urged to eat the less-refined but more nutritious wholemeal bread in preference to the customary white. A spokesman for Messrs Rogers bakery in North Street, Gosport, had doubts. 'In my opinion,' he predicted, 'it will never become popular with the working classes. Why? Because they do not like it.'

Another measure intended to reduce consumption also served to prevent indigestion. It became illegal for bakers to sell bread until it was twenty-four hours old. The public could also, under the Defence of the Realm Act, be arrested for feeding crusts to the birds, a law which the parks committee proposed to pre-empt by 'getting rid of' five of the nine swans on the Canoe Lake.

The Corporation

While many working people found themselves better-off, there were notable exceptions, one of the more conspicuously low-paid groups being Portsmouth Corporation employees working in essential services like the electric light and power station, sewerage, tramways, roads and works, parks, cemeteries and scavenging (refuse collection and disposal). As elsewhere, women replaced men, though they were prevented from taking on some notoriously dirty and physical jobs. A suggestion by a local feminist that women be allowed to 'scavenge' was met with a hostile response. 'If she was joking,' petitioned some incensed factory girls, 'it is rather in bad taste; if in earnest, it was an insult to (women's) self-respect.'

While some women sought to maintain their self-respect, scavengers, sewer men and street cleaners were finding it increasingly difficult to maintain their families. By March 1915, they had seen their wage of 27s (£1.35) for a 60-hour week, remain static while the cost of living had leapt by 26 per cent since war broke out, due in part to profiteering. The Finance Committee, under the chairmanship of Councillor H. R. Pink, rejected the men's demands as too costly as it would place an 'unfair burden on the ratepayer'. One year later, with the men's wages having been effectively halved by inflation, the Municipal Employees Association balloted on what action to take in the face of the council's continued intransigence. The matter was not helped by their refusal to recognise or negotiate with the men's union.

'Portsmouth Town Council,' argued a union leader at the Trades Club in Fratton Road, 'is the only one in the kingdom that has refused to acknowledge the principle of combination and the only one that has refused to pay an increase.' Local clergymen expressed their sympathy for the men's plight. The Revd Blackburne of St Mark's accused the council of being 'behind the times,' while the

Revd Pearce Carey of Lake Road Baptist pointed to the 'long hours and repulsive nature' of the men's work and prayed for the council's 'generous treatment' of their claim. But nobody was listening. The union's request for the matter to go to arbitration was rejected, feelings ran high and the men embarked on a strike arguing that they simply could not live on their earnings.

And so began a long and acrimonious industrial dispute; on one side there were some 600 men, nearly all with families to feed, and on the other there was the Finance Committee, which steadfastly refused to follow the Government's lead in working with the unions for the duration. Industrial relations was something to be practiced by others, preferably with the lights out.

Power stations were kept going by volunteers and 'blacklegs' who, according to the union, were bribed with beer and spirits to work 140 to 160 hours a week. Meanwhile, dustbins went un-emptied, streets were un-swept and drains remained blocked.

The population of the town was divided over the action of the men. A petition bearing several thousand signatures in their support was delivered to the town hall. Others denounced them as unpatriotic and selfish, advising them to emigrate to Germany if they did not like it in Britain. An anonymous letter from a 'Tommy's wife' recommended that they 'join up like men' because their 'wives and children would be far better off'. She went on, 'The women of Portsmouth are not afraid to sweep their own gutters. I have done mine since the strike, and it looks far cleaner than it did before.'

At the town hall, attempts by the Government to intervene were snubbed and the strikers' jobs appeared in the 'Situations Vacant' columns of the local press. Permanent employment was offered to prospective replacements. The strike collapsed.

The Garage

The formation of the first two wartime squadrons at Fort Grange began in October 1914, prompting an urgent demand for ground crew. Many men were recruited after direct appeals were made to the handful of garages in the Portsmouth area. Motor mechanics were considered ideally skilled for the servicing of the new and fragile machines of war. The motor car itself was comparatively new on the roads, though the sight of one was no longer a novelty. In 1914 there were 2,132 motor car licences issued in Portsmouth and garages were expanding to meet the burgeoning demand for the rich man's toy. A Morris Oxford cost 190 guineas (£199.50) 'complete and ready for the road', which represented a fortune to ordinary folk. But in spite of the cost and the obvious pride owners took in their new status symbol, members of Hampshire Automobile Club made the supreme sacrifice and placed their vehicles at the service of the military.

Restrictions on the use of petrol were imposed early in the war and were progressively tightened along with regulations regarding car lighting. It became

an offence to drive at more than 10 mph in Portsmouth at night and 'speed traps' were set up by policemen armed with stopwatches. Apprehended motorists argued that in the blackout they were unable to see their speedometers. By 1917, the number of accidents due to careless driving broke all records, provoking the comment from one councillor that 'he did not know of any town in England where the driving was worse than in Portsmouth'. Posters appeared exhorting motorists, 'Don't use a motor car for pleasure,' though it seems that this advice was only heeded by a minority. Perhaps the posters could not be read because of the blackout.

The Market

By 1915 about 120 local fishermen were employed on minesweepers, patrol boats or other war-services, causing the Chief Fishery Officer to report an abrupt decline in the catch returns. The traditional fish market on the Camber at Old Portsmouth was later suspended as the yield was further cut by U-boat activity in the Channel.

Market day in Commercial Road and Charlotte Street appears to have continued unabated notwithstanding the dire shortages of vegetables and fruits. The Charlotte Street market was noisy and colourful, with stallholders and itinerant traders dealing in a wide range of diverse articles and services. But if there were no potatoes, there was plenty on which the eyes could feast, as this vivid pre-war portrait from 1914 describes. The scene is set at just before twelve o'clock on a Saturday, a little before the dockyard men come out of the Unicorn Gate to go home for their midday meal:

> No other street in the town can vie with Charlotte Street in the range and variety of the goods displayed for sale. Fruit, flowers, vegetables, animals, sweets, old linen, books and papers, scrap iron, second hand furniture, cheap looking oil paintings, are all to be found on these stalls. Anything in the second-hand line, from a rusty nut to a wardrobe, can be had, supposing, of course, you have any use for either of these articles, including disused electric glow lamps, spectacles, and boots and collars in all stages of utility.
>
> When business is brisk the street is a perfect Babel. Hoarse, raucous-voiced vendors shout unintelligible praises of their wares, without seeming to attract the slightest attention from the crowds of dockyard men going home to dinner. The noisiest of all are the sellers of sweets and oranges, who keep up a continuous and monotonous patter, in striking contrast to the silent old women who sit by the secondhand stalls and watch the workmen picking over their stuff. What use on earth can be found for some of the material displayed for sale is more than I can say, and yet, since these heaps of rusty old keys, and scraps of leather, and antique fragments of bicycles do find purchasers, it is to be presumed that the ravages of time have not yet divested them of all usefulness.

Most interesting of all, and saddest of all, are the books. Surely a book has descended to the utmost depths of degradation when it lies here tumbled with a heap of others marked "all these 1*d* each". This leather-bound volume of sermons by some forgotten divine, or that *Life and Times of Calvin* have seen strange things since they issued new from the press some fifty or sixty years ago and were bought for half-a-guinea by some clergyman or theological student. Such, however, seems to be a common fate of religious works, judging by their preponderance on the stalls.

Besides the regular stall-holders, there gathers at the corner of Charlotte Street and Unicorn Road, a number of itinerant vendors whose methods afford a valuable lesson in the art of advertising. One discovers here that there is an art in the selling of boot laces, or cheap purses, or pens. Witness the bootlace seller. Having spread around him on the road a large sheet of paper, a heap of laces, and a large iron weight, he takes off his coat and begins to talk, while a crowd of workmen collect round him. He talks of the annoyance caused by the frequent breaking of bootlaces, of the need for a really strong make, of the fact that it is cheaper in the end to buy good laces, even if they cost rather more to begin with. He proceeds to demonstrate that the laces commonly sold in shops are shoddy. He takes a lace from one heap, grasps it in both hands and gives a sharp tug – it snaps. He takes another and tries to lift the weight with it – this one snaps too. Then from the other heap, his own laces, he takes one and repeats the tests – try as he will, he cannot break it. Obviously, then, the price he charges, threepence for two pairs, is ridiculously low for a lace that absolutely cannot break.

More noisy and more voluble ... is a man in a red jacket and very much battered top hat, who sells purses, tobacco pouches, and such-like articles, accompanying the sale with a running commentary, interspersed with snatches of music-hall songs, delivered in an indescribably raucous whine. The sale is conducted somewhat as follows, "Ere you are, gentlemen ... real crocodile purse ... come straight from Rorke's Drift; shot it meself when I was 'unting in South Africa with Sir James Dewar ... Dew-ar ... going for eighteenpence ... a shilling! ... sixpence!! I tell you what, look at this tobacco pouch – covered with fur from a real live teddy-bear ... shot in the wilds of Gosport ... the two together for sixpence ... right sir! You've got a d----d good bargain ... we don't give any change here ... all right, he looks big, give it to him," (this is to the boy who assists him), with much more in the same strain.

Finally, there is the quack medical practitioner, who extracts teeth free on Saturday mornings, and in the interval lectures to the large crowd which always gathers round his wagon. For some reason or other he wears his hair hanging down to his shoulders, and sometimes dresses in a costume which seems to be a cross between those of the cowboys and the Indians in cinematograph drama. He has a great contempt for the other cheapjacks around him. "If we can't have fun without vulgarity," he says, in pointed reference to the raucous-voiced man in red, "then for Heaven's sake don't let us have fun at all," and when a more than usually high-pitched effort interrupts his discourse, he makes a contemptuous allusion to "some people who ought never have been let out". He is, or appears to be, a public benefactor. "You all know my shop," he says, "If there's anything wrong with you, come to me. It doesn't matter if you

haven't any money. Come just the same – but if you have a shilling or two, bring it along. I shall be glad of it."

The Undertaker

The scale of the killing on the battlefields of Europe brought about a shift in public attitude to the fact of death, with a new pragmatism replacing old, unfashionable sentiment. Elaborate and expensive Victorian funeral ceremonial was increasingly seen as inappropriate and even vulgar at such a time. Traditionally, the competitive spirit of the self-made man or high civic official extended beyond death as he strove to put his neighbour's tombstone in the shade of his own individualised and ornately carved monument. His war was lost but he battled on.

In the Somme mud there was no opportunity or inclination to indulge in such one-upmanship. And, at the bottom of the North Sea, thousands of men shared huge, rusting communal tombs.

With a trend towards the modest funeral at a moderate cost the undertaker, contrary to popular myth, did not prosper through the war. Trade was constant with preventable diseases, as always, taking their toll. The death rate in Portsmouth was, however, higher than the national average, though deaths of wounded soldiers in local military hospitals were not included in the statistics. In February 1915, tenders were invited for 'military funerals and window cleaning' in the local press. Buying coffins in bulk saved money.

There was stiff competition between undertakers. Morants Ltd offered funerals and cremations conducted with 'reverence and economy'. Mourners could be hired to swell the numbers and this company offered a discount for their attendance at servants' funerals. One supposes their passing warranted fewer tears.

Other companies that buried people as a sideline, included Handleys, and John Dyer Ltd. Another rival, W. J. Groves of King's Road, continued to advertise 'arrangements ... to all parts of the Continent' in the spirit of 'Business as usual'. This particular service did not last. Before very long the Army authorities were making their own arrangements; estimates were made before each battle of just how many mass graves would need to be dug. At home the traditional public display of grief, the wearing of black, was practiced by all classes. Children wore black arm-bands to school while widows visited Marshall's Mourning Departments in Norfolk Street. One week after Jutland, Marshall's announced

The new shop, which we have added to our Mourning Department on the opposite side of the road, we think will contribute to your comfort when shopping. We now have a separate shop for black costume and dresses. We were so crowded yesterday that we had to hurry our builders to give us the use of this shop at once.

A Little of What You Fancy

She had sensed his interest from the very first time their eyes had met across the crowded pews. The tall, dark, respectably-dressed stranger had become a regular worshipper at the Albert Road Wesleyan Chapel and it seemed clear that he was not as attentive to the preacher's message as perhaps he should have been. His pleasant, smiling face scanned the congregation and sought her out at each service, she was sure of it. He was not handsome, but neither was he unattractive. She averted her eyes as modesty demanded, but in the depths of her heart she knew that *this* was it and the hymns and prayers became a swirling backdrop to a story as old as man himself.

Alice was a stout and jolly twenty-five year old who felt that, still unmarried, she was in danger of being pushed to the back of a very high and dusty shelf. She had arrived in Portsmouth in 1910 to take up an appointment as a private nurse to a retired banker, a Mr Holt living in Granada Road, Southsea, where she was given her own room together with a very good salary. But, after three long years of caring for her ailing, elderly employer, she was ripe for new experiences. There must surely be more to life than this. Then, one day, early in October, 1913, our maiden's prayer was answered. The tall, dark stranger followed Alice out of the chapel and introduced himself. His name was George and he was an artist. He specialised in 'flowers and figures', though really this was no more than a hobby because George had no need to work for a living because he was a gentleman 'of independent means'. Within a matter of days the romance had blossomed into an irresistible fruit – a proposal of marriage! Alice grasped it with both hands. Joyfully, she wrote to her sister in Wembley to break the good news:

Granada Road
Southsea

Oct 1913

Dear Rose,
I have had a proposal of marriage from an exceedingly nice gentleman, George J. Smith. George was brought up Wesleyan and is 40 years of age but does not look it. When George proposed to me he brought his bank books and private papers to show me

he can afford to keep a wife comfortable, without business. His idea is to have a nice villa house in the country and, as he says, it will be our own faults if we don't realise all the happiness we are now looking forward to I am so happy, Rose dear. My heart and soul thank God continually, for joining me to the love of so good a man, a perfect gentleman, very homely. You cannot fail to like him, so genuine and kind. I am the most fortunate and happiest girl in the world.

Alice

George, too, was delighted that Alice had accepted his proposal and immediately made the necessary arrangements to be married by special licence at Portsmouth Register Office. Alice gave up her job and tied lodgings and moved into the house where George had apartments, in Kimberley Road. Under the watchful eye of the landlady, a Mrs Annie Page, they occupied separate rooms. Mrs Page ran a respectable house.

Before they were to be married, Alice's parents invited the happy couple to stay for a few days at their home in Buckinghamshire. George courteously accepted and attempted to put their minds at rest about their daughter's sudden betrothal:

Kimberley Road
Southsea

23rd Oct 1913

Dear Mr Burnham,

I am looking forward to coming to (Buckinghamshire) to see you. You mentioned in your last letter whether we understood each other. My answer to that question is Yes and what is more we love one another ... I could make myself happy anywhere so long as Alice is with me ...

G. J. Smith

Two days later the loving couple arrived at Alice's parents' home to a disappointingly lukewarm reception. Mr and Mrs Burnham were elderly traditional conservatives, irretrievably Victorian in outlook. They could have no memory or understanding of the intense passions of youth, the throbbing impatience and powerful desires, the heady, irrational drives...They refused to give their blessing to the union, much to Alice and George's distress. But the bond between the two survived the parental disapproval and they arrived back in Portsmouth more determined than ever to tie the knot and consummate their undying love. The union was made in St Michael's Road Register Office by Registrar W. Wilson on 4 November and the couple retired to their apartments in Kimberley Road. For Alice it seemed as if life was just beginning.

Five weeks later the newlyweds set off on honeymoon to Blackpool. The Golden Mile in bleak midwinter looked untarnished to the promenaders locked arm-in-arm and in love. Nearby, the Winter Gardens provided an opportunity for a romantic *tête-à-tête* over tea for two, while in the evenings the tables were cleared for dances and concerts, for fun and laughter.

On 12 December, Alice penned the obligatory postcard, addressed to her mother who had been less unsympathetic than the uncompromising Burnham patriarch. 'I have,' she confirmed, 'the best husband in the world.' Alice posted the card and arranged with the boarding house keeper to have a bath that evening. It was while she was taking that bath that George murdered her.

Several days later, Mrs Annie Page picked up a postcard from the hall mat of her Kimberley Road home. The Blackpool postmark and familiar writing told her that she had not been forgotten. The message, however, in George's hand, told of how poor Alice had tragically died while taking a bath.

The *Blackpool Gazette* described how George Smith had 'suffered acutely while giving evidence' to the district coroner. His account of how he discovered his beloved wife's drowned body moved the coroner to describe the circumstances as 'very painful'. A verdict of 'accidentally drowned' was recorded, it being concluded that Alice had a 'fit or a faint' and had 'fallen helpless into the water'. George Smith attended the funeral and returned to Portsmouth.

He appeared grief-stricken and Annie Page offered her condolences, asking how poor Alice had looked after death. 'Her face,' he reflected with touching sensitivity, 'was very much smaller than in life.' Alice's clothes were tied into a bundle and taken away by a messenger boy while Smith visited his solicitor in the town hall square and his insurance agent in Southsea, flourishing her death certificate and a completed claims form. He had not wasted any time in those weeks between his marriage to Alice and their departure for Blackpool. Lovestruck and submissive, she had been persuaded to make a will bequeathing her substantial savings and jewellery to him. Smith had also insured her life for the sum of £500 with the local branch of the Mercantile Insurance Company. These arrangements were finalised and signed by Alice on the day before they set off for the fatal honeymoon.

After deducting overheads – the marriage, the courtship, the honeymoon and the funeral – a healthy balance remained for Smith to re-invest in annuities. These were added to other investments he had made after killing another wife the previous year. This way, Smith's enviable lifestyle and prestigious status as a man of 'independent means', was maintained.

Just before the Christmas of 1913, George J. Smith packed his bags and left Portsmouth for good, taking with him the condolences and best wishes of his landlady, together with his collection of wedding rings. War came and it seemed as if the world endorsed his perception of the value of human life. A year after leaving Portsmouth, Smith married and murdered another bride in the bath. Yet another investment policy was added to his already substantial portfolio. But Smith's impatience in realising his assets on this occasion was to prove his downfall. The inquest on this victim made the national papers because of the

novelty of a bride dying on the day after her wedding. The bold headline caught the eye of Mr Burnham who immediately notified Buckinghamshire police of the curious similarities with his own poor Alice's fate. Investigations revealed that Smith, using a variety of false names, had married at least six times and separated countless other young ladies from their savings. The title of a popular song of the day made a humorous inquiry that would have had Smith stop and think:

> Hello! Hello! Who's your lady friend?
> Who's the little girlie by your side?
> I've seen you with a girl or two
> Oh! Oh! Oh! I am surprised at you
> Hello! Hello! Stop your little games
> Don't you think your ways you ought to mend?
> It isn't the girl I saw you with at Brighton
> Who, who, who's your lady friend?

Every week for six months the lurid details of Smith's past made headline news. Readers immersed themselves in the steamy saga of the 'Brides in the Bath', welcoming it as a manageable alternative to the rolls of honour that dominated the inside pages. Here was a story of warm, innocent hearts and steely, wicked intent; of selfless trust and heartless betrayal; of simple goodness and calculating evil.

The Old Bailey was the setting for the climactic *denouement* and an all-star cast gave it everything they had. Edward Marshall Hall, the flamboyant and celebrated advocate of hopeless causes, defended Smith with characteristic energy and skill, though his performance was somewhat inhibited by the fact that his client was as guilty as sin. But far from being tempted to repent under the shadow of the noose, George Smith negotiated a tidy sum for his life story and decided that, upon his acquittal, he would tour the music halls with an act based on his experiences as a bigamist. He was assured of top billing. His confidence in Marshall Hall's abilities were not, however, shared by Marshall Hall who, in his closing address to the packed court, posed the question, 'Could any man, who was sane, commit what was, if the prosecution were correct, one of the most diabolical series of crimes in the records of any country?' The jury took twenty-two minutes to answer. In Maidstone Prison, six weeks later, a man named Ellis judicially snapped Smith's neck. Enormous crowds gathered outside the prison gates to celebrate the occasion. Newspapers gave more coverage to the execution than to the decimation of a division on the battlefield in France.

The 'Brides in the Bath' murders may have prompted some young ladies to look a little more closely at their intended, but the marriage statistics for the remaining war years showed a rapid increase. A concurrent wave of bigamy swept the land and was mostly in evidence in areas with a high concentration of servicemen. Portsmouth Police Court presided over a number of cases, mostly involving sailors whose argument was that women would 'give you nothing' unless there

was a promise of a ring. Men were not always the guilty parties in these illegal unions. One local soldier married his sweetheart in 1915 and spent four days with her before being drafted overseas. Three years later the hero returned to find her married to a leading seaman. Competition for 'Pompey lasses' was often intensified by the colour of a rival's uniform and on several occasions inter-service antagonism ended in punch-ups – personal honour was not all that was at stake.

Prostitution was practiced by an increasing number of women, unable to scrape a living by any other means. Many were widows or had been abandoned, and most were mothers who were prepared to do anything to feed and clothe their young children. The act of selling sexual favours was not, in itself, an offence though the police occasionally prosecuted individuals for offences associated with this thriving cottage industry. But, on the whole, the authorities appear to have followed a policy of peaceful co-existence, perhaps in recognition of their plight but more probably because of the social function of prostitution in a busy naval and garrison town.

Prostitutes, then, could ply their trade freely provided they were reasonably sober, polite and discreet. But it is clear that many were alcoholics and others needed a drink to come to terms with what they were doing. One drunken woman was arrested in the town hall square after trying to pick up a policeman. Another favourite haunt was under the nearby railway arch, where the narrow pavements facilitated surreptitious negotiations. Respectable ladies dreaded having to pass through this way and some complained indignantly to the press of having been accosted by coin-jangling men who had mistaken them for 'painted ladies'. They could gain some comfort from the fact that under the arch the light was not good.

For 'Jolly Jack' the dangerous months at sea had only been bearable by the self-promise of a 'dicky-flurry' involving a great deal of drink and female company, not necessarily in that order as this popular naval song celebrates:

I hopped up to the gangway and I hailed the picket boat,
I landed safe in Queen Street being just three years afloat,
With my bundle on my back and my pusser's crabs so neat,
I jammed my helm well over and I steered for Voller Street.
Singing hi diddly hi hi ho …

The notorious Voller Street area housed the poorest and cheapest prostitutes in Portsmouth. Lying to the east of Commercial Road, bounded on the south by Crasswell Street and on the north by Lake Road, this area was made up of small, dark, narrow streets where 'every species of crime and lust and immorality' could be found in rows and rows of cramped, decrepit, 'ill-kept hovels'. The police appear to have given this area a wide berth, preferring to concentrate their depleted wartime resources on apprehending prostitutes plying their trade in respectable areas. The arresting officer in the following case, a detective sergeant with the unlikely name of Hoare, gave evidence against two women who ran a brothel in Ashburton Road:

They kept observation on the house on the night of Tuesday, Wednesday and Thursday. Both women were seen to enter the flat with Service men. At about midnight on Thursday the flat was raided. The officers knocked at the door and were kept waiting for twenty to twenty-five minutes. A window was then opened by and on her being told by the Sergeant that it was the police the door was opened. In the bedrooms occupied by the defendants were evidences of what had been transpiring and in another part of the house a man was found hiding.

The outrage provoked by such cases was prompted not by the act of selling sex but by where it was being sold. Disgusting practices had no place in respectable neighbourhoods and anybody who transgressed recklessly invited the ire of elderly magistrates who had a lifetime's experience of upholding that great Victorian tradition of hypocritical moral propriety. Another brothel, set in the heart of fashionable Southsea, attracted strong condemnation, 'disgraceful in the extreme ... very serious,' muttered the judge whose horror was not assuaged in the least by the fact that 'officers only' were admitted. This 'elaborately furnished good-class property' was situated in Lowcay Road, an address which, like the previous house, was immediately identifiable as a brothel by the presence of a number of policemen loitering on the pavement outside:

Observations were kept on the premises by Durrant and other officers, and eight well-known women, accompanied by Naval and Military Officers, were seen to visit the house at frequent intervals. When the house was raided at twelve-fifteen on Sunday morning, prisoner admitted that she had used it for immoral purposes and had had a "jolly fine time".

Generally, though, prostitutes worked alone or in pairs and led miserable and squalid lives plagued by a war-time venereal disease epidemic and blighted by the fear of misuse and, not least, the ever-present possibility of being beaten or even murdered.

In peacetime the subject of 'social diseases' had been surrounded by a conspiracy of silence, sustained with little regard for the long-term untreated and fatal effects of paralysis, heart disease, peritonitis and madness. More than 50 per cent of blindness in newborn babies was attributable to syphilis and with it not being a notifiable disease, no statistics were compiled of the extent of this suffering. One of the reasons for this neglect, according to a Report on the Health of Portsmouth (1916), was the 'social and religious point of view of venereal disease as a just retribution for sin'. But while the well-heeled sinner received painful but ultimately effective treatment, the poor resorted to cheap back-street quack pox doctors whose remedies were as peculiar as they were dangerously ineffective.

In 1917 a Royal Commission on Venereal Diseases examined a number of allied troops 'drawn from the better classes' and found that an alarming 15 per cent were infected. Some voices of authority spoke of a sinister German plot to cripple the British Army, suggesting that Steinhauer's agents were plumbing new,

unimaginable realms of patriotic commitment. But there was a less complicated reason why an estimated 10 per cent of the populations of naval and military garrison towns like Portsmouth were infected with syphilis.

This crisis proved an unprecedented editorial from William Gates in the *Evening News*:

> To our discredit and terrible loss (it) has too long been neglected by the authorities, whose fear of offending the susceptibilities of the prudish and the intolerant has submerged their sense of duty and thereby consigned tens of thousands to suffering and to death. Thank God the war has torn away the mask of false modesty and simulated shame and opened the eyes of the nation to the prevalence of this awful scourge.

William Gates was unable to bring himself to state publicly what 'this awful scourge' was, but his prominent acknowledgment of the scale of the problem signalled something of the shifting morality of a nation at war; Victorian double-standards were becoming increasingly seen as impractical and out-of-touch. The scourge was boldly named by an eminent member of the Royal Commission speaking to a mixed audience drawn to the town hall one evening. While servicemen, civilians and 'women of all classes and ages' were being educated, the Medical Officer for Portsmouth announced a 'most important departure in public health administration', namely 'the provision of free medical treatment for all persons suffering from venereal diseases', believed to be the first in the country. Within two years of its opening, the clinic at the Royal Portsmouth Hospital had treated more than 20,000 cases.

The majority of those infected were men and yet, in the eyes of the law, VD was a woman's disease. A regulation in the Defence of the Realm Act made it an offence for an infected woman to have sexual intercourse with a serviceman, but not for an infected serviceman to have sexual intercourse with a woman. Prostitutes were jailed under this act, though a small number of younger offenders were taken away from the corrupting environment of Portsmouth to a Christian rescue home in Fareham. At Willow Lodge, they were cured and found alternative employment.

Prostitutes who were jailed found that prison was no comfortable refuge from life on the streets. While sentencing some poor wretch, the magistrate would add the gruelling disincentive, 'with such hard labour as possible', if the mood took him. Upon release, it was back to business as usual; older, broken, more fearful and desperate in a world where disease was by no means the only threat to life and limb.

Between 1913 and 1915, three prostitutes were brutally beaten to death, the first in Chalton Street, another in Voller Street and, later, another in Stone Street. (There was yet another in Blossom Alley in 1923.) All went unsolved. Despite what the Coroner described as the 'almost identical circumstances' of the murders, there was no evidence of any Jack the Ripper figure having stalked the

Portsmouth slums. They appear to have been isolated murders, made more tragic and poignant by the implicit assumption that if they did not deserve their fate then they certainly invited it. Little serious effort appears to have been expended in trying to catch the culprits.

But the 'oldest profession' continued undaunted. Like another 'game' being played in Europe, the participants minimalised the risk in their own minds in order, simply to survive.

The Stone Street murder victim left three young children, all fathered by anonymous, long-forgotten clients. This was not untypical; without widespread knowledge of, or access to, methods of birth control, prostitutes could expect an increasing number of dependents to feed and clothe, putting ever more pressure on them to earn more. But failing health and ageing looks inevitably conspired to make this impossible. The result is best described by an advocate of social reform who visited the Voller Street area in 1914:

> The children! That is the pity of it. The place swarms with them, unkempt, ill-fed little creatures who make one's heart ache to see them. Poor little mites. It might well be said 'Abandon hope all ye who enter here,' for what hope can there be for these little ones, nurtured in vice and crime from their earliest years. They have the same heritage to a fair chance in life as your child or mine, but what opportunities have they to become honest and decent men and women?

While not everyone could make a connection between impoverished slum environments and the character and behaviour of people brought up in them, the Portsmouth and District Church Council led the way in practical efforts to prevent the situation deteriorating further. 'Women's Purity Patrols' were set up to supervise the most notorious areas where 'street temptation' had been highlighted by the influx of smart, brave young soldiers training in local camps and jolly sailors on leave. Lord Kitchener's advice to his army – advice that he followed himself with an iron will – was to 'avoid any intimacy' with women. It seems, however, that many of his men were deafened by the roar of guns and did not hear Kitchener's other call.

They arrived in Portsmouth hopeful of experiencing something of life while they had the chance. The objects of their attention were 'girls from sixteen upwards who, excited, giddy and thoughtless, were beset with dangers'. Amorous, entwined couples were rooted out from under bushes and prised from shop doorways by matronly women who, bristling with a powerful and unwavering moral purpose, gave the sinners a good talking-to. The advice given to these officially sanctioned patrols was echoed in the words of a pre-war ballad, 'Never Trust A Sailor':

> One day came a sailor, A sailor home from sea, And he was the cause, Of all my miseree.
> He asked me for a candle, To light him up to bed, He asked me for a pillow, To rest his weary head.

And I being young and Innocent of harm, Jumped into bed, Just to keep the sailor warm.

And next morning, When I awoke, He handed me, A five-pun'note.

Take this my dear, For the damage I have done, It may be a daughter, Or it may be a son.

If it be a daughter, Bounce her on your knee, If it be a son, Send the bastard out to sea.

Bell bottomed trousers, And a coat of navy blue, And make him climb the rigging, As his daddy climbed up you.

Never trust a sailor, An inch above your knee, I did and he left me, With a bastard on my knee.

More popular than this brutal ballad was a song sung in the musical halls by male impersonator Hetty King. She proclaimed with unashamed gusto that 'All the Nice Girls Love a Sailor!' Another immensely popular number asserted 'There's a Girl for Every Soldier,' and so there was.

Many women were beginning to enjoy a certain degree of independence and with it self-confidence derived from their new status as Wren, dockyard or munitions workers. And together with a pervasive awareness of the transience of life, the straitjacket of Victorian propriety began to be discarded with varying degrees of readiness. As one woman put it, 'How and why refuse appeals, backed up by the hot beating of your own heart, or what at the moment you thought to be your heart, which were put with passion and even pathos by a hero, here today gone tomorrow.'

Women in the newly established military services, in particular, were suspected by reactionary moralists of suffering from an inability to say 'no'. There were, however, dangers in casting public assertions. The *News of the World* reported that two respectable, well-dressed ladies had been tried for implying aloud in a Portsmouth Street that girls in khaki were undignified and promiscuous. The patriotic magistrate was tempted to jail them but imposed a fine instead. They had suffered enough and would probably rather have gone to prison than into the *News of the World*.

Laxity in service girls' behaviour was not tolerated by the top brass under any circumstances. A Wren seen being embraced by a man in the Rock Gardens on Whale Island was severely admonished before the rest of her detachment. The man in question was a sailor, which made the matter infinitely worse. He, and all other bluejackets, were warned that 'the East end of Stamshaw Bridge was the limit for osculation'.

The worst fears of the guardians of public decency were realised as the hems of women's skirts steadily ascended to reveal not only the sight of pert little ankles, but also, most shocking of all, several shamelessly erotic inches of calf muscle. A blossoming of pride in personal appearance led to a revival of the cosmetic industry, which had all but disappeared in Victorian times; rouges and creams were no longer associated only with those 'painted ladies' who frequented the

town hall square. The genteel, old-fashioned camisole was relegated to a dust rag in favour of the bold and thrusting brassiere, whose owners thought nothing of smoking cigarettes in public or even trespassing on the male territory of the public house.

Football, that other tenaciously guarded male bastion, was tackled by revolutionary 'all lady' teams from both Portsmouth and Gosport, who took on all-comers at Fratton Park. While this could be excused as harmless spectacle, another insidious influence of far greater import was considered to be enveloping the town in another entertainment venue. Imported films of a 'dubious moral tone', being shown in a dark place and freely attended by members of both sexes, were seen as a recipe for 'canoodling', 'spooning' and worse. A Watch Committee was set up by Portsmouth Town Council to investigate these crucibles of immorality, and members professed themselves appalled by the suggestive nature of the entertainments being shown. The committee sent its recommendations for censorship to the Home Office urging that the music hall also be vetted for 'objectionable' sketches. One act which raised more than one eyebrow at the Hippodrome was built around a large man-size aquarium filled with tinted water in which chorus girls cavorted in daring bathing suits. In the auditoria no nook or cranny went uninvestigated by the moral watchdogs. The manager of the Victoria Hall Cinema in Commercial Road received an order to 'take means to prevent the existing privacy in the private box'.

While the Watch Committee watched the now not-so-private boxes, cinema managements went through the motions of vetting couples seeking admission, presumably with the polite inquiry: 'Hello! Hello! Who's your lady friend?' The vast majority of lady friends were ordinary respectable women who would remain staunchly chaste until marriage. They visited the picture house to be enthralled, not so much by their partners, but by spectacles like D. W. Griffith's epic, *The Birth of a Nation*, which was the talk of the town when it appeared at the Hippodrome in 1916. Costing an astronomical £100,000 to produce, this revolutionary film featured 5,000 horses and 18,000 extras. The lady's amorous companion stood little chance against what was billed as the 'Eighth Wonder of the World'. But there was another silent rival for the cinema-goers' attention whose ubiquitous presence on Portsmouth's screens gave testimony to his popularity – he was to become quite simply the most famous man in the world.

Back in the peaceful Edwardian autumn of 1909 the nation was staring at the heavens in breathless anticipation of catching a glimpse of Halley's Comet. 'Astronomers are becoming uneasy at its non-appearance,' reported a local newspaper. Meanwhile, a diminutive and unassuming young man stepped from the mean streets of Portsmouth through the stage door of the Hippodrome. By six-twenty that evening a magical metamorphosis had taken place. An outrageously inebriated swell emerged with a top hat that wobbled uncontrollably on a mop of ludicrous black hair, while a cigarette dangled precariously from the corner of his mouth. From his pocket protruded the tip of an immense handkerchief that would be produced with riotous effect later that evening in a skit entitled 'Mumming

VICTORIA HALL

SOUTHSEA.

CONTINUOUS — — 3 TILL 10.30.

MONDAY NEXT & DURING WEEK.

The Great and Only
CHARLIE CHAPLIN
IN
A DOG'S LIFE.

NOTICE THIS IS THE FIRST OF THE MILLION DOLLAR CHAPLINS
AND IS SHOWN AT THE VICTORIA HALL FOR THE FIRST TIME IN
ENGLAND

Good old Charlie, one of many wartime appearances on the silver screen.

Birds–an up-to-date Musical Travesty on the Modern Music Hall'. Fred Karno's army of London comedians had hit town with the unmistakable sound of slapstick.

In this act, the comical drunk was seated in a stage-box in a set representing the interior of a music hall. One man who recalled seeing the sketch (elsewhere) remembered the prominent role of the inebriate:

> The way this drunken one would fall head foremost out of his stage box and hang there like a hairpin without smashing his features or crashing to the floor was to all of us consternation. The way in which he could be gloriously, riotously drunk in such a manner as no mortal ever was, without giving offence, was flusterbation. And the way in which he fell out of his box and removed his dress coat to display a flannel shirt and a dickey, which with false cuffs was the everyday standby of the period, was a revelation.

The *Portsmouth Evening News* critic agreed. The act starring the little man with a violently encarmined nose was, he recommended, 'sure to make one ache with laughing'.

Six short but eventful years later, audiences were packing local picture houses for a welcome respite from the grind of war-work, the tedium of housework and the fear of school-work. They wanted entertainment and escape and one man provided it in the guise of, not a drunken toff, but a dignified tramp; a shambling underdog whom everybody loved, pitied and secretly identified with. This gallant figure smiled in the face of adversity and, above all, maintained his self-respect and dignity, come what may. Children especially, took him to their hearts and imitated his waddling gait. Hopscotch on the street was accompanied by the patriotic chant:

> One, two, three, four
> Charlie Chaplin went to war,
> He taught the nurses how to dance,
> And this is what he taught them;
> Heel, toe, over we go,
> Heel, toe, over we go,
> Salute to the King,
> And bow to the Queen,
> And turn your back
> On the Kaiserine.

On the march and at the Front, Tommies sang:

> When the moon shines bright on Charlie Chaplin,
> His boots are cracking
> For the want of blacking,
> And his baggy little trousers they want mending,
> Before we send him
> To the Dardenelles

While 'Good ol' Charlie' appeared almost continuously on the screen, somewhere in Portsmouth an old man called Albert scraped a mean and precarious living 'playing bones' outside Portsea pubs. Albert was a man of 'drunken habits'. He died under the wheels of a local taxi one day in the winter of 1916. Charlie played a tramp and Albert was a tramp. Both were entertainers.

However humble or celebrated, amateur or professional, the vital role of the entertainer in war-time in maintaining morale, cannot be underestimated. There was certainly something for everyone. 'Rapido – the Singing Cartoonist' provided a novel turn at the Gosport Theatre while 'Blind Charlie', the popular organ-grinder, turned the handle of his organ nonstop for a whole day, donating all proceeds to the War Relief Fund. 'Casey, the wandering Socialist violinist', found his way to a local function, while Rosie, a 'street singer', was arrested and fined

for 'causing a nuisance' after refusing to heed warnings to desist. Such itinerant performers were, generally speaking, poverty stricken individuals who, through bad luck or ill-judgment, had been forced to fall back on their only skill or talent, real or imagined. Every pavement was a stage on which they played and fretted and were heard no more.

Charlie Chaplin's defection from the music hall stage to the cinema screen reflected a changing allegiance among audiences, who saw the new picture houses as a cheap, dependable and exciting alternative. In 1914, twenty-seven cinematograph licences were issued in Portsmouth. By 1917, half of the entire population of Britain visited a picture house at least once a week. But though live entertainment had begun its decline, Portsmouth's music halls and theatres were able to play host to some of the most famous and talented artists of the war period. The most popular of all was Miss Marie Lloyd, the 'Queen of the Halls', who trod the boards at the Kings, singing the old favourites. Her appearance at the age of forty-eight gave hope to many as she asserted with a wink that 'a little of what you fancy does you good!'

CHAPTER TWELVE

The Fire Behind the Smoke

The affable young Dutchman had been into Portsmouth post office on a number of occasions to cable orders for fresh supplies from his employer, a cigar wholesaler based in Rotterdam. Haicke Janssen was a commercial traveller for the firm of Dierks & Co.; at least that is what his papers stated and there was nothing to suggest otherwise. Holland was, after all, a neutral country with whom business continued more or less as usual. What was it then that roused the suspicions of a busy post office worker one day in 1915?

The story begins with a legendary figure in the history of espionage, the German spy mistress Elsbeth Schragmuller, known by writers in the genre, for no accountable reason, as 'Tiger Eyes'. Schragmuller volunteered her services to the German Intelligence Service (*Nachrichtendienst*) on the outbreak of war shortly after having qualified as a Doctor of Philosophy at Freiburg University and, contrary to popular myth, was only as beautiful as her real name suggests.

With these qualifications, Schragmuller was put in charge of a 'school for spies' in the *Rue de la Pépinière* in Antwerp. Her brief was to produce agents trained in a new method of espionage based on strict discipline and routine drills covering all contingencies in the field. The makeshift tactics of Gustav Steinhauer's pre-war amateurs were replaced by a rigid adherence to reference lists specifying what the academic spy mistress believed to be the principles of furtiveness and the mechanics of guile. But there was a basic flaw in this step-by-step approach; human qualities of imagination, resourcefulness, character and plain common sense were not nurtured and found no place in the rigid curriculum of the Antwerp spy school. Espionage was to be a perfect science and not an unpredictable art.

Two of Schragmuller's first graduates were former seamen whose Dutch nationality provided an ideal basis on which they could build a plausible cover. An office was rented in Rotterdam where a polished brass plate told the world that 'Dierks & Co.' did a respectable business importing and exporting cigars. Identity papers, order forms and account books were issued to the two men, together with standard commercial travellers' suitcases packed with fragrant samples of Dierks' unrivalled range. After a briefing on cigar sales patter and the argot of the tobacco

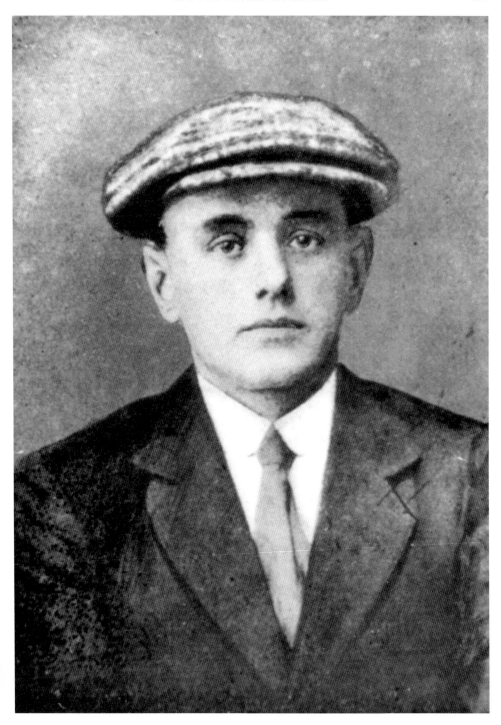

Wilhelm Roos, convicted as a spy and executed in July 1915.

connoisseur, Haicke Janssen and Wilhelm Roos were dispatched on their mission to report on fleet movements at Britain's naval ports.

The men worked separately and experienced little difficulty in gathering rumours and gleaning information from prospective clients and fellow travellers. Battleships could hardly be hidden and the mingling of smoke from two good cigars helped allay fears that this passing stranger was anything but a friendly alien. Everything was going as smoothly as a draw on the finest Havana until, that is, our post office worker became curious.

The Dutchman's regular cables appeared at first glance to be genuine orders for Dierks' cigars, but it was not so much the content of the individual telegrams that struck the clerk as odd, as the frequency with which new orders were being placed. Flicking through the retained carbon copies he quickly estimated that 48,000 cigars had been ordered in ten days, a remarkable demand for a town like Portsmouth where, notwithstanding profiteers, the inhabitants in general and naval ratings in particular were not noted for their high consumption of quality cigars. The clerk rather hesitatingly reported the matter to local police, who were sufficiently intrigued to hand it over to British Intelligence.

Dierks' overseas sales crashed when Janssen and Roos were arrested in London in June 1915. While being led away for interrogation at Cannon Row, Roos broke loose and attempted to kill himself by shattering a glass door and stabbing his naked wrists on the fragments. His wounds were bandaged and he was removed to Brixton Prison for observation lest he pre-empt the course of martial law. Under questioning neither man could produce evidence that he had transacted any *bona fide* business that tallied with the extraordinary orders cabled to his employer. They were secretly tried as naval spies and convicted. Under sentence of death, both men made confessions and revealed details of Schragmuller's code that led to their undoing.

A cabled order for 10,000 Cabanas, 4,000 Rothschilds and 3,000 Coronas sent from Portsmouth corresponded with there being ten destroyers, four cruisers and three battleships in Portsmouth Harbour on the date of the telegram. Betrayed by an inflexible and inappropriate means of communicating the information they had been sent to collect, the two young Dutchmen were executed on the firing range at the Tower of London on 30 July 1915. They met their ends stoically. Janssen was killed first and Roos asked as a last favour to be allowed to finish his cigarette. That done, 'he threw it away with a gesture as though that represented all the vanities of this world and then sat down in the chair with quiet unconcern'.

This indifference appears to have been shared by their former mentor. The Doctor of Philosophy and ambitious spy mistress refused with blind obstinacy to learn from her mistakes. Five more agents were caught within a matter of weeks, including Fernando Buschman who incriminated himself as a naval spy after taking notes of observations on a visit to Portsmouth and Southampton. He was arrested in lodgings at South Kensington and interrogated and tried at Westminster Guildhall. A gentleman by birth, Buschman could do little to conceal his origins with his manner, speech and dress, starkly contradicting his oft-made assertion that, yes indeed, he was a commercial traveller. He knew nothing about trade and was clearly

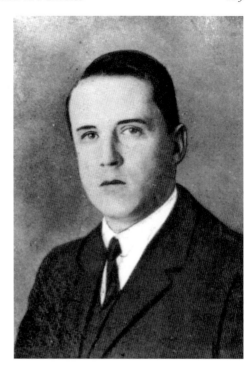

Fernando Buschman, executed by firing squad
in October 1915.

more attached to his polished violin case than his tatty sample bag. After sentence
was passed Buschman found solace in his playing. When they came for him he
kissed his beloved violin, saying, 'Goodbye, I shall not want you anymore.' Having
refused a blindfold he 'faced the rifles with a courageous smile'.

Putting aside the paranoia, hysteria and spy-mania that prevailed whenever the
world 'alien' was uttered, a further eight men were executed for similar espionage
offences in other parts of the country, suggesting that while there may be said
to be no smoke without fire, the density and volume of the former bore no sane
relationship to the size of the latter.

On the battlefields of the Western Front it was not uncommon for burial
parties to find propaganda literature scattered among the detritus of death, like
spent shrapnel from a discharged mine. One neat, pocket-sized booklet widely
distributed among German soldiers, is notable less for its twisted contents than
its curious source. For the 'trench-edition' of a series of war essays exhorting a
bitter hatred of England and everything English was written by a long-forgotten
son of Portsmouth.

Houston Stewart Chamberlain was born on 9 September 1855, within earshot
of the newly-built St Jude's church in the heart of Thomas Ellis Owen's emergent
Southsea. Elegant terraces and spacious stuccoed villas were graced by the *crème
de la crème* of Portsmouth – little did the residents know what a bad case of sour
cream was curdling in their midst.

The third son of a rear-admiral, Chamberlain came from a family distinguished
in the service of the Crown and seemed destined for entry into one of the services.

Houston Stewart Chamberlain, seen here with Cosima Wagner, was born in an elegant Southsea terrace. He was awarded the Iron Cross by the Kaiser and became a high prophet of the Nazi creed.

Continual ill-health determined otherwise and in 1870 the disappointed adolescent was dispatched by his parents to the Continent for 'finishing'. In keeping with this aim his appointed tutor, one Otto Kuntze, zealously instilled the virtues of Prussianism into his youthful charge, an education which apparently took four years.

After this experience Chamberlain felt no inclination to return to England but pursued an aesthetic interest in the Wagnerian conception of art and drama. His enthusiasm for Richard Wagner's work culminated in a celebrated meeting in the composer's home town of Bayreuth, after which Chamberlain was welcomed into the master's social circle and later into his family. Chamberlain divorced his first wife, who was half-Jewish, to marry Wagner's only daughter, Eva. After publishing several minor works on musical and dramatic themes, the ambitious Englishman embarked on a major historical study which ran to two volumes and more than a thousand pages. *The Foundations of the Nineteenth Century*, published in 1899, proved to be a very influential work. It provided a basis for the development of what are now chillingly familiar themes, for Chamberlain sought to substantiate by intellectual argument that history was basically about racial struggle, that Jews were a negative influence on civilisation and that the Aryan peoples were inherently superior to all.

Hailed as the new prophet of Teutonism, the English academic was summoned by an excited Kaiser who declared it was 'God who sent your book to the German people'. According to a witness of this first meeting, Wilhelm 'stood completely under the spell of Chamberlain' and thus began a lifelong friendship sustained by the mutual massaging of two inflated egos and a shared belief in the Teutonic destiny of world domination.

With the outbreak of war Chamberlain was motivated to prove that he was more German than the Germans, by turning his dubious talents to the production of crude anti-British propaganda. His promotion of the German war effort and bitter denunciations of his former homeland earned him the highest possible accolade. In 1915, a grateful Kaiser presented an Iron Cross to his sycophantic sidekick.

The defeat of Germany did not put an end to Chamberlain's evil influence. In the immediate postwar years his racist teachings found a new, louder resonance as the Nazi era dawned, and in the autumn of 1923 Chamberlain met Adolf Hitler for the first time. The following day he wrote to the nascent demagogue expressing his total support, and adding 'that in the hour of her deepest need Germany gives birth to a Hitler proves her vitality'.

Chamberlain became one of the earliest members of the Nazi Party (closely followed, incidentally, by one Elsbeth Schragmuller) and its official organ, *Volkischer Beobachter*, praised *The Foundations of the Nineteenth Century*, describing it as no less than the 'Gospel of the "Volkish" movement'. But the renegade Englishman was not to witness the logical outcome of his doctrine of hate – the conversion of Europe into a crematorium for the incineration of minorities. He died at the age of seventy-one in January 1927. Hitler attended the funeral and the Nazis published a tribute to Houston Stewart Chamberlain with the sub-title, 'The Pioneer and Founder of a German Future'.

CHAPTER THIRTEEN

Women and Children Last

'A good many fathers and mothers are probably wondering what, in years to come, their now quite small children will remember of the Great War and – which is not necessarily the same – what they will tell their grandchildren they remember,' mused a *Times* journalist in January 1915. 'Eighty years hence will some nice old gentleman, now attired in a purple jersey and knickerbockers and bare legs, recall how he was allowed to sit up into the mysterious hours after dinner to look at the illuminations on the making of peace, or how the newspaper boys shouted in the streets, and his father came home and said that Berlin had fallen.'

The writer was not far wrong, though peace was to come several years later than anticipated. But while the question of what youngsters were feeling about the war at the time, rather than how it would be viewed retrospectively, was the ostensible concern and the primary aim of the article was to put parents' minds at rest. Games of zeppelins and Red Cross nurses were a natural reflection of what children observed, and were played 'in a kingdom of pretending so far removed from the realities of life' as to be of no concern. Thus the resilience of children was affirmed.

As we have seen, some traditional childhood pastimes and activities were made impossible by the exigencies of war in an area of naval and military importance. R. Gladys Whiteman said 'before the war… picnics on the beach were everyday pleasures. Another was scrambling down into Fort Cumberland to pick "Sailor's Love" from the walls, a little creeper with blue flowers on it.'

Attempts to continue these activities were now likely to be met by a soldier's wrath. As children's imagination adapted to the novel sights and sounds on the Home Front the hardiness of traditional games and hobbies was in evidence. R. Gladys Whiteman remembered:

> In the house forecourt in Catisfield Road, we played dibs (five stones), and mothers and fathers, with dolls and prams (those who had them). We played whip-top, bowl a hoop and skipping games like "Buttercups and daisies", "The farmer's in his den" and "In and out the windows".

While girls were being girls, boys were being boys suggested D. S. Ford: 'The boys in Stamshaw School latrine used to compete to see who could "pee" the highest.'

In cramped, overcrowded working-class homes there was little or no space to play. A cobbled backyard, which saw no sun and was cluttered by a zinc bath and cast-iron mangle, was no place to dispel exuberant, youthful energy. And so children were encouraged to play in the street. Doris Ball (née Loving):

> There were no cars, or very few, only an occasional horse and cart or milk chariot to be avoided – so we could play "Hop-Scotch", "Higher and Higher" and "Out if you Move".

Edwin Cleall:

> We rolled marbles down the middle of the road. Another popular game was flicking cigarette cards from the kerb edge – stand 'em up and knock 'em down. Many a time, I trundled my iron hoop with the help of an iron hook along North End Grove, surfaced with gravel in those days.

Uneven, pot-holed roads caused many a twisted ankle and cracked hoop. A cold-compress soothed the former but the tragedy of a broken hoop necessitated an immediate visit to the blacksmith. Edwin Cleall:

> We used to take it round to Mr Abnett in Nancy Road who'd mend it for a penny, welding it when it was white hot, in the forge with the pump. Then he'd hammer it on the anvil – sparks everywhere – and then he'd dip it into the water, hissing and steaming. We watched him shoe horses, too.

The welter of running, skipping, jumping, chasing and shouting that typified a working-class backstreet was silenced whenever a military band was heard in the distance. The Royal Marine and Portsmouth Battalion Bands played during regular parades while passing through the main thoroughfares of town, attracting adults and children alike. This free entertainment was not without its dangers, however. Horses sometimes bolted when the band struck up, on one occasion straight into a crowd of children lining the pavements of Goldsmith Avenue.

Though the Army had commandeered many local traders' horses for transport purposes, the ones that remained provided a regular source of pocket money for the budding entrepreneur who was not afraid of getting his hands dirty. G. H. Dunbar:

> Droppings would be collected with a shovel and a bucket and almost every householder with a pride in his garden would willingly give a few pence to a boy for a bucketful, though many keen gardeners were quick to act for themselves should such a prize be deposited outside their house.

Other means of generating cash were more reliable. Edwin Cleall:

> We collected cockles and winkles in Langstone Harbour – their tell-tale spurts give
> them away – and earned a bob or two selling them round the pubs.

Ernest Ball:

> We used to hang about at Fratton Station (and) earn a few coppers when the
> train passengers arrived. When we saw a likely looking person such as an elderly
> gentleman we approached them and offered, "Carry yer bag, sir?"

With the hard-earned coins clutched tightly in hand, lessons in thrift dissolved as
rapidly as sherbet, and were completely gone upon crossing the threshold of the
local confectioners. R. Gladys Whiteman:

> You could take a penny into four shops and come out with four different bags of
> sweets or a "Lucky Bag" and then have change. Toffee apples were very popular.

D. S. Ford:

> The sweetshop opposite Stamshaw playground did a good trade – I recall gob-
> stoppers which changed colour as you sucked, liquorice boot laces (two for a
> farthing), tiger nuts and locust beans.

Towards the end of the war sweets became a rare luxury as imports of sugar all
but ceased and rationing was introduced. Lucky children received pocket money
of either a halfpenny or a penny, depending on behaviour or the completion of
chores. Most toys were beyond the reach of ordinary folk, though nearly every
child possessed a ball of some description and a spinning top. The educational
and social value of dolls was emphasised by one Southsea lady, who urged the
relatives of any girl not possessing one to remedy the situation immediately: 'It
is a powerful instrument for training the maternal instinct dormant in every girl.
A girl who has never loved a doll is like a boy who has never wanted to be a
soldier.'

Girls were expected from a very early age to help their mother with domestic
chores, to run errands, do the shopping and act as childminder and nursemaid to
younger brothers and sisters. These 'little mothers' could be seen in the street: 'The
small girl marshals along other mites, often helping boys bigger than herself and
cuffing the whole party into obedience, or kissing and comforting one or two who
have come to grief in some way.'

The dolls on which such love and discipline was first practiced varied from
crude-painted wooden sticks to delicate and elaborately detailed dolls which
had been made in and imported from Germany in more peaceful days. They
were removed from toy shop windows and shelves during the war, though long-

standing owners continued to love them regardless of what their elders and betters were doing. Sick dollies were rushed to the Doll's Hospital in Lake Road.

The popularity of model soldiers and wooden warships naturally increased as boys fought imaginary, glorious battles with the 'Hun' while demonstrating as much concern for their own casualties as many real-life British Army generals. War sets were available which included howitzers and intricate facsimiles of thirteen-pounder guns. Also included were instructions on how best to arrange the battlefield, the armies and ammunition supplies. A less common occupation than collecting toy soldiers was recalled by G. H. Dunbar: 'The acquisition by some boys, most likely from brothers or fathers on leave, of matchboxes containing human remains such as an ear or finger. This practice was quickly stopped by our teacher (at Penhale Road School).'

In early 1918, Portsmouth Grammar School's Museum Committee appealed to its many serving old boys for war relics for display to pupils. Within a few months the school was 'overwhelmed' with war relics, so much so that non-war artefacts were relegated to cupboards. Pride of place was given to part of a bomb from Kut, part of a zeppelin girder, a gas shell from Ypres, a German helmet badge, soldiers' trench newspapers and an iron plate from HMS *Warspite* with a big hole, pierced by shell at Jutland.

Children's comics were packed with heroic war stories, dramatic happenings in public schools and enthralling accounts from the Wild West. Portsmouth born 'ripping yarns' author Percy Westerman wrote many stirring, jingoistic stories for boys' comics, as well as publishing popular war novels that fired the imaginations of his young readers. Everywhere good triumphed over evil. All but the cheapest comics were beyond the reach of most children, with the *Magnet* and the *Gem* costing 2*d*, the *Boy's Friend*, 4*d*, *Girl's Own Paper* and *Boy's Own Paper* costing 7*d* and *My Magazine* 8*d*. Undeterred, children either clubbed together and shared or looked elsewhere.

Edwin Cleall remembered, 'In Fratton Road, near Alver Road, there was an old shop. You'd step down into it and there'd be this little old lady sat there. She'd buy and sell absolutely anything. Her shop was loaded with stacks of old comics and you could get one for next to nothing.'

Comics were all right if it was raining, but, for many boys, a good time had to have some element of risk attached. 'One excitement,' for James Callahan, 'was to run out from the pavement into the road to try to cling, unseen, to the tailboard of the horse-drawn carts as they clattered by, whilst other more envious boys would shout to the driver, "Whip behind, Guv'nor!" as we rattled along.' Ernest Ball:

The driver would flick his long whip round the back to get rid of the non-paying passengers.

One of my friends and I once got on to the back of one and managed to ride all the way to Cosham. As we got farther and farther away from home I wanted to jump off, but my friend persuaded me to stay on and we finished up on the lower slopes of Portsdown Hill ... Oh! What a weary walk it was home for our small legs. "Scrumping"

from private orchards and gardens brought its own risks and rewards. The Victoria plums from behind the new Teachers' Training College accommodation in Milton Road were very popular, their taste sweetened by the knowledge of their origin. There was another way of misappropriating fruit which removed any element of effort.

H. J. Reed remembered, 'walking along Highland Road or Festing Road I'm afraid I used to help myself to apples from the stalls when the owner wasn't looking. Sometimes we were desperately hungry; after all, half a cottage loaf a day wasn't much for fourteen and fifteen year olds.'

Such misdemeanors and pranks sometimes led to conflict with the police and a warning cuff or 'thick ear', delivered without ceremony by a weighty, gloved hand. Damage to property, however, led invariably to an appearance in the police court. A group of seven boys, seen throwing stones at a gas lamppost in Velder Avenue, appeared in the dock of Portsmouth Court, while in Gosport eleven boys were prosecuted for 'wilful damage of the turf' on the ramparts near Church Path, caused while playing football. The estimated cost of the damage amounted to two shillings (10p).

A wave of juvenile crime during the war was attributed to the lack of a 'firm hand', with many fathers away fighting. A correspondent in the *Portsmouth Times* linked it with a general decline in standards of discipline: '

> I witnessed the other day a typical scene. A little boy about four years old was standing at the door with his mother who was talking to some neighbours. One of them gave the boy, in pure good-natured fun, a little pat on the back. He turned round and told her to go away in language that would have been bad from a foulmouthed navvy! What parents have got to do is to teach children the Fear of God, or at least let someone else do it for them.

Mothers who were unable to cope with the errant behaviour of older children brought fierce condemnation from local magistrates. Some poor women, whose husbands were away, pre-empted the sentence of the court by asking that their sons be birched as 'it would do them good'. The miscreant was taken to the cells and strapped down while the birch was soaked in water. A muscular policeman then did his duty without mercy.

The youngest boy to have been birched during the war appears to have been a ten-year-old who was found guilty of stealing a bottle of sauce valued at 10*d* (4p) from the Commercial Road branch of Messrs. Pink & Sons. More hardened petty thieves persistently failed to recognise that the birch was an effective deterrent and were repeatedly beaten. Some were sent away to an 'Industrial School' (a reformatory) where the harsh and barbaric regime was guaranteed to either break a boy's spirit or set him up in a criminal career for life.

Girls appear to have rarely transgressed, or at least if they did, were rarely caught. One notable exception was the case of two schoolgirls, aged eleven and twelve who worked a highly profitable pickpocket racket in and around the Penny

Bazaar in Commercial Road. The older girl stole the purses and quickly passed them to the younger girl who remained outside. There appears to have been no Fagin-like character organising their activities.

While classic literature set moral and character-forming exemplars for the young population, the picture house was coming under attack as a dreadful, insidious, corrupting influence on innocent minds. A spokesman for the Portsmouth Band of Hope Union expressed horror at the 'cinema pictorial advertisements' on hoardings in the town which 'bordered dangerously near to the indecently suggestive' and were 'a moral danger to the highly imaginative and sensitive minds of our children'. The contents of the films themselves, as we have seen, also came under close scrutiny. It became widely believed that boys were led to imitate crimes seen at the local 'fleapit', or were stealing money to pay for admission.

Fear of God and the birch kept most children out of serious trouble, with the Sunday school playing a prominent part in preventing the Devil making use of idle hands. Adults organised play for children in the form of the boy and sea scouts, and girl guides also served the same purpose but acquired a new and exciting role in the early months of the war. More than 500 boys belonged to the local sea and boy scouts. The former patrolled the waters of Portsmouth Harbour while the latter guarded railways and public works and acted as messengers for the military. All desperately hoped to catch a 'Hun' saboteur in the act, which was something that happened with casual regularity in their weekly comics. Rifle ranges became more popular than ever as boys prepared themselves for their 'time'. Air guns were discharged in the streets, windows were broken and eyes blinded. The father of one lad, prosecuted for 'discharging a firearm' in Gladys Avenue, told the court that his son had 'only wished to become efficient as a soldier'. Service cadet corps provided a legitimate and safe outlet for patriotic aggression. Royal Marine Artillery cadets met at the rifle range at Eastney Barracks to compete for medals and cups for 'rapid, snap and target shooting'. The last category was made more interesting by the inclusion of new 'military airship' targets.

Another, not inconsiderable, advantage of belonging to one of these movements was the special dispensation that was sometimes granted during the war to escape that stifling and restrictive institution – school. The imposing ecclesiastical atmosphere and architecture of the typical school struck terror into the heart of the five-year-old new arrival. It was a different world, made remote by an unnatural silence and isolated by high windows that provided angled shafts of chalk suspended light, but afforded no view except that of passing clouds and the occasional bird. James Callaghan:

My schooldays began in 1916 at a large infants school at Copnor. The classrooms were big and high-ceilinged with a floor that was staged in order that the teachers, who had sixty children in each class, could see what those at the back of the room were getting up to. We had five rows of desks arranged in six blocks, two children to each desk and we began straight away to learn the alphabet and multiplication tables. We also learned not to speak to a teacher unless she spoke first to us and we spent many hours sitting "at attention" with our hands behind our backs.

The authoritarian regime and rote learning of facts provided a certain security. James Callaghan:

> Anyone who had a reasonably good memory and could learn the multiplication tables by heart and could recite the capes and headlands of England from St Abb's Head to St Bee's Head could escape trouble. The teachers were conscientious and hard-working and it never occurred to us, or perhaps to them, that education means more than committing facts to memory.

R. Gladys Whiteman:

> Children were taught the things that really mattered: reading, writing, arithmetic, grammar, religious instruction, as well as drill, singing, sewing, knitting and cooking. Everyone respected their teachers. The cane was a good deterrent to bad behaviour.

Canes, straps and rulers instilled fear, inflicted pain and enforced discipline. Concerned parents occasionally confronted teachers with complaints about the severity of punishments. One day in 1916, twelve-year-old Charles Ivens, a Gosport schoolboy, arrived home barely able to walk with blood flowing down his legs and soaking through his trousers. His distraught father examined him and 'on the boy's buttocks and thighs he found six great weals, from one of which blood was flowing, the flesh being cut'. The boy's father reported the matter to the police and in an unprecedented court case a respected local headmaster found himself charged with assault. The bench heard that the boy had been beaten for 'not doing his French lesson properly' and concluded that the punishment had been 'excessive'. A fine of £2 was imposed, warning all teachers not to draw blood while beating their charges.

Some teachers preferred a more subtle approach. R. Gladys Whiteman remembered:

> Our mistress's name at Milton School was Miss Wiltshire and she was very fair with us but also very strict where our behaviour was concerned. To her it was more of a punishment to any girl sent to her to give the girl a halfpenny to go across the road to Milton Market and buy and be seen bringing back a cane.

Naughty girls were generally treated less inhumanely than naughty boys, reflecting many other differences in their respective experiences of school. Doris Ball (née Loving): 'In September our mixed infants class was broken up, the boys went to the big boys' and the girls to the big girls' school. From now on boys were strange beings we never saw, unless we had brothers.'

R. Gladys Whiteman: 'We dare not go to the railings that separated the girls' playground from the boys'. Our head mistress's rooms were just above and she could see all our movements in the playground.' This separation of the sexes eased the process of preparing boys for the disciplined world of work and girls for domestic service and motherhood. Elsie Harbut (née Mullins):

We used to do embroidery, knitting and sewing. The teachers at Grove Road School brought in articles to be hemmed or mended ... one time a huge pair of cami-knickers, though we couldn't work out who those were for. I was good at sewing. If button holes needed doing the teacher would say, "Give them to Elsie Mullins!"

As many male teachers volunteered to fight, their classes were distributed among the rest of the school. Replacements were found but they caused some consternation. Edwin Cleall:

Our head teacher at Fratton Road School (on the corner of Arundel Street and Besant Road) was a Mr Suitor, a bearded man, very strict but fair. He would tell us at assembly that Mr So-and-So had been called up and that later they'd be replaced by ladies! That was unheard of! Later he would tell us of those killed in action.

The death of Portsmouth Grammar School House Master Captain Skinner in 1916, serving with the First Portsmouth Battalion (14th Hants), plunged the school into mourning. The school magazine recorded with disbelief that 'we shall never again see him!' However, his example, 'will serve to strengthen our reserve and nerve us to carry on this fight to the death, until Germany is beaten to her knees...' Another teacher, F. P. Randall, was reported missing or wounded, with no further news for a year until it was reported that it was 'practically certain that he was killed soon after going over the parapet'.

That some teachers were dearly loved is clear. But death was a fact of everyday life in some areas of the town; a baby born in Portsmouth had as much chance of reaching adulthood as a soldier had of surviving the war at the Front. Lack of health care, poverty and slum housing were 'enemies within' but were largely tolerated by the powers-that-be, though social reformers found in the latter years of war that opposition to what was considered to be their 'interference' became less pronounced. The dreadful sacrifices being made by fighting men had to be given some meaning and so notions of communal responsibility and planning for a better future became less likely to provoke hostility.

In 1916 maternity and child welfare clinics were established in Fratton Road and at St Patrick's Institute in Winter Road. Mothers could take their babies along to be examined, free of charge, by two 'qualified lady doctors' who gave advice about the feeding and rearing of infants but were not permitted to treat them in any way. Any 'defects or diseases' were referred to the 'private practices of medical men', who, like the corset makers and special constables, were on piece-work. Concerns that such 'interference' by the clinics would put the doctors out of business were soothed by the assurance that, on the contrary, the new referrals would prove profitable.

The Portsmouth School Clinic, which had opened in 1912 in two adjacent houses on the corner of Montgomerie Road and Victoria Road North, did its best in the face of inadequate resources and a medical staff depleted by the war. Prices at the clinic were considerably lower than elsewhere with, for instance, spectacles

War orphans line up outside the town hall for a charity tea.

costing less than a half of what they cost privately. A cost-effective means of treating the common complaint of ringworm was discovered using the clinic's new and much vaunted X-ray apparatus. Children were irradiated over a period of up to twenty-seven days and the proud boast was that 100 per cent of cases were cured. In Gosport, school medical facilities were, fortunately, less advanced in this particular field. The medical officer there was quite happy removing adenoids for 5s.

Death cast a shadow over many families. Whooping cough, diphtheria, scarlet fever, measles, influenza and tuberculosis killed as effectively as a bullet or a bomb, while bronchitis, ear and eye infections, pneumonia and general under-nourishment caused widespread casualties. James Callaghan:

> The fever van was a familiar sight in the street, calling to take children to the fever hospital. I do not recall any vaccinations other than those against smallpox. My sister used to argue that we were brought up in Sunday school to accept that child mortality was a natural event, and that we should look forward to going to heaven as a reward.

Doris Ball:

> In September 1914 my baby sister was born. I almost immediately gave her scarlet fever and we were taken to St Mary's, to the Fever Hospital as it was called (now the East Wing), where I was later to languish with typhoid fever. She was sent home quite soon but I stayed over the Christmas as I developed an even stranger rash. I

remember on the day I came out of hospital seeing all my Christmas presents waiting for me.

School logs of the period describe the effect that disease and illness had on school life. But it was also a matter of financial concern because any falling off in attendance meant a corresponding drop in the educational budget. Hence, the prominent role of the attendance officer or 'Board Man'. 'Woe betide any child being absent for even half a day without a previous note of explanation to the teacher', said R. Gladys Whiteman. 'The attendance officer would be on your doorstep the very next day wanting to know the reason why.' Reasons varied. Monday was a favourite day for girls to play truant – they were helping with the washing. Food shortages meant queuing and queuing wasted mother's valuable time and so children would sometimes be required to help out in that way. Boys from large families without a breadwinner sometimes played truant to earn money to feed the family.

Another explanation – which could never be admitted – was simple. D. S. Ford:

I never liked school. In fact I was frightened of it and when very young played truant frequently. I remember hiding behind the door in Putman's bakery to keep warm during those escapades. Putman's had a shop in Twyford Avenue, the bakery being at the back of the premises overlooking Stamshaw School. The bakery was not only warm, it also afforded a good vantage point. Many's the time I watched the (attendance officer) walk by, trembling in my shoes, making sure not to be seen.

The children of many dockyard 'mateys' saw nearly as little of their fathers during the war as the children of men on active service. Consequently when a dockyard holiday was grudgingly announced by the Admiralty, arrangements were made for a family day out or some other treat. Officially sanctioned time off school was occasionally granted on special occasions such as the departure of the first Portsmouth Battalion, Armistice Day and later, when two surrendered U-boats were brought into Portsmouth Harbour.

Empire Day – 24 May – was a time to celebrate the expansive red patches on the world map pinned on the classroom wall. R. Gladys Whiteman: 'We lined up in the playground and sang patriotic songs, "Rule Britannia", "God Bless Our Sailor King", "Three Cheers for the Red", "White and Blue" and of course the "National Anthem" and we all wore our little red roses made in class. The rest of the day was holiday.' Doris Ball remembered Empire Day pageants at Francis Avenue. 'I was Britannia in one, carried a shield and wore a Union Jack.'

Edward Lane:

We marched round the playground (of Cottage Grove School) with a large Union Jack carried in front by one of the older boys. We then lined up in front of a long table, loaded down with books for the annual distribution of prizes by one of our

proud City Fathers. After the prizes, came a short homily on patriotism which we quite naturally accepted with pride.

Older children at Portsmouth High School's celebrations in 1915 were treated to a recital of Rudyard Kipling's 'If' which echoed around the playground and stayed indelibly in the mind. Kipling had spent the best part of his childhood in Portsmouth, and enjoyed immense popularity in his former home town. The girls were given a lesson by a visiting notable who, 'after pointing out the derivation of the word "Empire", which in reality signified military domination, proceeded to show that in English minds "Empire" stood for freedom and liberty'. 'If' was also reproduced in the Portsmouth Grammar School magazine, giving inspiration to boys anxious to finish their studies and prove their mettle.

An observer of a war-time Empire Day celebration held in Penhale Road School playground remarked on the poignancy of the event 'when one appreciated that a very large number of the youngsters who appeared so cheerfully were possibly thinking of their soldier or sailor dad risking his life on land or sea, or of the parent who would never return'.

Service mothers and wives did their best to submerge such thoughts and kept up their hard, physical struggle for survival on the domestic front. The battle of the humble housewife is often overlooked in accounts of the war, and yet these women far outnumbered their pioneering sisters and daughters who entered the Dockyard and munitions factories. After all, somebody had to shop, cook, clean and look after the family while the breadwinner built ships or sailed off in them. Families were often large, a dozen or more children was not uncommon, and with food shortages strict economy had to be practiced at all times. But, always, at the back of the mind, where it could be contained, was the dreadful, ever-present fear of losing a son, a brother, a husband. On the eve of victory came yet another threat to life and family. The *Portsmouth Times* reported, 'Since the war, queues have been somewhat fashionable, but the last place we expected to find one was at the office for the registry of deaths.... the long line of folk waiting in queue has grimly demonstrated the ravages being made by the influenza epidemic'.

The influenza pandemic of 1918/19 had first appeared in Britain among sailors at Scapa Flow, but rapidly spread throughout the country. In Portsmouth, inhabitants suffering from primary symptoms were urged to rest and refrain from taking drugs. In any case there were no effective medicines available to treat this virulent and lethal strain, which all too frequently led to acute pneumonia and death. In terms of the mortality rate Portsmouth had seen nothing like it since the terrible cholera epidemic of 1849, the horror of which could still be recalled by more senior residents.

As the disease took its alarming toll, all schools were closed and children were prohibited from visiting picture houses and theatres lest they catch the germ. People avoided people. Sociability itself was now rationed. Vulnerable babies and robust sportsmen alike kept the coroner's court in permanent session. Brave heroes who had survived hell and high water were struck down by the invisible

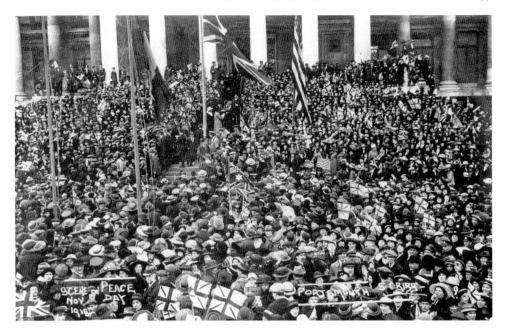

Armistice Day in the town hall square. Deafening applause greeted the announcement of the signing.

Empire Day at Portsmouth Grammar School, 1914. A recruit in the Officer Training Corps appears to have fainted behind the bush on the left.

killer without distinction. Any belief in justice that had survived the carnage of war seemed to have been crushed without meaning or reason.

One dark, November night in 1918 a Private John Cocks lay in his bed on ward 6A of the Southern General Military Hospital, when he was alerted by the sound of a hooter. Just one at first, then another and another until a discordant, deafening chorus filled the night air. Then, as he later described on a postcard to his mother, 'somebody shouted, "Peace!", and in a moment Bedlam was raised'. Excited crowds thronged the streets outside. Other wounded soldiers joined them, ignoring the protestations of nurses and pushing comrades out past them in bath chairs. Peace!

But the excitement was short-lived. 'False alarm,' recorded Private Cocks with bitter disappointment. 'Gosport had reached a quarter of a million war-bonds.' In Gosport, Camper and Nicholson's hooter had been sounded in all good faith to announce the town's proud achievement, but had been misinterpreted as the best possible news there could be. Everyone, everywhere desperately longed for peace. On the day of this, the biggest false rumour of the war, Kaiser Wilhelm abdicated and fled to Holland.

At the eleventh hour on the eleventh day of the eleventh month, the armistice was signed – eleven years to the day that the Kaiser, dressed in the uniform of a British Admiral of the Fleet, had been greeted by the Mayor and people of Portsmouth. The Great War was over.

Petty Officer George Burtoft, was at the bottom of a torpedoed merchant ship in the dockyard organising the removal of coal. When he emerged up from the dry

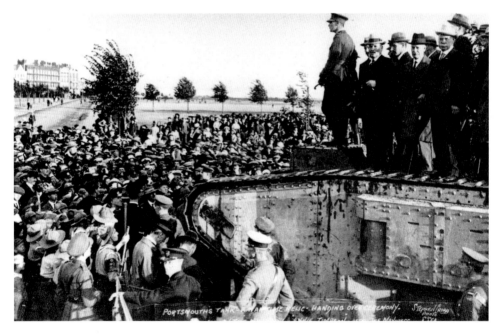

This obsolete tank was named *Annie Timpson* after the mayoress and was presented to the town at the end of the war.

dock he found the dockyard deserted. 'I was walking along and I ran into a bloke and asked him what was wrong and if there had been a bomb or something. "No," he said, "Don't you know?" "Know what?" "The war's over!" So I said "Bless my garden city" – or words to that effect!'

James Adams, then a schoolboy, remembered Armistice Day vividly:

I am not able to say why it was on this day of days I was not at school. My sister and I had been regaled with half of a boiled egg each – a week's ration on one of our ration books – and then we were taken to the Co-op in Albert Road to buy some groceries. Although this was the brightest day of the past four years, in actual fact, daylight hardly came through at all. All around was a thick yellow fog, so thick that it was only just possible to see the other side of the road. The tram drivers were clanging their warning bells continuously as the vehicles crawled along at little more than a walking pace. Their lights, as with those from shops and so on, were surrounded by haloes not making things round any lighter – only tending to increase the gloom if anything.

We suddenly heard a maroon being fired off, and guns from some of the naval ships in the harbour, followed by the sirens of what must have been every vessel there. The sounds seemed to be a signal for everyone to go mad. People went up to others in the street, shaking their hands vigorously, and not a few planting a kiss on the cheek of a total stranger who happened to be nearby.

Mother was ecstatic – the war had ended. "Will Dad be coming home?" I wanted to know. "Will he be back tomorrow?" The replies to my questions were a great disappointment. It would be a while yet. Still, it was a very happy day for Britain and her allies as a whole, but for some it would also be a sad day. Aunt Lily, in Winchester, had lost her husband – my Uncle Arthur – at the Dardenelles; my five cousins had lost their father. One could not expect their joy at the war's ending to be as complete as it would be for some people – grief tempered their joy.

The fog seemed to be even thicker – the trams were full as everybody seemed to be making for the town hall square. It was impossible to board a tram so we made our way to Thomas's Street on foot, forcing through the mad throng in Commercial Road. Having met up with Great Aunt Annie and some of her family we eventually got through to the square where someone was speaking from the town hall steps. "On behalf of the King and His Majesty's Government, it is my pleasure and duty, as your representative, to announce that the Armistice was signed this morning" (deafening applause) "and that hostilities have ceased" (renewed applause).

An echoing murmur of 'Thank God' passed over the crowded square and tears of joy and relief were wiped away to give vent to cheers and songs. From the platform the mayor, Councillor John Timpson, called for three cheers for the Army and Navy, and the Revd Cyril Garbett made the blessing. At 12.15 p.m. the town hall clock struck the quarter, breaking three long years of silence. Wounded soldiers marched as best they could up Greatham Street and were given seats of honour on the backs of the lion-guardians of the town hall. Penny Union Jacks

were tied to pram hoods and clutched in chubby fists while the adventurous climbed buildings and trees from which to wave their flags and join in the stirring mass chorus of the '*Marseillaise*'. Children were released from school and hurried to join in the fun; even the attendance officer would not begrudge them that. The crowd swelled to more than 40,000, many of whom stayed singing, dancing and cheering until well past nightfall.

> Newsboys were running madly through the crowd as they sold out of the *Evening News'* over and over again. Everyone appeared to be waving a newspaper. Sailors, Marines and soldiers were going along with girls – groups of four, five or more – many wrapped in huge Union Jacks.
>
> Trams were brought to a standstill ... The police had quite a job trying to maintain some sort of order in the excited crowd. I suppose it was to be expected as the evening wore on that a number had drunk too freely and the Army and Naval pickets were kept busy taking some of the lively servicemen into custody.
>
> Everyone here, and no doubt throughout the whole nation, were overjoyed that the terrible conflict was over. It was only right that people should be happy. Some had a cup full of joy in anticipating the return of husbands, sons and brothers unhurt from the war, but there were others whose joy was tempered by the sorrow of personal loss.

Celebrations lasted all day and continued through the night, with an estimated 50,000 people taking part. A journalist described the atmosphere:

> The press was suffocating, but jostling and banter was all part of the Carnival. One saw "all the fun of the fair", and by its very infectiousness, could not help participating in it. A sailor separated himself from his little group of jazz exponents in order to embrace a solemn policeman. After vowing eternal friendship, he claimed the perturbed "Peeler" as his old shipmate, and endeavoured to lead him – vainly – to the tavern "where his main brace is spliced"... The gas office was the first building to illuminate, and it did so with its own production ... the town hall became a twinkle with myriad pin-points of lights, all glowing in the three national colours. When the great word "PEACE" beamed with radiant delight on the populace from its towering height, their enthusiasm knew no bounds...Searchlights from four roofs played on the excited upturned faces of the revellers, who kept up their jollification until the "wee sma' hours" ... The people on The Hard made merry in the illumination of a tremendous bonfire on the mud. The scene was tumultuous; the effigy of the Kaiser duly received its quietus; and the last event of the night was the circlet of flame that beaconed – a magnificent close to an inspiring day.

The death toll sustained by all belligerents in the Great War is generally reckoned to be between 10 and 13 million. But behind every cold statistic, every cursory and impersonal entry in a Roll of Honour, a family grieved. Some fatherless children would have no memory of bereavement. James Callaghan:

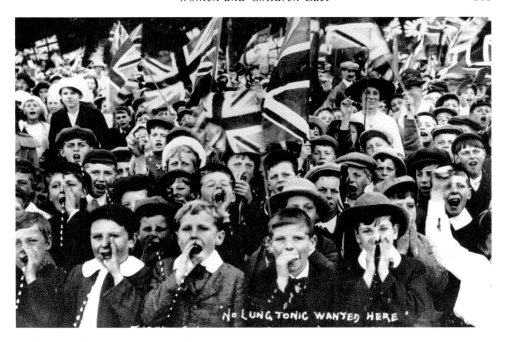

Children at the Peace Pageant, July 1919.

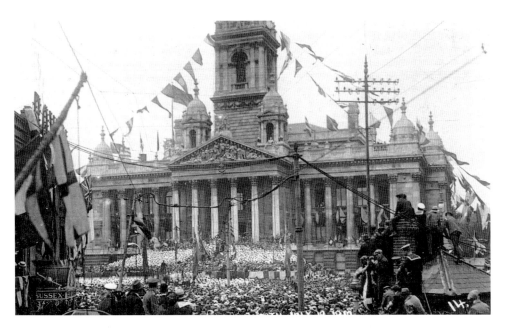

Cheering from the rooftops in the town hall square during the Peace Pageant.

The Portsmouth war memorial was unveiled on 19 October 1921.

The naval war memorial was unveiled in 1922 and was dedicated to the abiding memory of the 9,000 men who laid down their lives in defence of the Empire.

Among those killed [on the *Good Hope*] was our neighbour. It took a few days for the news to filter back to Portsmouth, and when it did I have a clear memory of clutching my mother's hand as she walked down the street to visit and comfort the widow. I was conscious of the grief in that room. What engraved the visit indelibly on my memory was the sight of the young widow suckling her baby at her breast.

Older children were told but some did not really believe. Others could not help but believe as they watched their fathers fall apart before them. One dad returned to his Milton home suffering from shell-shock received at sea and died a little each day until there was nothing left. Children could not always be told the truth. A traumatised local sailor committed suicide in his ship while at sea, leaving a widow and five youngsters. Another family, one of countless made fatherless by Jutland, dissolved as the widow suffered a nervous breakdown and the children were placed in institutions. Other large families were torn apart as inadequate pensions and grinding poverty meant that the children would be better fed and stand a better chance of survival in an orphanage or military institution, frightening places that they were. For others, less unfortunate, there was some precious time before their fathers succumbed to war-wounds and diseases. James Callaghan:

> I do not have a day-by-day continuous memory of my father. I was only two years old in 1914 when he joined the Grand Fleet at Scapa Flow and I do not recall him coming home during the war, although I suppose he did. He was demobilised when I was seven and died when I was nine. The only real time we spent together was during the two years before he died. It is those days that are among my happiest memories. I remember him as a jolly man, ready with a practical joke and a fund of exciting adventure stories... I wish that he had lived longer...and that I had known him better.

Self-pity is rarely entertained by those brought up in hardship, but a dignified sorrow remained in the hearts of thousands orphaned by that war. 'Cecil' Harbut remembered 'when the news came. Us kids sat out on the pavement. Crying our eyes out we were. All seven of us.'

Locally, more than a third of the men who joined the Portsmouth Battalions are known to have been killed. Numbers lost wearing the uniform of other regiments cannot be known. Neither can the exact total of sailors and marines drawn from the area. The Naval War Memorial on Southsea Common commemorates 9,666 'officers' ranks and ratings of this Port' who died at sea during the wars 1914-1918. 5,000 names were submitted for inclusion in a 'Roll of Honour' published in the *Evening News* and subsequently in William Gates's volume *Portsmouth and the Great War*. This compilation of names is not and does not claim to be complete.

References

Abbreviations:

PEN: *Portsmouth Evening News*, HT: *Hampshire Telegraph*, PT: *Portsmouth Times*, LT: *The Times* (London), DM: *Daily Mirror*, HM: *Hampshire Magazine*, YD: *Yesterday Magazine* (Portsmouth), ILN: *Illustrated London News*, IWM: Imperial War Museum, CRO: Portsmouth City Records Office, PRO: Public Records Office, PCM: Portsmouth City Museums, RMM: Royal Marine Museum.

Chapter 1

Hough, R., *Dreadnoughts – The History of the Modern Battleship* (1965); Howarth, D., *Dreadnought launch: The Dreadnoughts* (1979); *Kaiser's visit*: PEN 11/11/07; *Dockyard fire*: PEN (13/11/07); *Kaiser mental state*: PEN (10/1/15, 4/9/14); *Cradle Dreadnoughts*: PRO p. 249; *Lloyd George: War Memoirs* 'Vol. 1' p. 9, 'Vol. 2' p. 581; Clarke, I. F., *Alarmist literature: The shape of wars to come in History Today*, 'History Today, Vol. XV No. 2' (Feb 1965); Le Queux, W., *German spies: German spies in Britain* (1916); Steinhauer, G., *Steinhauer* (1930); *Grosse* PEN, PT, HT (Dec 1911 – Feb 1912); LT (10/12/13); *Maddick*: HT (5/6/14, 12/6/14, 19/6/14, 25/6/15); *Justice Darling*: PEN (10/2/12); Bulloch, J., *Helm: MI5 – the origin and history of the British counter-espionage service* (1963); PEN (Sept 1910); LT (14/11/10); *Kaiser visit: My early life Wilhelm II* (1926); Churchill, W. S., *Diplomacy: World Crisis 1911–18* (1939); *Kiel: op cit, The BBC scrapbook for 1914* (1964); *Proposed German visit*: PEN (18/7/14).

Chapter 2

Bishop, J., *Bathing: Social history of the First World War* (1982); *Hampshire Post & Portsmouth Standard* (13/9/13); Howell, S., *The Seaside* (1974); *Tea rooms:*

Mikado Cafe ad. In *Clarence Pier programme*, (Nov 1914); *Fleet Review*: LT, PEN, HT, PT, Scotsman (21/7/14); Lipscomb, F. W., *Heritage of sea power* (1967); *Proposed German visit*: PEN (18/7/14); Musselwhite, B., *Some royal Fleet Reviews of the past*, 'Gosport Records 11'; Stalkarrt : *Diaries 1914–16* (CRO); Mander, R., and Mitchenson. J., *Billy Williams: British Music Hall* (1974); Dunbar, G., *Call-up: As I saw it*; *Memories of Milton G Rogers*, PT (7/8/14); Finch, J., *Ferries: The Port of Portsmouth floating bridge* (1971); *Railways*: HT (7/8/14); Marwick, A., *The Deluge* (1965); *Mobrail: timetable* CRO Timetables; Taylor, A. J. P., *The First World War* (1963); *Tension*: PT (7/8/14). *Poem*: Punch (5/8/14), p. 122; Wyllie. M. A., *Tourists: We were one* (1935) p. 216; Wyllie, W. L., *Boom More sea fights of the Great War*, PCR, PEN; *Hoarding*: Stalkarrt diaries; Turner, E. S., Dear old Blighty (1980); PEN, PT, Portsea Parish Church Magazine; Pinks ad PT (7/8/14); Mumby. F., *Inflation: The Great World War* 'Vol. IV p. 18'; *Reservists: The Royal Naval Barracks, Portsmouth and its history* (1932); Young, R. T., *Fishermen The house that Jack built* (1955); *Soup* HT (7/8/14); *Reception*: HT (7/8/14); PT (7/8/14), Film held by IWM; Gieve, D., *Gieves & Hawkes 1785–1985 – the story of a tradition* (1985); *Billeting*: PEN (17/8/14); *W. Gates*: PEN (3/8/14); *F. Jane* HT (7/8/14); *War demo*: PT PEN (Aug 1914); Titheridge, C., *Glimpses of a gunner's war*, HM 'Vol. 29, No. 3', (Jan 1989). Anon. *Sailor*: PEN (8/8/14); *Turner op cit*, Daily Mail, p. 27; *St Thomas's*: PEN (14/8/14); *MacTavish* PEN (26/8/14); Yexley, L., *Magic of war*: HT.

Chapter 3

Defence area: HT (7/8/14); *Debating society: Portsmouth High School Magazine*, (1914); *Preparations*: PN, PT, HT (July–Aug 1914); *Territorials: History of the Hampshire Territorial Force association and war records of units 1914–18*, HM 'Vol. 6, No. 1' (Nov 1965). *Grove Road*: PT; *Secret Service: German Spies in England* p. 90; *Agents arrested* PEN, HT (14/8/14); *Church service*: PT (14/8/14); *Tailor*: HT (21/5/15); *Watchmaker*: PEN (6/11/14); *Gosport girl*: PEN (2/12/14); *Swiss cafe*: HT (18/9/14); *Fritz: Queer People Basil Thomson* (1922) p. 37; *Detestable aliens*: PEN (11/9/14); *Fair play*: PEN (5/9/14); *Hulks*: PCR, Hansard (19/2/15); *Jane*: HT (18/9/14); *Motor excursion: Stalkarrt diaries*; *Martial law*: PEN (19/8/14); *Priddy's Hard*: PEN (21–22/8/14); *Riots*: PT, HT (14/8/14, 21/8/14); *Beresford*: Hansard (28/8/14) 'Vol. LXVI p. 268'; *Defeat rumour: Stalkarrt Diaries*; *Knitting* HT (14/8/14) (Drummond Hall); *Magazines* PEN (29/8/14); Esmond, R., *Southsea Castle: Portsmouth not so old* (1961); *Invasion*: London Magazine (Nov 1914); *Spencer Road*: HT (14/8/14); *Sydney Road* HT (18/12/14); *Solent firing*: Punch (19/8/14) p. 160; *Prisoners* PEN (14/8/14) (see also YD No. 4); *Ritz*: PEN (8/9/14); *Scouts*: PEN (7/8/14, 14/8/14); *Jane* HT (28/8/14); *Raiders*: PEN (12/8/14); *Marmion Road, execution: Bill Buckley* (interview 1986); *Spies shot: Dear old Blighty* p. 56; *Gates*: PEN (10/8/14); *Baker*: HT (15/9/16); *Atrocities* HT (15/9/16); *Nurse*: DM (30/12/14); *Belgian appeal*:

PEN (28/8/14); *Refugees at Gosport*: PEN (18/9/14); *Winchester* HT (26/5/16); *Undesirable*: PEN (10/12/14); Harbour attack Pinks Pictorial (1909) p. 12–13.

Chapter 4

Dockyard: Edwin Cleall and Annie Eason (interview 1985–86); *Beresford*: PEN (7/9/14); *Thorngate*: HT (4/9/14). *Kitchener*: HT (20/11/14); *Cribb & Kitchener: Ron Brown* (interview 1987); *Dockyard* PEN (29/9/14); *Francis Ave School* PEN (18/8/14); log (August 1914); *Lauder*: PEN (6/8/15); Taylor, A. J. P., *Bottomley: The First World War* (1963) p. 56., Cars: HT (7/5/15); *Locksmith: Dockyard audio interviews* (Celia Clarke – PCM); *Encouraging words*: HT (7/5/15); *MacTavish*: HT (7/5/15); *Women*: PEN (4/9/14); *Whisper*: PEN (24/8/14); *Emasculated specimens*: PEN (1/9/14); *White feather*: PEN (7/9/14); *Suicide*: HT (18/9/14); *Garbett: Portsea Parish Mag.*, (Oct 1914); *Beresford*: PEN (4/9/14); *Jane*: HT (28/5/15); *Joy rider*: HT (4/9/14); *Brawny Englishmen*: PEN (21/8/14); *First match*: PEN (28/8/14); *Cornford*: PEN (22/8/14); *Means to an end*: PEN (29/8/14); *The Day*: PEN (21/8/14); *Frogmore Road*: PEN (5/10/14); *Amateur soccer*: HT (3/9/15); *Play Up*: PEN (11/11/14); *King's Theatre*; Gates, W., *Portsmouth & Great War*, PT (22/8/14); Abrams, M., *Average wage: Conditions of the British People 1911–45* (1946) p. 82; *Admiralty chemist*: PEN (1/9/14); *MacTavish*: PEN (2/9/14); *Errand boys*: PEN (7/10/14); *Fred Barker*: PEN (2/9/14); *Leaving without notice*: e.g. PEN (4/12/14, 5/11/15); *Pinks*: PEN (2/9/14); *Brickwoods*: PEN (22/8/14); *Dyer*: PEN (5/10/14); *Municipal College: The Galleon (college magazine)*, Xmas 1914. *Land ports*: PEN (5/10/14); *Play the man*: PEN (3/9/14); *Intended to join next day*: HT (27/8/15); *Governor's Green*: HT (18/9/14); *Khaki shortage*: PEN (2/11/14); Commandeering horses effects: PT (21/8/14); *Horses on Common*: Portsmouth & Southsea Remembered, William Curtis (1984) p. 47; *Anti-vivisection*: PEN (27/11/14); *Sleep under canvas*: PEN (1/12/14); *Typical camp*: PEN (1/12/14); *Wounded*: HT (9/10/14); *Palatial*: PEN (1/12/14); Sharing rifles: PEN (2/11/14); *Machine gun proposal*: PEN (1/1/15) Basset's: PEN (11/11/14); *Aid to recruitment*: PEN (editorial) (9/11/14); *Poetic tribute*: PEN (2/1/15); *Kitchener more men*: PEN (10/11/14); *Inspection*: HT (20/11/14); *1st Battalion departure*: (16/4/15); *Gates op cit. 2nd Battalion*: HT (22/10/15); *3rd Battalion*: HT (7/1/16); Atkinson, C. T., *Trenches: Regimental History of Royal Hampshire Regiment 'Vol. 2'* (1952) p. 138–9.

Chapter 5

Additional attraction: PEN (30/10/14); *Clarence Parade resident*: PEN (13/11/14); *Trevor Rogers: Gosport Records, Gosport Society. Corsets: Portsmouth Corset Industry W Lewis Lasseter, Stay factories 1841–1911 – Notes, Ray Riley*; *Unemployment and poverty* PEN (18/8, 22/8, 24/8/14); *Practical patriotism*: PEN

(19/8/14); *Gates*: PEN (18/8/14); *Hungry women at Town Hall*: PEN (7/10/14) (letter); *Falle*: Hansard *op cit*. *Unemployed seamstresses*: PEN (2/11/14); *Pantomime*: PEN (28/12/14); *Brothels*: court reports (1914–18); *YMCA*: PEN (1/1/15, 21/10/14); Weston, A., *Weston: My life among the bluejackets* (1919), PEN (8/8/14); Webb, L., *Anecdote: Music hall jokes* (1971); *Municipalisation*: PEN 2/11/14; *School Medical Officer*: PEN (2/11/14); *Gates appeal*: PEN (6/10/14); *Soup kitchen*: PEN (17/11/14, 25/11/14); *Anne Eason op cit. Gosport*: PEN (8/12/14); *Voller Street*: Pinks Pictorial 'Vol. 1, No. 6' (Jan 1914); *Infant mortality: Practical hints on the feeding and management of infants*, Town Hall Health Dept booklet, (1911); *Cumberland Street*: HT (17/9/15); *Revd Tanner*: HT (19/2/15); *Garbett*: Portsea Parish Church Magazine, (Oct 1914); *Mothers' Union*: HT (21/5/15); *Abyssinian Arms*: PEN (23/12/14); *Naval wives*: HT (11/12/14); Punch: (17/3/15), p. 215.

Chapter 6

Garbett: Portsea Parish Magazines, PEN; *Cyril Forster Garbett – Archbishop of York*, C. Smyth (1959); *Aboukir and Cressy*: Churchill op cit p. 277–9; *Howarth op cit* p. 74, PEN (10/10/14); *Strong swimmers: Warships of the First World war*, B. Fitzsimmons (1973); *Good Hope*: PEN (5/11/14), Howarth *op cit* p. 83; Taylor, J., *Edwin Cleall. Nearer my God: The sea chaplains* (1978); *Bulwark*: HT (27/11/14, 4/12/14); LT. *Stalkarrt* : op cit. *Evening News* offices: Gates op cit p. 24; Lipscomb, F. W., *Impact casualties: Heritage of sea power* (1967), PEN (3/5/16); *Garbett*: Smyth op cit, p. 133; *Doris Loving (Ball) interview* (1988); *George Dunbar, As I saw it*, p. 41; *Casualties*: PEN (5/6/16); *Gates*: PEN (7/6/16); *Relief fund: Notes on Work in Milton*, p. 7 (CRO); *Hospitals: Faith & Service*, G. L. Squire, Gosport Records (11), (April 1976); *History of the Hants Territorial Force Association*, p. 214, PEN, (10/11/14, 2/12/14, 10/12/14); HT (28/1/16); *Someone said … : Cleall op cit. Bloodied effluent: Dunbar op cit. Fawcett Road: The Portmuthian* 'Vol. XXXII, No 1', (March 1915); PEN (1/9/14); *Germans*: HT (18/9/14,9/10/14, 29/9/14); *Curtis op cit* p. 47; *Gifts*: PEN (1/9/14, 9/10/14); *Suicide*: HT (5/3/15); *St James's: The history of St James' Hospital*, G. Purvis (1977); *Continuous trips*: Trevor Rogers. *Direct delivery*: HT (25/2/16); *German's funeral*: PEN (2/10/14); *Fred Jane*: HT (6/11/14); *Haig: see On the psychology of military incompetence*, N. F. Dixon (1976) p. 371–392; *Portsmouth Battalion*: Atkinson op cit, *Battle Story of the Hampshire Regiment*, F. E. Stevens (1927); *Very multitude: Diary of a journalist*, H. Lucy (1922); B. W. Rogers: HT (5/2/150).

Chapter 7

Houseman, L., *Hush up the worst side: War letters of fallen Englishmen*, (1929); *Mud, people opposite*: Punch (11/8/15), p. 121; Thompson, J., *Cecil Talbot: The*

War at Sea 1914–18 (2005) p. 54; *Royal Marine, Gosport: History reflected*, BBC Radio 4 broadcast (May 1985); Davies, W. R., *The Portmuthian*, 'Vol. XXXII, No. 2', (April 1915); *Holbrook*, DM (15/12/14); PEN (19/12/14, 21/12/14, 28/12/14); *J. H. Bishop*: HT (11/6/15); Keynes, G., *Brooke: The letters of Rupert Brooke* (1968); Hassall, C., *Rupert Brooke* (1964); Jerrold, D., *The Royal Naval Division* (1927) p. 46; *Arthur Ferrett: interview*, (1989); *Marine, Zeebrugge: Evening Despatch* (24/4/18); *Casualties*: PEN (27/12/18); *Bill*: letter held by RMM; Bayham, H., *Blanch: Men from the Dreadnoughts* (1976); *Frankham*: author's collection; *Reed*: HT (20/11/14); *Edge-Partingdon*: Portsea Parish Church Magazine, (August 1915); *Cutis*: HT (9/4/15); *Stringfellow*: PEN (18/12/18); *Hearn*: PEN (28/12/14); *Old boy: The Portmuthian*, 'Vol. XXXII, No. 1', (March 1915); *Rogers*: HT (5/2/15); James Gray interview (1986); *Rundell: Letters held by CRO, Portsmouth Boys' Secondary School Roll of Honour*; Fraser and Gibbons., *Slang: Soldier and sailor words and phrases* (1925); *King*: HT (8/1/15); *Reservist*: HT (11/9/14); *White: Diary entries* (in possession of Dudley White), from article by C. Salter, HM, (Jan 1980).

Chapter 8

Nervous youth: PEN (5/7/16); Boulton, D., *Wastage: Objection overruled* (1967); *Gates*: PEN (9/3/16); *Council minutes*, 1916, (8/2/16), p. 143; *Statutes: Military Service Act*, (1916); Ch 104, 2nd schedule, clause 2, p. 367; *Portsmouth times*, (7/1/16); *Deserters: Military Service Act. Fully representative: Boulton op cit.* *Women members*: PEN (9/2/16); *Police raids*: HT (26/5/16); PT (15/9/16); *Tramps*: PEN (9/2/16); *No liking for army*: HT (19/5/16); *Procedures: Military Service Act, clause 5. Billiards and bets*: PEN (4/7/16); *Watchmaker*: PEN (28/4/16); *Impartiality*: PEN (27/2/16); *89 per cent*: PEN (24/2/16, 25/2/16); *Mechanical turn of mind*: PEN (12/5/16); *One eye*: PEN (7/7/17); *Government contracts*: PEN (5/4/16); *Harpist*: PEN (8/3/16); *Pneumonia*: HT (21/9/160; *Natural causes*: PEN (15/2/17); *Let off*: PEN (8/8/16); *Worms*: PEN (2/9/16); *Babies*: PEN (2/9/16); *Zeppelin*: PEN (11/3/16): *Shoot 'em*: HT (28/4/16); *Numerous class*: PEN (6/1/16); Ashworth, G., *Around half: Portsmouth Political Patterns* (1976) p. 3; *Good preachers*: PEN (19/7/16); *Lady clerks*: PEN (26/2/16); *Male preserve*: PEN (1/7/16); (see Doctor and his chauffeur) *Bank clerk*: PEN (1/3/16); *Non-Combatant Corps: Boulton op cit*, p. 131; *Military machine*: PEN (25/3/16); *Bramsdon*: PEN (9/3/16); *South Parade Pier*: PEN (9/3/16); *Wickham Road*: PEN (14/3/16); *Punch nose*: PEN (8/4/16); *Anti-conscriptionists*: PEN (29/3/16); *Sermon on Mount: Boulton op cit*, p. 125; *Accept any penalty*: PEN (20/4/16); Moore, W., *Mock execution: The thin yellow line* (1974); *Kingston Prison*: HT (26/5/16); Hobhouse, H., *19 C.O.s: I appeal unto Caeser* (1917); *Heinrich*: HT (26/5/16); *Starvation diet: Boulton op cit*, p. 157; *Rapid handling cases*: PEN (12/9/16); *Stirs blood*: PEN (29/8/16); *Town Guard death*: PT (20/11/14); *Manoeuvres, Hotchkiss*: PEN and Volunteer Training Corps Gazette.

Chapter 9

Gamma: HT, PT (19/6/14); *Debating*: Portsmouth High School Magazine, (1915); *Churchill op cit* p. 265–8; *Cosham poll*: HT (17/12/15); *Blackout facilities*: HT (29/1/15, 17/9/15); *Poem*: PT (28/12/17); *False name*: HT (13/8/15); *Motor regulations*: HT (25/2/16); *Women specials*: PEN (16/2/17); *Trams insurance*: PT (13/8/15); *Royal Hospital*: HT (1/10/15); *Copnor lady*: PEN (15/12/16); *Safest place*: PT (16/6/16); *Good job if they came*: PEN (16/10/14); *Piece work*: HT (3/11/16, 10/11/16); Robinson, D., *Portsmouth target: The zeppelin in combat* (1962) p. 50, 67; Jones, H. A., *Aerial defences: War in the air* 'Vol. III' (1931), p. 81–5; *Stalkarrt , op cit.* PT, *The Royal Naval Barracks, Portsmouth* (1932); *Horsea Island mast: Corporation Records*, p. 251; PEN (10/1/14), Ripley. B., *Horsea Island and the Royal Navy* (1982); *Gates*: PEN (25/9/16); *Mathy's letter: Zeppelin in combat* (1971); D. H. Robinson, p. 11; *Mathy's orders: Robinson op cit, Jones op cit*, p. 190, 233; Klein, P., *Nobody has ever been: Achtung! Bomben fallen* (1934), p. 137; *Progress of L31: Klein op cit*, p. 173; Wells, J. J., *Burtoft: Whaley – the story of HMS Excellent*, (1980), p. 80; *Augriff auf Portsmouth in Achtung! Bomben fallen*, translated by H. & G. Warren; *Cobden Street: Elsie Harbut (daughter), interview* (19870; *Mathy's account: Jones op city*, p. 234; Robinson op cit, p. 192; Oliver, R. D., *Inadequate defences: HMS Excellent 1820–1930*, (1930), p. 117; *Anti-Aircraft: Dunbar op cit. Falling Zeppelins: Klein op cit*, p. 144; MacDonagh, M., *Times journalist: London in the Great War* (1935); *Penhale Road souvenir: Dunbar op cit*, p. 42; Ashworth, C., *Fort Grange: Action Stations*, (1983); PEN (29/3/68, 6/1/70,30/3/78); Stretton, J., Gosport, cradle of the RAF, PEN (30/3/76).

Chapter 10

Shifts, overtime: PEN (12/3/15); Lane, E., *Royal Sovereign: The Reminiscences of a Portsmouth Dockyard shipwright* (1988), p. 25; *Dockyard facilities: Jane's fighting ships* (1916); Goss, J., *Submarines: Portsmouth built warships 1497–1967* (1984); *Survivors*: PEN (June 1916); Magan, M., *Cradled in history* (1976)l; *Every mechanic: Dockyard oral history project*, PCM; *Women: Gates op cit* p. 57–8; Peacock, S., *Votes for women: the women's fight in Portsmouth* (1983) p. 20; *Dockyard memories: Dockyard oral history project*, PCM; *Change nature*: HT (1/10/15); *No non-combatants: Woodbine Willie in Turner op cit; Municipal College: Gates op cit*; Murfitt, A. E., *Poison gas: Roll of the Great War – Section X, Portsmouth*, entry p. 163; *Gosport aviation Co.*: HT (27/7/72); Sadden, J., *Flag days: Gates op cit. Portsmouth – a century of change* (2009) p. 96., *POWs: Gates op cit*, PEN; *Dockyard record: Corporation Records 1835–1927* (1928) p. 274; PEN; *Queen Elizabeth: Churchill op cit*, 'Vol. 1', p. 453; *Swift: Magan op cit; Vindictive, Iris, Daffodil: Lane op cit*, PEN; Coles, A., *Baralong: Slaughter at sea* (1986); Simpson, C., *Hedworth Meux, Q ships: Lusitania* (1972) p. 40;

Combing out: Dockyard oral history project, PCM, PEN; *King's visit*: PEN; *War memoirs of Lloyd George*, 'Vol. 1, p. 319'; *Hunting patrols, Jellicoe, A Temple Patterson* (1969), p. 157; Gunston, D., *Nab: Britain's strangest lighthouse*, HM 'Vol. 1, No. 12', (Oct 1961); Medland, J. C., *Sinkings: Shipwrecks of the Isle of Wight*, (1986); *Voluntary rationing* PEN (1917–18); *Tram cars*: PT (21/9/17); *Disappearing letters*: PT (17/7/17); *Queues*: PEN (7/1/18); *Dunbar op cit. U-Boats at Portsmouth*: PEN (Dec 1918); *Hoarding*: PEN (4/1/18); *Allotments*: HT (15/12/16); *Gates op cit. Lose parks*: PT (16/2/17); *Lee: Turner op cit qf A good innings by Lord Lee. Back to land: Gates op cit*, p. 54–5; *Wrens: England Expects, membership card* (author's collection); *Wrens: The Royal Naval Barracks, Portsmouth and its history* (1932); Barnett, C., *The Great War* (1979) p. 142; *Dockyard unions, standards of living*: HT (2/4/15, 12/3/15, 19/3/15, 17/12/15, 3/8/18 etc); *Overtime: Lane op cit. Café*: HT (7/5/15); *Photographer*: D.O.R.A., PEN (29/1/16); *Tobacconist*: PEN (8/3/16); *German tyke*: PEN (16/9/14); *Pub, Voller Street*, PEN (31/12/15); *Naval wives' intemperance*: PEN (Dec 1914); *Munitions workers: Marwick op cit* p. 65; *Garbett: Smyth op cit*, PEN (2/12/14); *Riots, mutiny*: HT (15/1/15, 3/12/15, 15/12/16 etc); *Court's disapproval*: PEN (19/11/15); *King's pledge: Marwick op cit; Tailor*: D. Gieve *op cit; War Office warning*: PEN (27/8/15); *Deceased officers' kits*: PEN (27/8/15); *Bank: Gates op cit. Female bank clerks*: PEN (21/8/15); *Dockyard payday: Lane op cit*, p. 17; *Hotel prosecution*: PEN (9/7/15); *Haig: Bishop op cit*, p. 102; *Domestic registry, servants' conditions*: Hampshire Post & Portsmouth Standard (4/10/13); *Post office: Gates op cit. Postwomen*: PEN (21/8/15, 4/2/16); *Illegible address*: HT (28/4/16); *Pawnbroker: Report of the Police Establishment and the State of Crime*, (1914); *Three balls: Cleall op cit. Floating bridge company*: PEN (5/1/63, 6/7/63); Finch, J., *Directors' report: The Port of Portsmouth Floating Bridge Co. 1838–1961* (1971); *Landlord, rents: Smythe op cit*, p. 105; *D.O.R.A.: Bishop op cit*, p. 105; *Grocers, deferential customers*: PEN (11/5/17); Brown, R., *Pinks: The Portsmouth Emporium* (1983); *Tobacco*: PT (19/10/17); *Queue: Lane op cit. Profiteering: Gates op cit*, PEN; *Maypole*: R. Gladys Whiteman (interview 1988); Michell, J., *Dairy: History of the Portsea Island Mutual Co-operative Insurance Society to 1919; Milkmen*: R. Gladys Whiteman *op cit; Baker, mayor's call*: HT (12/5/17); *Rogers bakery*: HT (17/11/16); *Canoe Lake swans*: PT (12/10/17); *Corporation, insult to women*: PT (14/8/14); Mumby, F., *Inflation: The Great World War*, 'Vol. VI', p. 95; *Dispute*: PT, HT, PEN, (Feb–March 1916); *Only one in kingdom*: HT (25/2/16); *Clergymen: St Mark's Parish Magazine*, (March 1916); *Blacklegs*: HT (18/2/16); *Tommy's wife*: PEN (28/2/16); *Scavengers' work*: PEN (20/4/16); *Watering Cart*: R. Gladys Whiteman *op cit; Women on trams*: PEN (8/10/15); *Optimist*: PEN (8/10/15); *Paper shortage*: PEN (29/12/16); *Market: The Galleon*, 'Vol. III, no. 2', (Spring 1914), p. 4–6; *Garage, ground crew*: C. Ashworth *op cit; Licences: Report of the Police Establishment*, (1914); *Hants Auto Club*: PEN (19/8/14); *Morris Oxford: Turner op cit*, p. 238; *Bad drivers*: PEN (11/9/18); *Accidents*: PEN (27/10/16); *Fry's*: PEN (19/8/14); *Petrol*: (11/1/18); *Undertaker, Marshalls*: PEN (9/6/16).

Chapter 11

George and Alice: DM, LT, PEN, (Feb–July 1915); Spencer, E., *A Companion to murder*, (1961); Blackpool Gazette (16/12/13); *Marriage stats*: PEN (28/8/16); *Bigamy*: PT (31/10/18); *Returning soldier*: PEN (6/9/18); *Punch-up*: PEN (9/7/15); *Portsmouth Crime Returns*, (1914); *Prostitute and policeman*: PEN (18/3/18); *Railway arch*: PT (14/6/18); Tawny, C., *I hopped: Grey funnel lines* (1987); *Voller Street*: Pink's Pictorial 'Vol. 1, No. 6', (January 1914); *Ashburton Road*: PEN (10/8/18); *Lowcay Road*: HT (2/4/15); *V .D. effects*: Southern Daily Echo (Southampton) (Sept 1918); *V. D. play*: PT (12/10/17); Punishment for sin, over 10 per cent effected: Report on health of Portsmouth (1916); *German plot*: Turner op cit, p. 247; *Gates*: PEN (12/5/17); *Lecture*: PEN (14/5/17); 20,000 cases, Willow Lodge: Report of the Medical Officer of Health 1917, 1918, Town Council minutes (8/3/17), p. 174–7; *Hard labour*: HT (22/12/16); *Murders*: PEN, HT (1913–15); Triggs, A., *Blossom Alley: History in hiding* (1989); *Purity patrols*: PEN (9/12/14, 18/12/14); Hamilton, A., *Beating heart: Our freedom*, p. 109; *Maligned Wren*: News of the World (25/8/18); *Kissing*: Wells op cit. Watch Committee minutes, (13/3/16); Bern, L., *Prevent piracy: Cinemas of Portsmouth 1910–5* (unpublished notes), Victoria Hall (9/1/17); *Birth of a Nation*: HT (17/11/16); Huff, T., *Chaplin: Charlie Chaplin* (1952); Payne, R., *The Great Charlie* (1964); Chaplin, C., *My Autobiography* (1964); Nown, G., *When the world was young* (1986)., (The PEN critic indicates that this act had appeared in Portsmouth on previous occasions, but individual players are not identified.); *Albert*: PT (4/2/16); *Street acts*: PEN, PT, HT (1914–18); *Marie Lloyd*, PT, HT, (July 1918); *Man who stayed at home: Play Pictorial*, (1916); Fergusson, J., *Clara Butt: Arts in the First World War* (1980); Hall, Mander and Mitchenson., Little Tich and other acts: British Music (1974); Francis, D., and Rogers, P., Portsmouth in Old Picture Postcards; *Baseball*: PEN (5/7/18); Moulton, J., *Antwerp: The Royal Marines* (1972), p. 51; *Propaganda film*: IWM film catalogue p. 842, (1919); Pearson, H., *Conan Doyle: Conan Doyle* (1961); *Gates* PEN (20/10/14); *Rotary Club*: PEN (18/9/18); *Mary Pickford*: HT (16/7/18); *Combat pacifism*: PEN (7/5/18).

Chapter 12

Newman, B., *Post office: Spies in Britain* (1964); Haswell, J., *Schragmuller: Spies and spymasters* (1977); Thomson, B., *Janssen and Roos: Queer people* (1922) (in this account, Dierks was set up in The Hague); Bulloch, J., *Buschman: Thomson op cit, MI5*, (1963); *Chamberlain: birth announcement*: HT (15/9/55) p. 5; Biddis, M., *Prophet of Teutonism*, History Today, 'Vol. XIX, no. 1', (Jan 1969); Palmer, A., *The Kaiser* (1978); Sydney Jones, J., *Hitler in Vienna 1907–13* (1983); *Obituary*: LT (10/1/27).

Chapter 13

A good many: LT (22/1/15); *Shovel and bucket: Dunbar op cit* p. 34; Hugget, R., *Handleys: Growing up in the First World War* (1985) p. 45; *Value of dolls*: HT (22/12/16); Reed, H. J., *Memories of a R. M. Bandsman*, Arch (11/13/28); Callaghan, J., *Time and chance* (1987); *Gosport court*: HT (20/4/16); *Character of films*: HT (5/5/16); *Discipline decline*: PT (14/9/17); *Birching*: HT (9/10/14); *Persistent offenders*: PEN (21/9/16); *Industrial school*: HT (28/5/15); *Penny Bazaar*: HT (7/1/16); *Indecent*: PEN (21/9/16); *Bad influence cinema: Marwick op cit*, p. 118; *Gladys Avenue firearm*: HT (21/1/16); *Rifle range, Eastney*: HT (8/1/15); Wyllie, M., *Sea scouts: We were one* (1935); *Head prosecuted*: HT (8/12/16); *War alphabet*: Portsmouth High School Magazine, (1914); *Maternity clinics*: HT (20/4/16); Durham, W., *School clinic: Portsmouth Education*, (unpublished paper); *Adenoids*: PEN (11/2/16)l; *Attendance: St Luke's School Log*, (1915); *Budget concerns*: HT (4/2/16); *Dockyard holiday: Francis Avenue, St Luke's school logs* e.g. (17/6/17); *U-Boats at Portsmouth*: PEN (4/12/18) see also Submarines in Fareham Creek, F. Beckett, Fareham Past and Present, Spring (1988); *Empire Day, The Portmuthian, Portsmouth Grammar School Magazine, Portsmouth High School Magazine*, (May 1915); HT (11/6/15); *Juvenile employment*: Education sub-committee report, (Nov–Dec 1915); *Kate Edmonds*: PEN (9/11/18), Peacock op cit. *John Cocks: postcard* (author's collection); *James Adams: Armistice Day in Portsmouth 70 years ago*, HM, (Nov 1988); *Mutiny*: PN, HT, (Jan 1919); Peake, N., *Mutiny on the March* YD; Macready, N., *Annals of an active life*, p. 306; Hansard (12/3/19); Moore, W., *The Thin yellow line* (1974); *(15th Hants) Peace pageant*: PN, HT (July 1919); *Influenza*, PN, HT, (Sept–Nov 1918); YD magazine no. 7; *Doris Ball née Loving, Ernest Ball, Bill Buckley, D. S. Ford, Anne Eason, Arthur Ferrett, James Gray, Cecil Harbut, Elsie Harbut née Mullins, R. Gladys Whiteman, R. A. Lowe* (personal interviews 1986–89); *Callaghan quotes from Time and Chance* (1987).